SELF-PORTRAITS
Reflections of an Artist's Journey

Lea M. Fisher

SELF-PORTRAITS
Reflections of an Artist's Journey

DAY
Productions
film • publishing • events

First published in the United States of America in 2023 by

Day III Productions, Inc.
www.DayIIIProd.com

Editor – Abra Garrett
Designed by Douglas King
Copy edited by Jessica Manley

First Printing, December 2022. Printed in South Korea.
ISBN: 978-1-7376256-2-9

Dedication

To JD Miller:

The one who put a painting knife in my hand and unconditional love in my life.

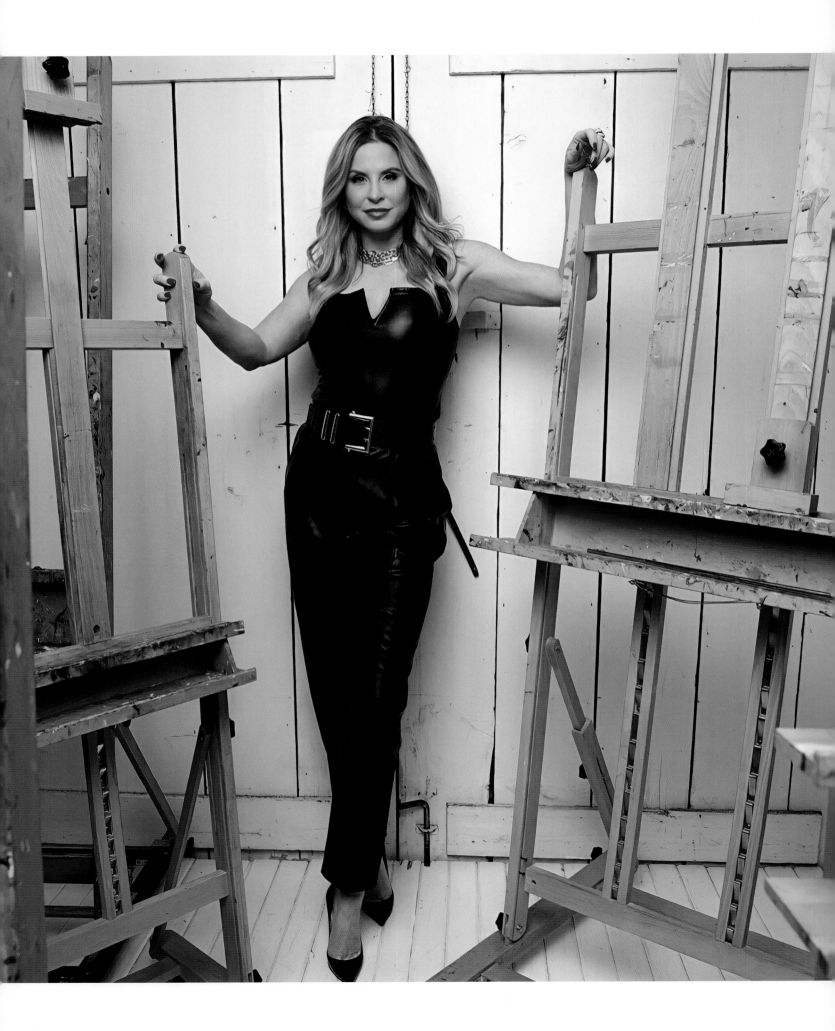

Introduction

My Dearest Reader,

Thank you for joining me here. This book you hold is an autobiography of sorts, accompanied by self-portraits I created between 2017 and 2022. These self-portraits do not represent me in a literal sense, in terms of my physical appearance, but rather they are more inner self-portraits that depict my personal journey. Each portrait may embody a thought, an emotion, or my experience of an important person in my life. They are the pictorial representations of my mental landscape with all its ups and downs, sharp turns, and unexpected detours.

One common theme you will see throughout this series is that the personalities of the characters, and when I say characters, I mean the different versions of me that are represented, seem to be moody and full of angst, anger, and sadness. There are a few cheerier, sweeter works, because no one is in a foul mood ALL of the time, but for the most part, the general tone is a bit temperamental. They were created in the true spirit of the Reflectionism school of art (established by JD Miller, my mentor), and they are, indeed, snapshots of my personal energy, translated onto canvas.

It wasn't that I felt miserable for the entire duration of creating this series. It was more like there was an undercurrent of unresolved trauma that flowed beneath my reality at this specific time. In fact, my life was the best it had ever been during this period, so the emotions portrayed in these works didn't necessarily have anything to do with my present circumstances. These paintings were more of a reflection of my subconscious beliefs and programing, bubbling to the surface of my current existence, originating in my history of growing up in a dysfunctional household.

My mother and father both suffered from addiction and mental illness, and I was negatively affected by their afflictions, which some of these paintings represent. However, as an extremely important side note, I want to be very clear that I do not blame the pain of my process on my parents. I know that, without a doubt, they did the very best they could. In fact, both my father and mother were very loving toward me, and I have great admiration for them for what they did provide, physically and emotionally, especially considering the horrific circumstances they endured themselves. But, even so, they were very ill, and I was part of their story, and life was difficult for me as a child and young adult. A great deal of what you will witness in this book is the account

of my struggle—but not to worry, for there is a silver lining: this is also the story of my recovery from our familial trauma.

These portraits were a vehicle for me to see myself, and when I started writing about them, I was smacked in the face with my reality and the part that I played in it. You see, I could only blame my parents for my suffering for so long and then I had to take responsibility for my own life. This process was uncomfortable to say the least. It took me three years to complete this book, and avoiding my emotions around my unresolved grief, shame, and anger played a big part in my procrastination. However, being confronted with my past and my feelings about my past was actually a gift for it jolted me out of denial and forced me to start seeking help to come to terms with myself. I had attended Al-Anon for thirteen years and had much therapy by the time I began this book; however, it was time to go deeper into peeling the onion layers, much deeper, and this book provided the perfect opportunity.

I committed to myself that I was, once and for all, going to get serious about healing my trauma, forgiving my parents, and loving myself. No stone would be left unturned. I started meditating on a regular basis, reading spiritual and wellness books, listening to podcasts, and seeing different therapists. I opened myself up to the healing arts and began to research how my body needed to be healed in order for me to have the full understanding of my current reality. I took a pilgrimage to Sedona, Arizona, where I learned about energy and the healing properties of the Earth. I was open to it all, and I have to say my mind was blown. I learned so much about myself and my family and how, even though the way our pain manifested may have looked very different, we were really much more similar to other families than I could ever have imagined. I did heal in so many ways, and I now possess a hopefulness and a knowingness that I didn't have before, a deep, visceral realization that everything, indeed, will be OK. This is a big deal for me because for much of my life I didn't know things would be OK. I didn't even know if they would be close to OK.

Throughout this book I mention some of the resources that were so helpful to me during this process, with the hopes that you, my readers, might be inclined to investigate your own self, should you relate to any of what I have written. I sincerely desire that my experience will be helpful to others who struggle, and that by reading this book they will know they are not alone and that there are resources to empower them to embark on their own beautiful journey of healing.

As you view these paintings and read these vignettes, it will be helpful to keep a couple of things in mind. Leaving the literal behind will streamline the experience. I play plenty with gender and jump in and out of social norms, but always know that this is all me and different aspects of my thoughts. I expect there to be a bit of confusion and, hopefully, if I am lucky, some questions. I so look forward to a further conversation.

Writing this book has been such a gift. I am so incredibly grateful to have had the time, space and, most of all, the unwavering support of remarkable people in my life as I wrote it. Without the backing and encouragement of those around me during this process, I would not have had the courage or fortitude to bring this project to completion.

And, lastly, I hope my story and my art show that we are all together on this wild ride we call life. I hope as you view my portraits and read my words you might see some small part of yourself in there and know you're not alone (especially if it is a little scary to look at certain things). I hope that my story will paint the picture that pain is only the bridge to joy and that bridge is an integral part of each and every one of our journeys. With that said, I am humbled to be on this trip with you.

With love,
Lea M. Fisher

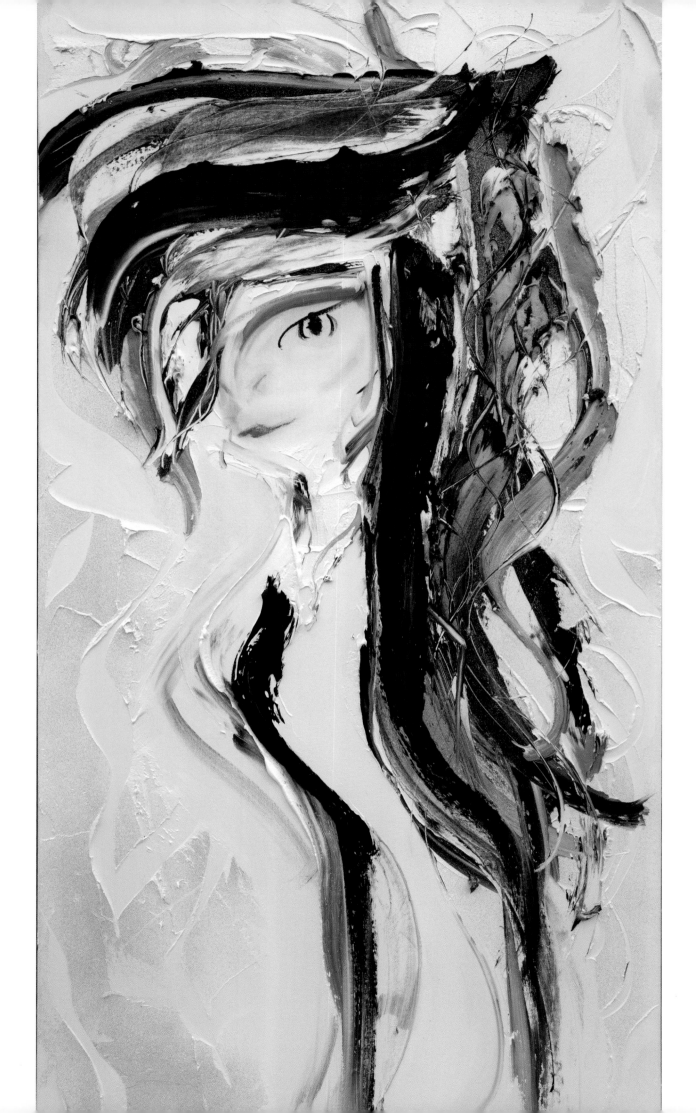

O h, what is this sexy little minx thinking? I'm not exactly sure, but it seems to me she has a trick or two up her sleeve. Don't let the starkness of her black-and-white surroundings fool you; there are hidden passions and unmanifested dreams residing within her, just waiting for their turn. I'll let you in on a little secret—she knows that she gets what she gives, time is not linear, and the answer is always love. Be there no doubt: she believes in magic.

At the time that I am writing this I am coming close to completing this book. It took me approximately five years to do so and, oh my gosh, am I ready for this project to be completed. Whereas I might have been hard on myself in the past, beating myself up for not finishing sooner, at this point in my life I choose to be gentle with myself, not demanding expedient perfection. This choice to be gentle is a huge deal for me. Also, I recognize that the very nature of this project is not about producing quickly but rather more of a documentation of my spiritual development, accompanied by my artistic development. I guess looking back I might have known this was not going to be a quick, tidy job, but I'm super happy I wasn't afforded this knowledge because I can tell you this for sure—I wouldn't have even started.

Now, given that I did, in fact, start the book and went down the rabbit hole of observing myself closely for the past three years, it has all come down to one essential question for me to answer, a question that should be basic to the creative or the artist. I found that by dissecting my art and its deeper meaning, it was time for me to hold not just my art but my life up to this illuminating question. *What do I want to create?*

One of the blessings of writing this book is that I believe I have greater clarity when answering this question. I want to create art. I want to transform my painful past experiences into a useful vehicle in which I can be a healing force for others. I want to find a love that is a true connection in mind, body, and spirit, and I want to be able to be present and available for this union. I want to create a space that is nurturing, beautiful, and the true home to embody a conscious community.

As I read my own words, no doubt, old thinking comes into play. Old programing that tells me, "You are forty-seven for God's sake; you are too old to find new love or take a sharp turn in your career path. Also, where do you think you are going to get resources? And who is really going to want to listen to you? I mean, who do you think you are anyway?" Ah, yes, this old, familiar, critical voice telling me I can't have what I want because

Self-Portrait Deep Imagining | Mixed Media on Canvas | 56 x 29 in. | 2021
In the private collection of Brad Gorrondona

I am incapable and unworthy. Well, you know what I have to say to that today? Fuck that. I'm going to do and have all of that and more. Just watch …

The fact is, yes, I'm forty-seven and divorced with no kids. Some people, mainly twenty- or thirty-something-year-old ladies, may think this is the worst possible fate to ever fall upon a woman, but I beg to differ. The way that I see it is at this moment my life is a clean slate. I am responsible to and for no one but myself. My life is a blank canvas, if you will, and I am free to do whatever I want and go wherever I want. And you know what's even cooler about being forty-seven and in this position? I can actually afford it. Maybe, theoretically, I may not have as much time left to be alive as others, but really, if you think about it, none of us knows how many more trips around our sun we are going to have, so really, each day we are here could be our last. The fact is I do still have time left, and it is completely up to me what I want to do with it. I can do whatever the hell I want, and I have to tell you, friend, it's a beautiful thing. I don't know for sure, but I don't think many people get afforded this opportunity. I consider it a great gift, and I intend to squeeze every drop of joy out of it that I can.

My path may be unconventional, but that's OK with me. I have never really been the type to do things in life just because everyone else was or because I was supposed to. I have a vision that my life today and tomorrow can be more dynamic than it was in my yesterdays. I dream of the people I have yet to meet and the lands I have yet to see. I anticipate the deep fulfillment of healing and magical kisses. And, mostly, I look forward to all the richness and blessings coming my way that I cannot yet even fathom because my mind is just not capable of imagining such sweetness. This is one of the most wonderful things about creating—we are not in it alone. Equipped with an unshakable knowing of worthiness and an alignment with a power greater than myself, I observe as this power often lends a hand, ices the cake, and puts a bow on top. Then, if I can lean in, this elusive yet strangely familiar power takes me on a beautiful trip, much like the trips of my past but surprisingly different. No schedule and no tour guide but far better than I would have ever expected.

Reference:

The Expanded Podcast, hosted by the founder of To Be Magnetic, Lacy Phillips

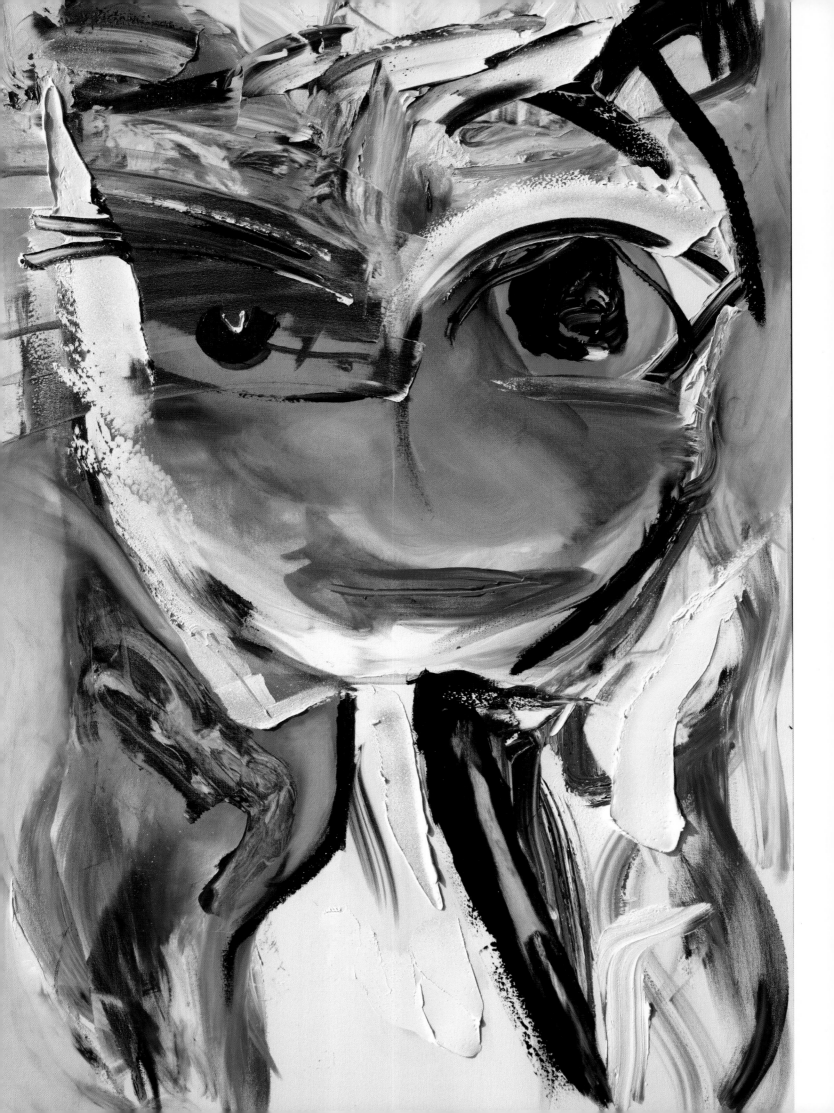

I was taking a shower one morning at my condo in Dallas, Texas, and the idea came to me to write about my self-portraits and how they related to me and my life experiences, and poof! The concept for this book was born. I thought this was a brilliant idea, and I was completely energized and psyched about the project, so I started to write. I didn't know exactly what the finished product was going to look like, nor the precise story I was going to tell, but I was willing to trust the process and see where it led.

As soon as I began writing, I realized my task was going to be tougher than had I anticipated. I'm not sure what I expected while writing an autobiographical book about my art, but I soon learned that this project was going to take a certain amount of vulnerability and authenticity in order to convey my message and do justice to my unique experience.

To be honest, the thought of writing with this level of transparency scared the shit out of me. All my secrets and feelings documented, available for anyone who ever has or ever will know me to read—yikes! I had to ask myself some serious questions, such as: Will I hurt any of the people that I care about? Will people judge me, my past, and my actions? Will this negatively affect my reputation and credibility, professionally or personally?

I knew that as soon as I put my life experiences and thoughts about my life experiences out there it would be permanent. As someone who has allowed shame to dictate many aspects of my life, these were not easy questions to answer. Goodbye deniability. Goodbye masks. Goodbye image management.

The next thing I realized as I got a little deeper into my process is how much work it is to write. You see, I had never written anything professionally, much less a book, so I was blissfully unaware of how tedious writing could be or the amount of mental strength it took to put together a string of coherent thoughts over and over again. In short, I had no idea as to the commitment I had made. The work was infinitely tougher than I anticipated and, frankly, it was altogether overwhelming.

These two realizations were obvious as I began to engage in my process, and I made the assumption they were the main blocks causing me to write at a snail's pace after my first bursts of enthusiastic beginner's effort. My writing nearly stopped for about a year, and all I can say is that I didn't want to do it. I mean, I *really* didn't want to do it. The thought of sitting down and writing caused a visceral reaction in my body, and believe me, it was not difficult to give in to myself and not do the work.

Self-Portrait I See Through You | Mixed Media on Canvas | 72 x 48 in. | 2018

The fact was completing this book wasn't required of me to keep my job, and no one's life would be on the line if I didn't see it to completion. These two facts coupled with my fear of exposure and the inconvenience of tough work were enough to stall my progress for a long while. However, there was a part of me that wasn't going to be defeated by this book, so I made a commitment to myself to finish it no matter how long it took or how painful it was. Plus, and probably more importantly, I had promised my clients that this book about my self-portraits was on the way, and I didn't want to appear unprofessional. Alas, shame as a motivator ... the truth is, it works!

So, when I finally committed to completing my book and made the final decision there was no turning back, I started to hold myself accountable for my feelings of conflict and become curious if my resistance to writing could teach me about myself. I decided to hold my thoughts around my creative writing process to the same scrutiny I would if I were working on understanding romantic relationsh family trauma and see if there was any useful information there that might aid in my ultimate healing. It should come as no surprise, as with many forms of resistance, there was much to be learned from the experience.

I can now see the value of practice and tough work, especially when I don't feel like doing it.

The first thing I did was run my feelings past my inner child, as this has been one of the most effective tools to get to the bottom of the unconscious thoughts that have, all too often, contributed to my frustration and suffering. I wondered if she might have something to say on the matter and, oh, she did! Actually, she was pissed.

My inner child told me she hated writing because it was hard and boring, and she would rather be doing anything in the world other than sitting at a computer. She wanted to know why we weren't painting or hanging out with our friends. She didn't see the value in what we were doing and thought the whole thing was stupid. Not only was she angry, but she was also sad, and she wanted to cry at the thought of sitting down and writing. You can imagine how interesting it was to me that my inner child was actually throwing a tantrum! What the hell was going on here?

As I pondered what my inner child revealed to me, I started to remember myself as a little kid. When I was a child, I started many things but never finished or mastered much. When something got hard or practicing became tedious, I would quit. Because my parents were operating from the space of their addictions and illnesses, they didn't have the energy or endurance to encourage me to stick with activities when they became difficult, and I can only assume it was much easier for them to let me off the hook.

I want to be extremely clear: I'm not criticizing my parents here, only objectively observing, for my own benefit, what happened when I was a child. Now, as an adult, equipped with this information, I can be conscious of the fact that this programing I received is not useful in my life. I have hopes and dreams, and they will require me to sit through uncomfortable feelings and do things I don't necessarily want to do if I want to accomplish these goals.

As feelings of annoyance and disinterest surface as I work, I can re-parent myself and teach myself to persevere through uncomfortable situations that may be hard at the time but have huge payoffs upon completion. Given this adult perspective and shift in consciousness, I can now see the value of practice and tough work, especially when I don't feel like doing

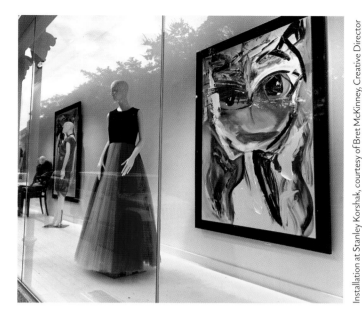

Installation at Stanley Korshak, courtesy of Bret McKinney, Creative Director

it. With this discipline that I can provide for myself through re-parenting and presence of mind, I get to reap the rewards of commitment and hard work and experience the healthy pride of achievement. Whereas quitting and giving up when the going got tough has contributed to my feelings of low self-esteem, low self-worth, and separateness, dedication to my purpose and perseverance through unease has opened me up to a future full of possibilities and a path to usefulness.

It has been so interesting for me to realize that every one of my perceived struggles, the above example being a subtle but good one, has something to teach me about unlocking joy in my life. All I have to do is be aware of my thoughts and feelings in all situations, be grateful they are there to point to something that needs healing, and then use the tools I have been gifted to heal them.

In my opinion, cultivating consciousness around my reality has actually been the hardest part of my spiritual journey. I am truly grateful self-awareness happens slowly because, truthfully, I'm not sure I could handle it all at once. Whatever the case, I am committed. No more sticking my head in the sand hoping to avoid, well, anything, even writing. My goal these days is to observe and see myself as I truly am.

As the viewer experiences *Self-Portrait: I See Right Through You*, it may appear odd at first that the subject

presents as a feline presence. I have dabbled with the animal form in my paintings. It isn't a theme I visit often, but in this piece, the cat's presence signifies an interesting bit of information expressed through her eyes. Cats are extremely intuitive and watchful. They take note of their surroundings and adjust their game plans accordingly. In my life, I can absolutely relate to this aspect of the feline archetype.

As a child, observation and resilient agility allowed me to navigate my circumstances and dysfunctional environment, aiding in my emotional and social evolution. Having a critical, analytical eye, as represented in the large, serious green eye on right side of this character's face, ensured survival and self-protection. On the other hand, we can move to the other side of this feline face and notice a softer gaze reflected. This eye is wiser, more relaxed, and not threatened. This is the eye of an older, more domesticated kitty cat who trusts that her needs for love and safety will be met by the powers that be. She sees things clearly with this eye and is not spooked easily.

These two eyes coexist in this painting, and I like to think this is where I live today, having the ability to see challenges and my limitations but also the confidence to handle adversity.

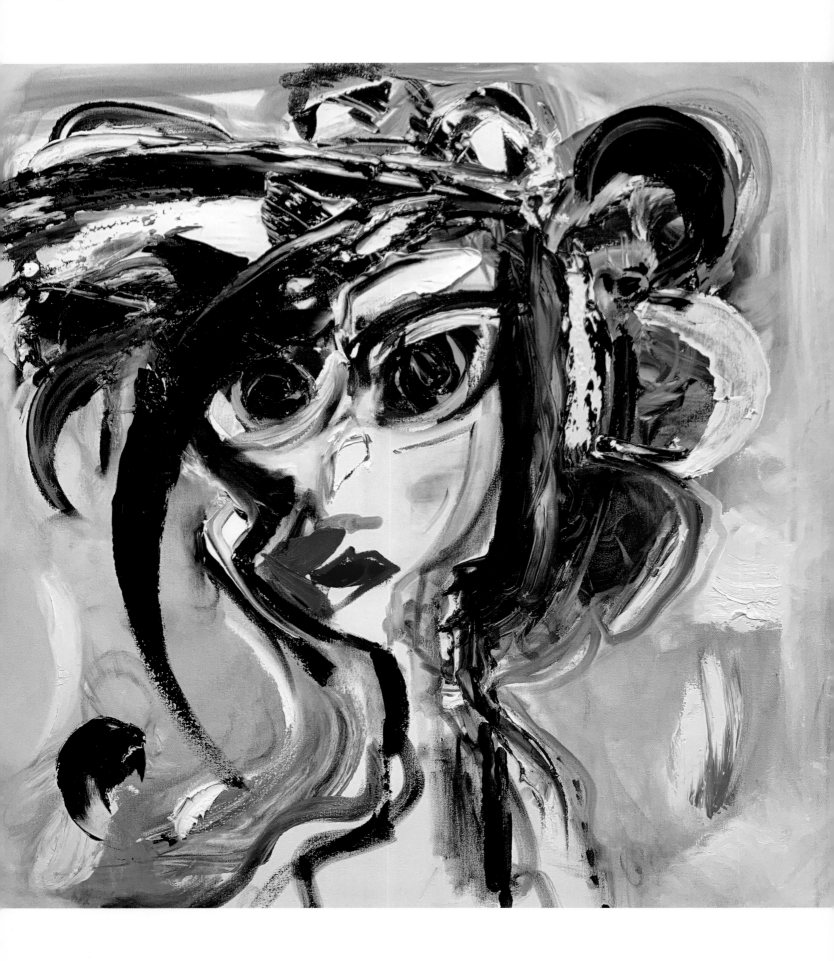

In this painting, the character is sitting up straight, and she did her hair and makeup this morning. She is laser focused and has a goal in mind, and she has more than enough ambition to achieve that goal. Her eyes are wide and thoughtful, yet she is humbled because she knows the task in front of her will require more than she has given on previous days. At other times in her life she might have given up in similar situations, but today she suits up and shows up with the confidence that her efforts will be rewarded.

As a professional artist, one of the questions I get from interested art appreciators and aspiring artists is if I only paint when inspired. Let me tell you something: I adore the idea of being an oil painter struck by a grand image or ironic idea from somewhere buried in my subconscious and being carried away at the studio where this elusive, magical idea pours out onto the canvas. This, however, has not been my experience most of the time. I am not saying it doesn't happen but when it does, I consider it a gift from the universe because, more times than not, this scenario is not the norm. The truth is, if I waited until I got the inclination or inspiration to paint, or write for that matter, most of my best work would have never happened.

Sometimes I paint when I want to. Sometimes I paint when I don't want to. Sometimes I paint when it's the last thing I want to do. I may have a deadline for an exhibition, a commission for a client, or need inventory for another gallery selling my work. I haven't formally surveyed my artist friends, but I am willing to bet the ones paying the bills with their art aren't waiting around for the million-dollar idea to hit.

Being a professional artist is not easy. It helps to have talent when pursuing a career in art but, to be completely honest, it isn't absolutely necessary. What is necessary is having the ability to create on demand, and it separates the novice from the professional. Yep, we are talking about discipline, my friends, and next to self-confidence, it has been my greatest struggle as an artist.

Creating art teaches us things about our life, and my art has taught me how to suit up and show up. I realized I can't count on being motivated, so I have had to learn how to do things I do not want to do, often at times I do not what to do them. I have had to learn to fight procrastination and not give in to my every fanciful whim. I would love to tell you the more I have held myself accountable the easier it has become, but I cannot.

Self-Portrait Suit Up and Show Up | 3-Dimensional Oil on Canvas | 40 x 40 in. | 2020
In the private collection of Traci Rupe-Kettle and Dean Kettle

You see, discipline, when done in a healthy, loving way, is a priceless gift a caretaker gives to a child; it's not generally an innate personality trait. To discipline takes time, attention, commitment, and consistency, and the disciplinarian must be deliberate, kind, stern, and intentional in their delivery. If you were not consistently disciplined as a child, as I was not, odds are you are not exactly great at disciplining yourself as an adult. The silver lining is we as adults, armed with knowledge and self-awareness, are able to give ourselves the things that, for whatever reason, our parents could not. We have the ability to re-parent ourselves, if you will, and reap the benefits. Self-discipline can be learned and practiced, thank goodness.

The truth is, no one is forcing me to create art, and no one forced me to write this book. It is a privilege and an honor to do this work. I had to set my own standard of performance. There was no one there telling me I was going to get punished if I didn't paint these paintings. I was not going to get grounded if I didn't write this book. I didn't threaten myself with consequences if I didn't finish this project. Instead, I had to discipline myself, focus my attention, and know I was inherently doing a loving thing for myself by completing a project I committed to and believed in.

In essence, I had to have obedience to the unenforceable, a concept with which anyone who is a participant in a twelve-step group will be familiar.

It is the extent to which I can be trusted to obey the self-imposed laws and standards I have set for myself. Understanding this concept has facilitated me in accomplishing my career goals, helped me personally, and has aided my ultimate and ever-increasing happiness.

I certainly do not consider myself to be one of the most self-disciplined people I know—hell, not even close. I can say, however, that I do see myself improving in this area, and it feels good to be proud of myself for a change.

Julie Andrews once said: "Some people regard discipline as a chore. For me, it is a kind of order that sets me free to fly."

(Working on it, Julie, I'm working on it.)

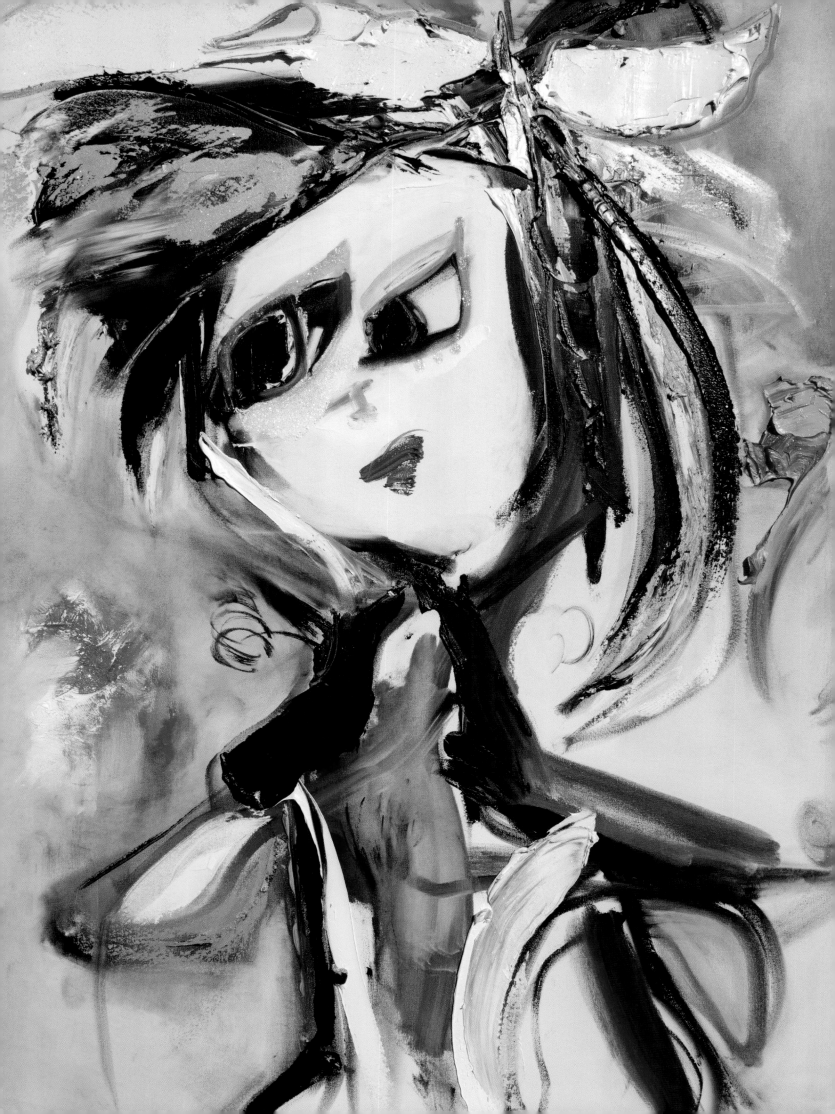

When I was young, I loved eating fresh fruits and vegetables from my parents' garden. My favorite snack was raw green bell pepper.

When I was young, my mother and I had to leave my father for a long time, and I didn't know why. When I saw him a year later, he had changed, and I never again saw the father that I had once known.

When I was young, I loved horses and kitty cats, and Barbie was my spirit animal. I hated baby dolls.

When I was young, my mom had to work a lot, and I felt very sad and cried when she would go.

When I was young, I wanted to grow up to be as beautiful as my mother, tall with long blond hair.

When I was young, my mom started acting funny. She slept a lot when she was home and slurred her words when she was awake, and she didn't have much time to play with me.

When I was young, I loved all things creative. I was always happiest when I was dancing, singing, drawing, painting, coloring, or sewing.

When I was young, I started to notice I was different from the other kids.

When I was young, my grandmother was the most magical person in the world.

When I was young, I never remember a time I wasn't capable of taking care of myself.

When I was young, other kids made fun of me at school.

When I was young, I was glad not to have brothers and sisters because the world revolving around me was just fine.

When I was young, I took turns sleeping with my stuffed animals because I didn't want them to feel left out or lonely.

When I was young, I realized there was something wrong with me, so I started to fix it.

Self-Portrait When I Was Young | Mixed Media on Canvas | 48 x 36 in. | 2018

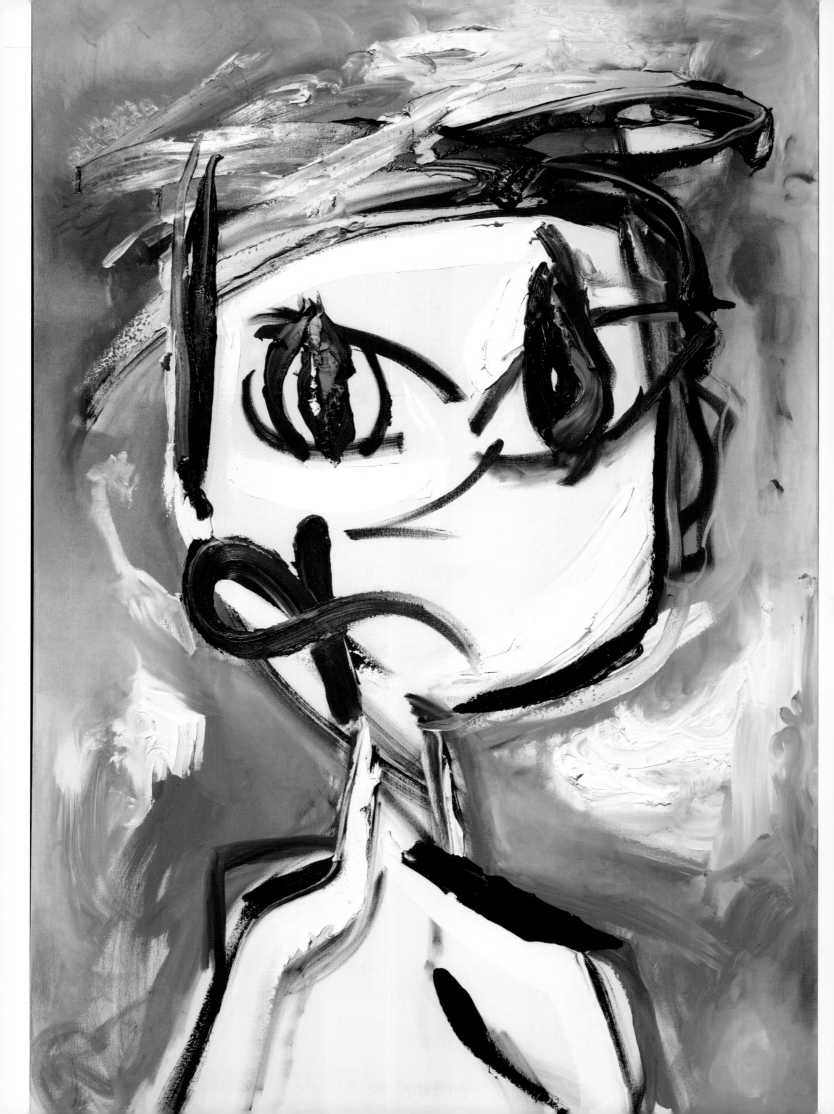

It is true. I did grow up in a dysfunctional environment. I think as adults we tend to assume that kids who are raised within dysfunction (i.e., addiction, abuse, mental illness, a parent in prison, extreme poverty, etc.) are probably going to lead a painful life and have poor chances of achieving the success of a so-called normal functioning adult. It seems like a rational assumption, but I am living proof that it is not always the case. In fact, if you dig deeper into the average person, you may be surprised that there are many who come from less than ideal circumstances, even horrifying conditions, who go on to live purposeful and oftentimes extraordinary lives. Meg Jay illuminates the inner workings of this subgroup of people in her book *Supernormal: The Secret World of the Family Hero.*

I definitely relate to this supernormal label Jay explains in her writing. In my case, it wasn't that the weight of my parents' mental illnesses and addictions did not negatively impact me, but the impact did not present the way one may assume. One might guess that I too would become an alcoholic or struggle with a diagnosable mental disorder, considering that I was not only exposed to these environmental circumstances, but I also had a significant biological predisposition. Luckily, I dodged both of those bullets. Instead,

according to Jay, I fall under the supernormal category, meaning rather than buckling under the pressure and living a life of desperation, I was motivated by my misfortune and determined to do something with my life that I deemed respectable and important.

You see, I wanted to be the exact opposite of my parents. I wanted to be safe, independent, and in control of what happened to me. I wanted to be financially successful, be seen, and feel proud of myself. I didn't want to struggle and worry about the basic necessities. I wanted to be normal. This is understandable, right? I don't think these goals and aspirations were unreasonable, but the problem was, I didn't have a lot of role models to show me how one actually goes about achieving these dreams. My grandparents tried their hardest to teach me how to do life, but they had monumental struggles of their own. So, I did my best with what I had and, you know, I think I have been quite successful at realizing my goals. There was, however, a cost to my methods. My quest for normal, fueled by ego-driven perfectionism and shame, has taken its toll on me. Much like other supernormals, I didn't come out unscathed.

My intention was to be a productive and respectable person and, for the most part, I would say I am. However,

Self-Portrait Supernormal | 3-Dimensional Oil on Canvas | 72 x 48 in. | 2017
In the collection of the Virgin Hotel, Dallas, Texas

as I was unbalanced in my thinking and negatively affected by living with illness and dysfunction, I also ended up with some undesirable results. For example, sure, I have performed in life, attaining a decent amount of success professionally, yet I have felt like an imposter much of the time. I have feared my accomplishments were not really earned but rather happy coincidences or some good fortune. I've worried people are going to decide that I am full of crap, that I have no talent and all I have created and achieved can be attributed to dumb luck. Also, although I am financially stable, I am often waiting for the other shoe to drop and worry that all my security will dissipate overnight. You know, the whole I am going to end up homeless living under a bridge scenario.

I also have really valued being reliable. In fact, I think I am an empathetic person willing to help others, but unchecked I can get into trouble here. I have a hard time setting boundaries. In fact, the more I love someone, the harder it is for me to say no to them for fear they will become angry with me or, in the worst case, abandon me completely. I have definitely felt responsible for the emotions, health, addictions, and finances of my loved ones. But, when I am tired of the dance of trying to fix them and them refusing to be fixed, I resent them and subsequently cut them out of my life. Yeah, I can be a real peach.

On the flip side, I tend to be overly self-sufficient and hate asking for help. I detest the feeling of exposing my vulnerability and weakness. I avoided showing emotion or weakness growing up because the emotions of the adults in my home were, understandably, at such a heightened state all of the time. I didn't want to contribute to their suffering by burdening them with my ugly emotions and problems. In my child's mind I

believed that if I was OK, then it was one less thing for the adults to worry about. I hid my emotions because I felt a lot of pressure to be alright, believing if I was doing well, at least they had that. No one ever told me it was my job to save the family, but I certainly put this pressure on myself, at least subconsciously.

I am resilient and have been my whole life. I have survived so much and lived to tell the tale. I have never allowed life to crush me. But I'm not great at processing painful experiences either, so I store them in my body and in my hidden mind and they tend to come visit me at the most inappropriate times—like when I am trying to have an intimate relationship or fall asleep at night.

I am inclined to stand up to injustices, but sometimes I can become single-minded, judgmental, and dismissive of others' experiences, seeing myself as superior. I can also be stubborn, arrogant, and competitive, all character traits that have served me on occasion, but in the long run don't contribute to my overall goals of happiness, peace, and connection.

I am lonely a lot, even when I am in a group of people, but others don't know this because one of my supernormal powers is keeping people from really knowing what is going on with me. I will avoid this at all costs and keep the focus on them. This way, they don't get to know that I am insecure, and they also get to feel special. Win, win.

Oh, I am also very honest. That is until I am really scared of getting in trouble, hurting someone's feelings, or I feel super ashamed of my actions.

So, yes, I'm not a mentally ill drug addict—only an anxious, manipulative, codependent, control freak.

> That is the beauty of us humans. We are the creators of our realities, and we choose who to be in every moment.

Whew ... thank goodness for that! Also, I can be sarcastic.

By now maybe some of you are saying to yourself, "Hey, I do that, and I feel that." Maybe you are supernormal too. Maybe if you have survived the fuckery of this world and are left standing and creating a life for yourself, we can dance in this paradigm together. But don't worry, if you choose to see yourself through this lens for a brief moment, it's OK, you don't have to live here. It's only a tool, a different perspective to provide information, a jumping-off point, if you will. We can do this together.

I have come to terms with my supernormal tendencies and done some healing for sure; however, I very much accept that this is my lifelong journey. I know these thoughts and habits may have dominion over me from time to time but there is a big difference in me today. I am aware of it and know this about myself intimately. This is the first step, awareness. Now, the interesting part of this story is that I get to change myself, my reactions, and my circumstances, if I choose to do so. And I do, I do choose to do so. Every day. That is the beauty of us humans. We are the creators of our realities, and we choose who to be in every moment.

My desire has changed from wanting to be different from my parents to wanting to be different from my prior self that no longer serves me. I no longer want to be normal because, let's be honest, at best that's boring. However, I don't want to be supernormal either. Instead, I want to be the opposite of normal in all its interesting, elevated forms. Uncommon, unconventional, rare, extraordinary, exceptional—this is the goal these days.

As for this painting, the intensity and anger shouts silently. She is judging and wondering just when the hell those she judges are going to get their shit together. The red background suggests that this character has felt indignation for longer than even she can imagine. Maybe she even felt this in a past life and is reacting to generational trauma and grief. One thing is for damn sure, someone is in big trouble.

I so relate to the emotion of this painting. I have felt this so much in the corners of my mind. And on a really tough day when my childhood wounds are triggered, I can feel this character in real life. If only I was like a caged tiger behind bars at the zoo, maybe then everyone else would be safe. Once this character is let loose there is emotional shrapnel dispersed everywhere, usually followed by sincere apologies and promises that you will never see her again.

Reference:

Supernormal: The Secret World of the Family Hero by Meg Jay, Ph.D.

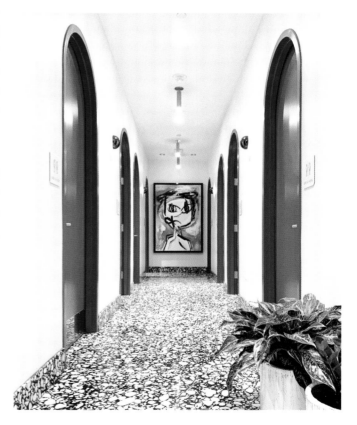

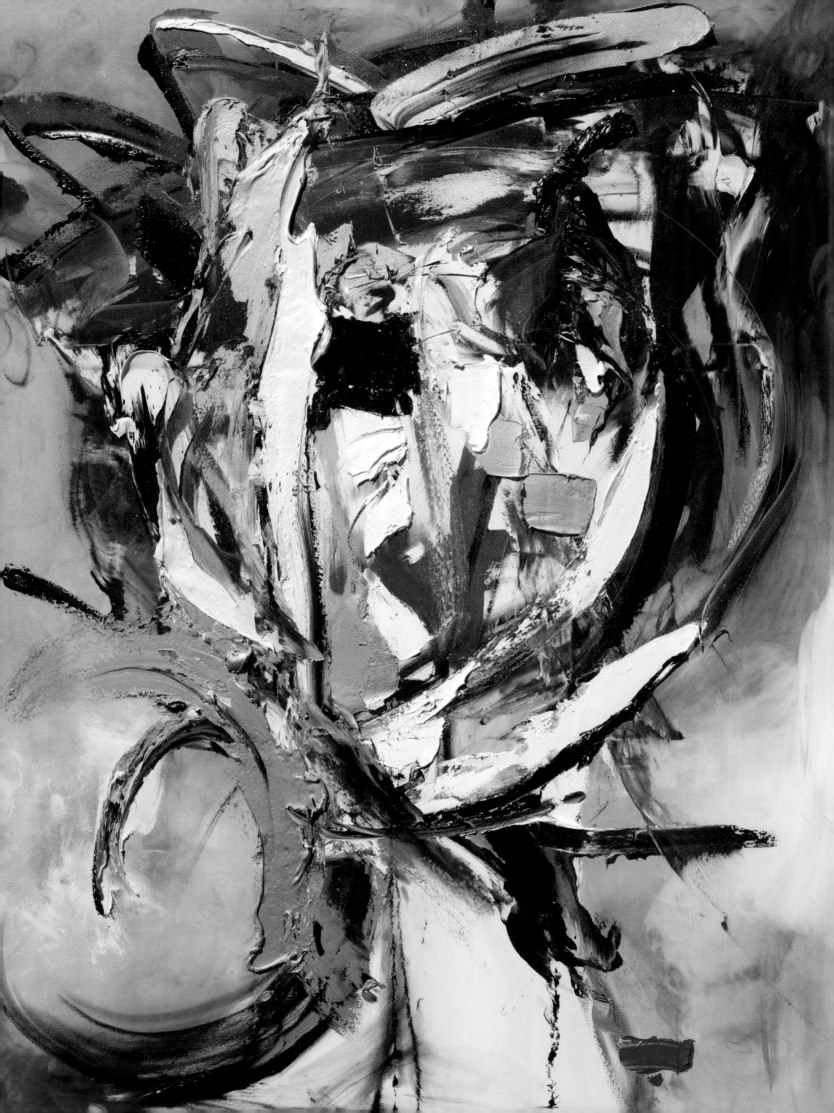

My mother told me she had her first drink of alcohol when she was nine years old, and it was the first time in her life that she felt happy and normal. She continued to drink and started to use drugs of all kinds, which ultimately progressed into a heroin addiction that spanned over a twenty-year period. She was physically abandoned by her father and emotionally abandoned and physically abused by her mother. She suffers from mental illness. She is a survivor of sexual assault and divorce, and she lived with a spouse who was schizophrenic. She currently is in stage 4 cirrhosis of the liver, has complications from hepatitis C, and is not eligible for a liver transplant. My mother will most likely die as a result of these conditions.

This same woman is childlike and easily thrilled. She loves anything that is fanciful or beautiful, and she loves music and will dance anytime she gets the chance. When she was young, she was tall, five-foot-ten, with ironed-straight, flower child hippy hair; long, strong legs, and beautiful, big brown eyes. She lived on a commune and said when she met my father, it was the happiest time of her life. She has a green thumb and has tended many a beautiful garden. She has told me she loved being a mother and said that she never felt more beautiful than when she was pregnant

with me. While she struggled with addiction, she also enjoyed many years in recovery healing from her heroin addiction, an accomplishment not many can claim. She has shown so much strength in her life and certainly has an indisputable survival instinct.

So many things I have written have been in relation to my experience of being the adult daughter of a heroin addict mother, but obviously her story is much more complex than that and should not simply be summed up by her addiction. For most of my life I, unfortunately, saw her through the lens of her misfortunes and how they affected me, but my perspective has changed and softened as I faced humbling experiences in my own life. As I have cultivated compassion for myself, inadvertently, I have gained compassion for my mother as well.

What I have realized is that although my mom and I are different in many ways, we also share the experience of suffering from great abandonment issues that have extended over many generations. Because of addiction and mental illness, it was never possible for either of us to have the loving care of our parents to confide in or lean on when we were scared, lonely, or confused. As a result and as a coping mechanism, we both have looked outward to anything that may temporarily soothe us,

Self-Portrait Flower Child | 3-Dimensional Oil on Canvas | 72 x 48 in. | 2018
In the private collection of Yatzil and Thomas Surgent

whether it be drugs, alcohol, other people, success, or accomplishment. The major similarity between us is that we were using things, circumstances, or people to gain what we never had as tiny children—comfort, self-worth, and love.

It has been extremely difficult for me to put myself in this same category as my mother as I liked to believe my coping mechanisms often looked more refined than hers, but I certainly have glaring character defects that rival hers. I have held so much resentment toward her for not being there for me as a child and have always positioned myself as superior. Even more so as an adult, I have continued to struggle with anger toward her, and I have been relentlessly judgmental of her. I have been incensed about the choices my mother made and the loss of the fantasy mother I imagined, the one that addiction stole from me, while simultaneously blaming her for major disappointments I have felt. In this way, I have been selfish and self-centered, rarely considering that maybe I bore some responsibility for my own struggles and failings. I didn't begin to realize how hard life must have been for her, before and after I was born, somehow unconsciously assuming her trauma stopped when she became an adult. I was hardened to the sorrow and loss that she must have felt, only concerned with what I didn't receive.

This brings me to forgiveness. I had been so angry and essentially blamed every bad thing in the world on my mom and her addiction, and I just couldn't wrap my head around forgiving her. I certainly wanted to let go and let bygones be bygones, but I just couldn't figure out how to do it! I didn't know how to make my feelings of anger and resentment dissipate. I read books, worked the twelve steps, and prayed for my

anger to go away, but I just couldn't let go of believing she willfully was an inconsistent, neglectful parent. I couldn't help but think that if she really cared about me, my life, and being a good mother, she simply would have gotten treatment for her addiction and wouldn't have sabotaged both our lives. In therapeutic circles I always heard that parents do the very best that they can with what they have to work with. What I thought when I heard others say this was, "Well, her best sucked." I always thought that she could have done better.

I don't have any children, so I can only compare being a parent to being a dog mom. For me, if my little dog was sick, lonely, or hungry, my heart would ache, and I would be in a panic until I made everything in the world right for my little princess. I always thought that if I feel this much love and responsibility for a dog, then there was no way my mother loved me at all because she failed in these areas with me as a young child. What I didn't understand but have now begun to grasp is that my mother's addiction made her incapable of doing even these basic things. I thought my mother didn't love me because she didn't show up for me in these ways.

> What I didn't understand is that my mother's addiction made her incapable of doing even these basic things.

Artie Wu, of Preside Life, finally framed this up in a way that I could actually understand. In his program, he explains that a parent's love is always present and unconditional in mammals and other species as well. However, if they are injured, sometimes they are not capable of taking care of their young, and in the direst of circumstances, they may abandon them or even hurt them. He gives the example of whales and their calves. If the mother whale has been attacked and injured, she will often abandon her calf, not because there is not love there but because her injuries are so

extensive she simply does not possess the ability to care for her offspring. She simply cannot care for her baby, not because she does not instinctually love her calf but because she is so sick, so debilitated, it just isn't physically possible.

Another visual Artie provided that was helpful to me was that if my mother's injuries were on the outside of her body, I would have been able to see her wounds, and I might have understood how much pain she was in, which would result in my having more compassion and less anger. The fact is that my mother was so injured from her past wounds from her parents that she could barely function, much less have the strength to parent me. If she was covered from head to toe in gauze, wounds seeping, I certainly could have understood this better. It's not that I would have been needless and wantless, but I would have better understood that she simply couldn't give me what I needed, when previously, I just thought she wouldn't because she didn't love me.

At the end of the day, I have forgiven my mom. I think it is important here to state that forgiving her doesn't excuse the behavior, erase the past, or minimize the effects it had on my life, but it does take away the venomous thoughts around her past actions. Truth be told, this act of forgiveness is really more for me than her when it comes down to it, because I no longer live with the resentment that is so toxic to my emotional health. You know what they say: resentment is like drinking poison and expecting the other person to die.

In addition to forgiving my mom, today I am able to give her credit for some of the things that she did well, and yes, there were many, if I'm honest and not

completely immersed in victimization. Given her severe addiction, when I think about it, it's actually kind of miraculous that she kept a roof over our heads and food in the refrigerator. In addition, she was quite kind and supportive of me, which was a significant improvement over her mother, who was verbally and physically abusive. In this way, she did better than her parents and that should be noted.

Today, I know my mother loved me when I was a kid and loves me now. This is truly a miracle, and I am grateful to know this truth, but this knowing has not magically cured all that is lurking within our relationship. It is very important for me to have firm boundaries with my mom and be super clear with myself, and her, that I am not responsible for her mental, physical, and financial health as she struggles with her difficult end-of-life circumstances.

But still, the fact remains that I was abused and the recipient of some destructive programming that has presented many difficulties for me. Because I mistakenly internalized the idea that my mother didn't love me, I didn't learn to love myself, which did significant damage to my self-worth. It no longer feels appropriate or justified to blame my mother for my wounds and their effects on me and my life, and I can learn from her mistakes and take responsibility for the ways that I have made the same mistakes she did. For example, I can focus on myself, no longer wishing to go back and change the past. I can ask myself if I am I truly there for the ones I love or if I am using them to fill a narcissistic emotional void? What are my addictions, and am I addressing them? How can I make amends for my hurtful behavior, and how do I heal my deep-seated abandonment issues so that I don't continue to do harm to myself or others?

> Forgiving her doesn't excuse the behavior, erase the past, or minimize the effects it had on my life, but it does take away the venomous thoughts around her past actions.

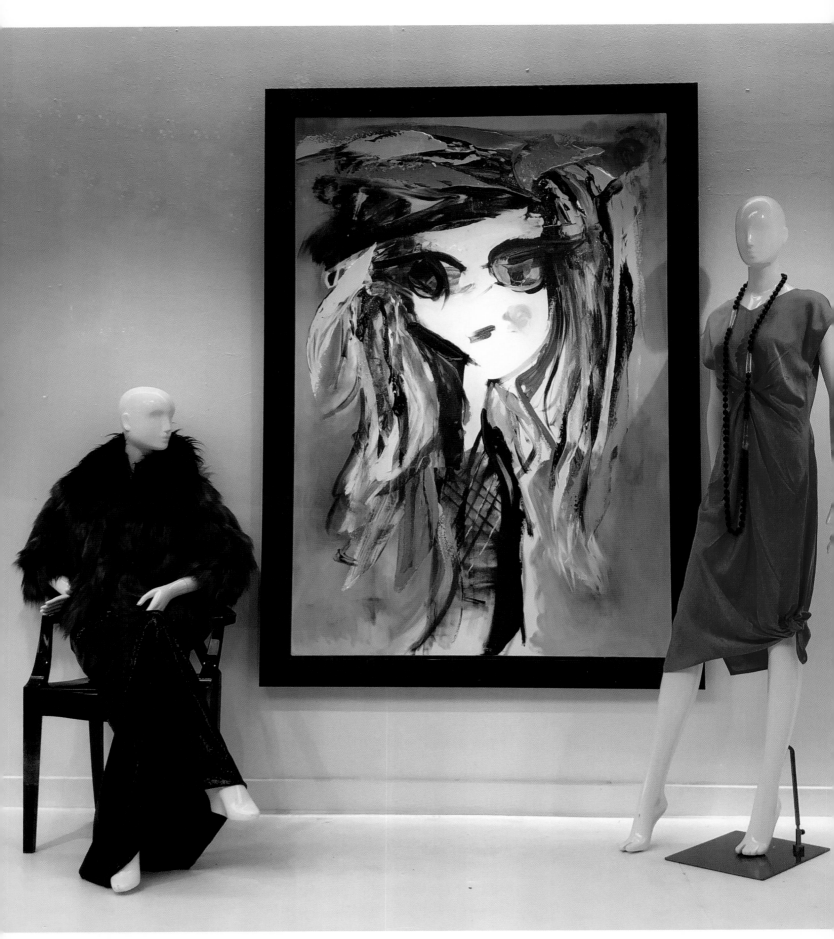

Installation at Stanley Korshak, courtesy of Bret McKinney, Creative Director

This is hard work, the work of spiritual warriors that are presented with new challenges every single day. As much as I want to be free of these afflictions, I know healing doesn't happen all at once and is more of a journey than a destination. I am dealing with a generational spiritual illness that is ingrained in me so deeply that it is coded in my DNA. However, my hope lies in the fact that, as humans, we are capable of change, even great change. I know this to be true because I have experienced it and seen it happen for others. I believe this is part of a spiritual journey that has a spiritual solution, so I continue to learn to trust that if I am open to being different, what I call God will carry me through this task when I feel unable to continue forward.

Ultimately, my mother is my fundamental mirror, my greatest reflection. She shows me everything I am scared to see in myself, and as she does so, I am presented with a choice: I can resent her for showing me the truth about myself, or I can accept what I see, be grateful for the reflection, and take action to heal. I have chosen the healing path rather than the dead-end road of victimization, so on a good day, I am able to see myself clearly and do my work and true healing occurs. In this space, I can be thankful to my mother and everything we have experienced together in this mysterious world, for she is the biggest catalyst in my healing.

References:

Sacred Contracts: Awakening Your Divine Potential by Caroline Myss

Artie Wu, Preside Life (meditation) presidelife.com

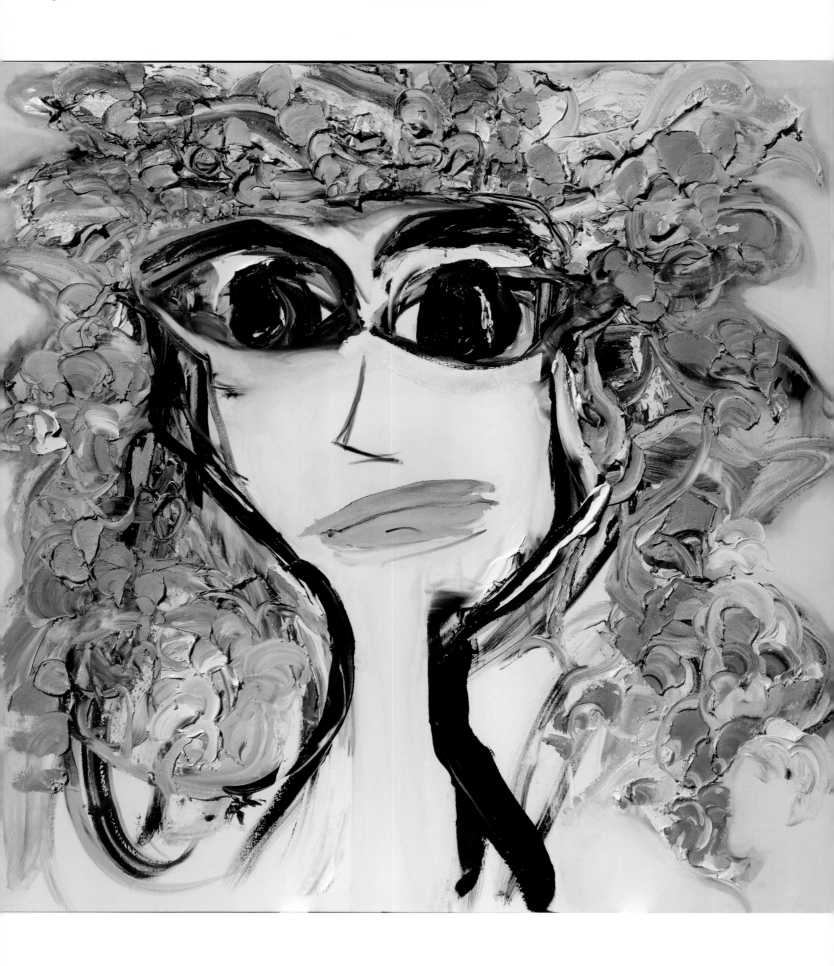

Experts say that if kids living in dysfunctional homes have just one stable person in their lives to support them, it significantly increases their resiliency and ability to become high-functioning adults. Based on my personal experience, I would absolutely agree with these experts. Luckily, I was fortunate to have many angels in my life, ranging from teachers to neighbors to other family members, who supported and protected me from dangerous and impoverished circumstances. The one person who hands down modeled stability and safety in my life was my grandfather Howard Fisher.

My grandfather was an extraordinary man. His father, my great-grandfather, left him and his mom when he was very young, and no one ever spoke to him again. This event paralleled the experience my mother had with her father, and it is interesting to analyze, in hindsight, how each of them adapted to their respective traumas. Whereas my mother became a drug addict and never really seemed able to overcome her grief and abandonment issues, my grandfather thrived and made sure he became the best man he could be, the man his father never was. I guess Howard fell in the supernormal category.

My grandfather went to college when he was fifteen years old, and after college he fought in World War II. This was always difficult for me to imagine because his demeanor was so gentle and later in life he would faint at the sight of blood. He was an extremely successful advertising executive and a highly respected businessman. In addition, he was a photographer, actor, public speaker, and poet—a true master of the English language in both its written and spoken forms.

When I wrote him letters from camp as a child (yes, this was before email), he would send them back to me edited with a note saying that he loved me but this was for my own good. He was also very suspect of television, and for every hour of TV that I watched at his house, he wanted me to read for an hour. There were lots of books at his house. At the time, I hated these rules (and these books) and what I perceived as criticisms. As an adult, I recognize that he was spending time investing in and really paying attention to me, providing me with the loving discipline that I often lacked but so desperately needed when I was younger. He was reliable and rock-steady, and if he told you he was going to do something, by God, he would do it. He was wickedly funny with a sharp wit and sense of humor. Extremely well-read, he was always up to date on politics: city, state, and national. As an adult, one of my favorite things was sitting at the dinner table (which, by the way, was eternally equipped with the

Self-Portrait No Pretense | Mixed Media on Canvas | 72 x 72 in. | 2018
In the private collection of Cali Evans

salt, pepper, garlic, and Tabasco sauce that he added to EVERYTHING) and discussing politics with him. We were very aligned in this way, and the intellectual gymnastics of conversing with him was invigorating.

It is my intention to be my authentic self and show up as I really am in this world.

My grandfather was Jewish but didn't believe in organized religion. In fact, it was quite the scandal when he got engaged to my grandmother, Beverly, who was an Episcopalian. I still have the heartfelt letters he wrote to my grandmother, telling her he was at long last going to tell his dear Jewish mother that he was going to marry her anyway, Jew or not! Very high drama for the time. They were married for over fifty years.

I learned from my grandfather that education was important and, once acquired, something no one could ever take away from me. He paid for my first undergraduate degree and encouraged all my future educational pursuits. He often said that it wasn't necessarily what one studied in college that mattered, nor what their grades were (thank God, because mine were less than impressive), but rather that college was for learning how to think. I have to say, in my experience, this is absolutely true.

When I went to college at eighteen, I had no idea what I wanted my life path to be, so it was difficult for me to pick a major. The English degree I landed on three years into my college career undoubtedly has been useful in my professional life, but it certainly wasn't all part of my master plan. So, I will forever appreciate my grandfather's grace and attitude around the purpose of college because, indeed, I did learn how to think. I lived on my own for the first time and there was a little shock absorbency between being completely dependent on my family and entering the real world. I needed that time to learn how to think for certain!

My grandpa also had a strong belief that love of family was one of the most important things in life. I do agree with this philosophy, but I can't help speculating that he must have struggled a bit with caretaking for his

family and how he probably didn't get as many of his needs met as he required, although I never once heard him complain. If I had to guess, I would imagine the greatest struggle in his life was having his firstborn son, my father, suffer from schizophrenia. I know it broke my grandmother's heart to witness my father's plight, and I know her pain, in turn, broke my grandfather's heart doubly. As in other areas of life, however, he handled his fear and worry with grace and was supportive of my father to the very end. Like us all, he had to learn about healthy boundaries and how to implement them so that he didn't lose himself in guilt and selfless devotion. He did this well and was a shining example for me to emulate.

As it often is with family when they are gone, I wish I had spent more time with him and my grandmother. They just don't make people like that anymore. There was no pretense with this man. For example, a couple of days before he lost his battle with bone cancer was one of the most bittersweet moments in my life. It was the last time I was with my grandfather when he was coherent. He said, "I don't know if you will think this is funny or not, but I do. The doctor asked me if I knew who the president was and I said, 'Yes, it's Donald Trump, and he's a liar, a cheat, and a whore!'" and then he laughed out loud. Whether you agree with my grandfather's assessment of the forty-fifth president of the United States, you have to at least admire his conviction. The thing about my grandpa, good or bad,

was you always knew where you stood with him. There was no bullshit, and I loved that about him. Also, I love that he was delighted with himself in his last days. We should all be so lucky.

I hope I have a bit of this purity and ability to be real inside of me, too. It is my intention to be my authentic self and show up as I really am in this world. It can be difficult to say my truth at times due to fear of what others will think of me or that I may hurt their feelings. I will think about my grandpa at these times when I need the courage to speak my truth and will attempt, as I do so, to articulate as precisely and elegantly as he did. I know he had faith in me and saw me as a capable, confident communicator—as in this painting, *No Pretense*. He believed in me and told me so, and I knew this because I trusted him to tell me the truth. How blessed I am to be his granddaughter, a gift for which I will be eternally thankful.

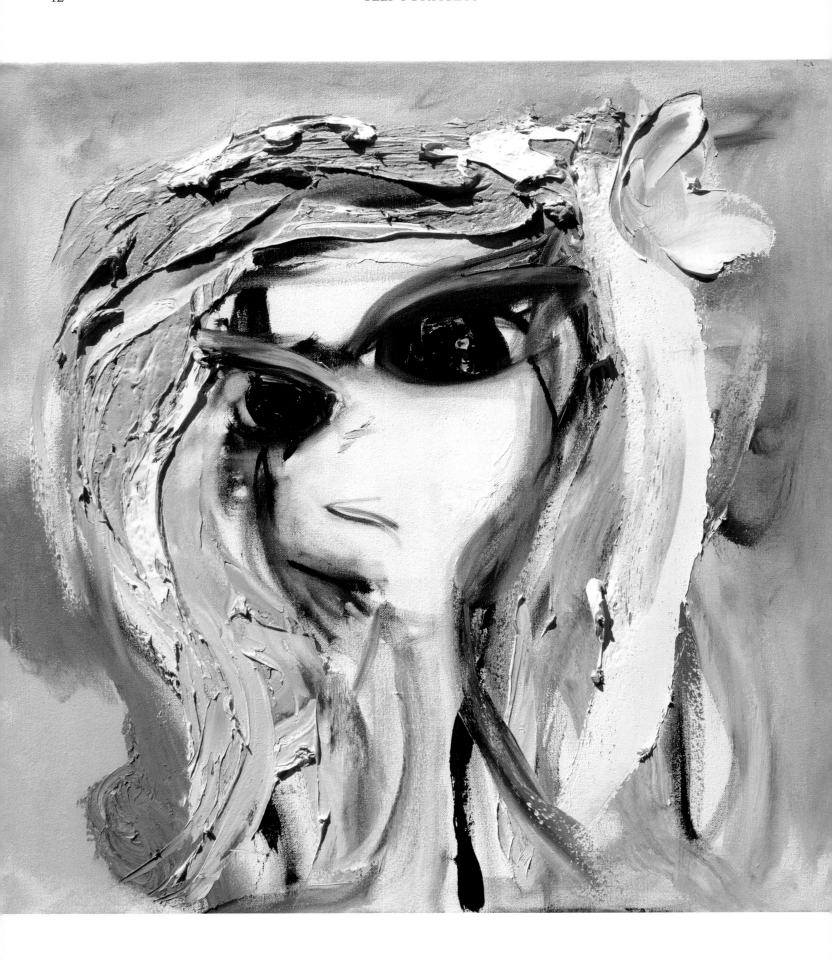

I initially ended up at Al-Anon, the twelve-step group for friends and families of alcoholics, because, at the time, I was dating an alcoholic and it was my last-ditch effort to make him stop drinking. Before the end of my first meeting, however, it was extremely clear to me that alcoholism and drug addiction had infiltrated much of my life, and my issues ran significantly deeper than my current relationship. In fact, not only had alcoholism affected every relationship I had ever been in, but it also cloaked me in veils of depression, anger, and codependency. I was miserable, and it was easy to point to the current person in my life who was struggling with addiction as the cause of all my suffering, but the problem, I realized, was actually me.

For those of us who have been lucky enough to make it to the twelve-step rooms, there are certain themes that come up regularly. Whether one is recovering from alcoholism, drug addiction, codependency, eating disorders, or a process addiction, the twelve steps and their key concepts are basically utilized in the same way in all these programs.

One of the concepts Al-Anon revealed to me, as I sat believing myself justified in both my feelings of judgment and victimization, was the idea of acceptance.

Acceptance is a belief derived from the *Big Book of Alcoholics Anonymous*, and it means relinquishing your control, acknowledging your limitations, and facing reality. This was the very last thing in the world I wanted to hear, and I had a major problem with it. In my mind, accepting my set of circumstances was the very last thing I should do. I couldn't believe the people suggesting this to me were so weak, just willing to give up and give in. I thought, what a bunch of losers. You see, to me, acceptance meant that others were getting away with what they had done to me. It also meant that I was giving up on my efforts to influence things I perceived as wrong and allowing their completely unacceptable behavior. I had little interest in releasing my grip on my perceived reality, and I was committed to fixing the lives of all the dysfunctional people in my orbit because I knew that this was the only way I was ever going to be happy. There was just one problem— it wasn't working. The truth was all my efforts, manipulations, logic, and hysterical antics hadn't changed anyone's behavior or healed my grievances with my past, and my life didn't even approximate happy. It was quite the opposite. The more I tried to exert power over others in my life, the more miserable I became. I was in a complete state of desperation and in the depths of an emotional breakdown, rock bottom to be sure. I was out of options.

Self-Portrait Cool Table | 3-Dimensional Oil on Canvas | 24 x 24 in. | 2018

because I was going to save myself. This was how I was going to fix my life and, indeed, figure it out, right?

And so it began. I wanted to be safe, respectable, and happy. I thought if I did all the right things—got an education, made money, achieved professional success—all the things my parents didn't do, this would solve my problems. I thought if I could control how I looked on the outside, I would feel good on the inside. I believed if I tried hard enough, I would feel loved and the hole in my chest that I had been trying to fill and repair my entire life would finally be healed and the pain, shame, sadness, and rage would go away.

This was my path and the way I lived my life for a long time. I have to say, it did help me survive my childhood and definitely benefited me in my adult life, but no matter my accomplishments, personally or professionally, I still felt hopeless. I would feel good temporarily when I got a degree, excelled professionally, achieved financial goals, or entered into a new romance, but ultimately, it all just hurt me more in the end because none of it was my magic pill. These things only dulled my pain for a short while. So, I tried harder. When I failed once more, I doubled down on my efforts.

In addition to my relentless pursuit, I also got creative about what solutions might work. I have used all kinds of things to numb my feelings and fill my void—alcohol, drugs, sex, relationships, work, food—but they all failed. Over and over, I would go back to a dysfunctional situation, person, or substance, just one more time, to see if I could finally solve this problem. Life got complicated. So complicated it was unmanageable, and I was left feeling depressed, angry, ashamed, filled with grief, as intense or even more intense than when I was ten years old. Despite all of my efforts, nothing worked. In the end, when all was exhausted and I could no longer point my finger to any person or circumstance I could fix, I came to the conclusion that the pain was inside of me, but no matter how hard I tried I could not make it go away.

What I have come to understand is that the wound I was dressing did not originate with me. It was much bigger than me, and my ten-year-old self's coping mechanisms never stood a chance. It was an inherited wound, ancient in fact, coded in my DNA from generations before me on both sides of my family. My parents couldn't provide me with what I needed emotionally because it was never given to them. I was humbled. If I didn't have control over this affliction, what I needed was something, someone, outside myself. I was powerless—powerless. Despite giving my all, my best efforts had failed me. I needed help.

The assumption that I made as a young child that people and the world were not there to support me was wrong. Of course, in my tiny universe it was correct, but in reality there is support. The people in my Al-Anon family had traveled down the road I had been on and thrived in their lives, not living under the oppression of their own minds. There was information and there were resources and countless miracles where people healed their hearts and lives. I finally realized I was not terminally unique, and I was not alone. Yes, I was powerless, but I was not helpless. All I had to do was ask because sometimes it is impossible to figure it out with limited cognitive resources, BUT the powers greater than me were more than capable of working it all out.

Resources:

It Didn't Start with You: How Inherited Family Trauma Shapes Who We Are and How to End the Cycle by Mark Wolynn

Al-Anon, al-anon.org

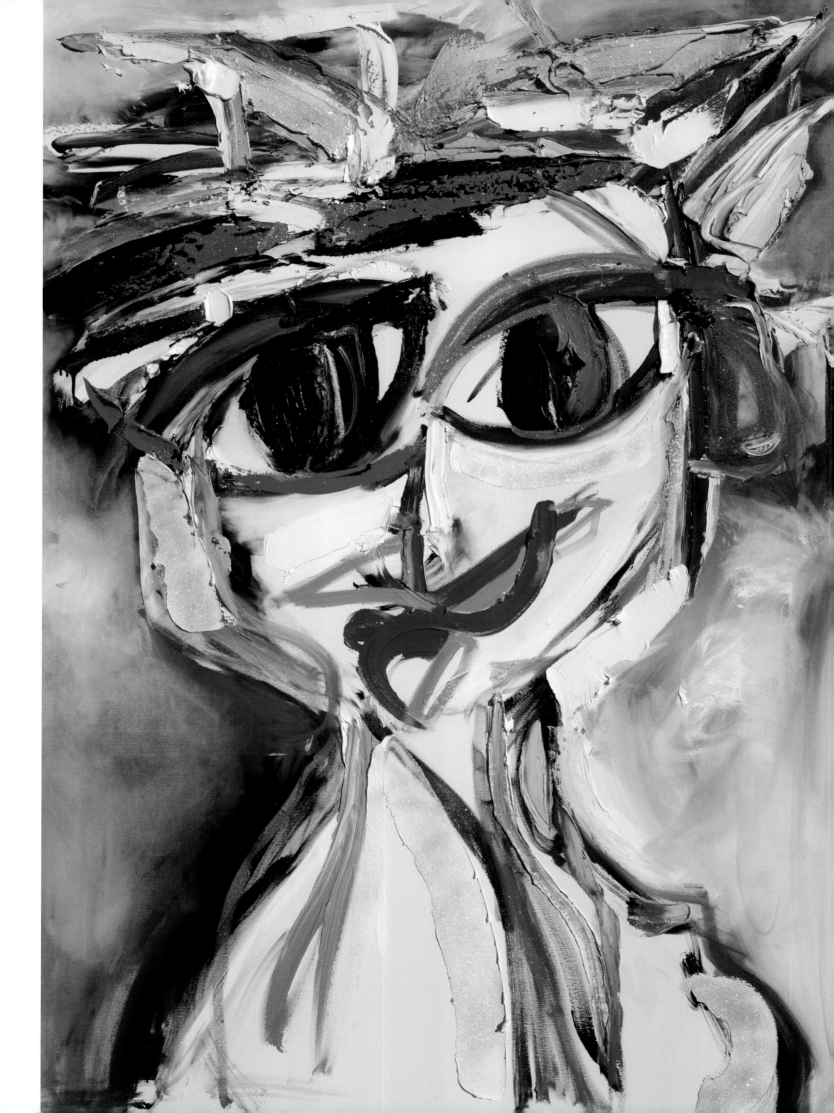

Not exactly pretty but not boring either.

This painting makes me laugh inside and, thank God, we can lighten up with this character a bit. However, I wouldn't exactly call this version of myself serene or worthy of a PG rating. This character is distinctly a more powerful bloke, again with the androgyny, than the character in *Self-Portrait I,* but he's not exactly someone you would want to take home to the family. This guy is probably a snapshot of the narcissistic/sociopathic side of my personality, and he is a devious prankster. His hair even slightly resembles devil horns, and his prominent smirk certainly suggests he is snickering. The problem is, we cannot tell whether he is laughing with us or at us.

He is young, about twenty-eight years old, and knows how to work a room, as his favorite book is *The 48 Laws of Power,* by Robert Greene. Well-dressed, armed with quick intellect, and dripping with charm and sex appeal, we can't help but like him.

We have no idea what he is up to, but we do know three things:

 1. It isn't good.
 2. He is having a great time doing it, whatever it is.
 3. He won't be calling the next day.

If we engage him, he may even take us on a trip to New Orleans, and it would be spectacular because he is no stranger to the city. The background of the painting is high energy, as this character is backlit by streetlights at Mardi Gras. He is enthralling and captivating, because deep down we just *know* there is a good person in there somewhere. At key moments he shows us glimpses of his humanity or alludes to caring for a greater cause. He may even talk about having the idyllic family one day, even though marriage and children are the very last items on his priority list. In reality, he is probably just mentioning it because he knows we want to hear it. He is very manipulative in this way. He takes his youth and beauty for granted and has the accompanying arrogance, as he has no idea of the very painful lessons of humility that await him in the future.

Oblivious to the hurt he might be causing to those around him, he is a stranger to guilt and shame, emotions that will relentlessly torture him later in life, in the not-too-distant future. But for now, life is a party and not meant to be taken that seriously.

Self-Portrait II | 3-Dimensional Oil on Canvas | 36 x 36 in. | 2017
In the private collection of Sharron Moss & Marty Boikess

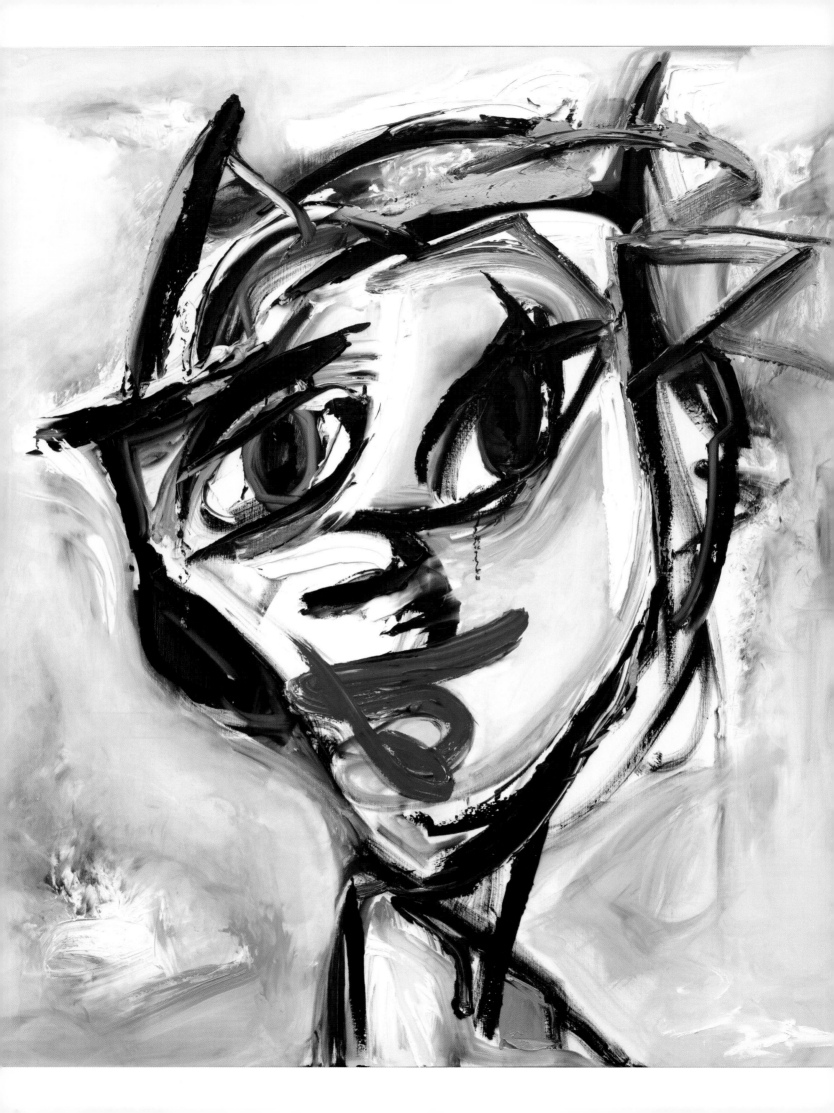

There are questions I am asked often about my painting process: How do I decide what to paint? What inspires me? What do I think about when I am painting? Do I listen to music? And so on and so on ... Therefore, I thought I would take the opportunity to talk about my experience with painting and what it looks like and feels like in action.

First of all, for over ten years now, I have shared a studio with JD Miller at Samuel Lynne Galleries in Dallas, Texas. I can honestly say that this studio is the ultimate creative space for oil painting, stocked with just about every type and color of paint that I would ever want or need. In addition, many tools and materials are at my fingertips, ready for use when I feel the ping. It's a truly wonderful place, full of expansive people, good music, creative energy, and love. I will be forever appreciative to JD for sharing his space with me.

No matter what type of painting I am doing, they are always under the umbrella of Reflectionism. JD Miller, artist, co-owner of Samuel Lynne Galleries, and my mentor, founded Reflectionism in 2001. Reflectionism combines a philosophy of art and a style of painting that is grounded in Asian mindfulness, meditation, and the New Thought philosophy, founded in the United States in the nineteenth century, which holds that Infinite Intelligence is everywhere, that spirit is the totality of real things, true human selfhood is divine, divine thought is a force for good, sickness originates in the mind, and that "right thinking" has a healing effect. In twenty-first-century terms, Reflectionism is rooted in the law of attraction: the belief that by focusing on positive or negative thoughts, a person brings positive or negative experiences into their life. This belief is based on the idea that both people and their thoughts are made from "pure energy" and that through the process of "like-energy attracting like-energy" a person can improve their own life experience. As a Reflectionist, I practice the law of attraction in my art by allowing the universe to speak through me, manifesting in a reflection of energies onto my canvas.

As far as my actual process, sometimes I go into the studio knowing exactly what I am going to paint, but it is rare. Most of the time, if I know what I am specifically going to create, it is because it is a custom commission for a personal or corporate client, and it is a variation of a style that I have done in the past. These types of painting sessions are atypical and tend to cause a bit of anxiety for me because the client is expecting a specific outcome. The commissioner has an idea or image in their mind, which I am then expected to physically

Self-Portrait III | 3-Dimensional Oil on Canvas | 72 x 60 in | 2017
In the private collection of Sarah and Ben Lamm

manifest in my creation. When I am finished with the painting and the clients come to view their piece for the first time, I keep my fingers crossed, hoping I have met their expectations. There have been a few incidences where I have had to redo entire paintings, a couple of times over even, but I don't mind redoing the attempted piece because I want the new owners to have exactly what they want and love their new art. I am happy to do it, but it certainly tests my self-confidence and patience.

People often want to know how long it takes for me to complete a painting. This is a more complex question than one would imagine. Sometimes I can nail a painting quickly, sometimes in under an hour, which, in my circles, we call a gift from the universe. This is definitely not the norm but pulling this off is one of the most satisfying feelings. Other times, a painting will go through many variations, and my first version will not resemble the end product whatsoever. These paintings can take hours, days, or years, depending on how many times I have to revisit it. Occasionally, I work on a painting to exhaustion only to totally wash the canvas down with turpentine, having to surrender to the reality that that particular painting was never meant to be in existence. This is the worst! It doesn't happen often, but when it does, it is very defeating. But as JD has said to me many times, "If painting was easy, everybody would do it."

I feel some of my most creative energy flows when I do abstract paintings, paintings that utilize color, texture, and composition but don't represent a specific object, such as a still life or landscape. I tend to start with whatever specific color palette I am drawn to that day, consulting with my intuition if I am feeling more warm or cool. Then, I decide what tone I am going for, happy, edgy, somber, or perhaps other emotions I am feeling in that moment, and then I begin the physical act of painting. At this point, I start to apply oil paint, utilizing the Reflectionist technique characterized by a multidimensional oil application on canvas. Much of what follows after is, as best I can describe it, like something is being downloaded through me. I think every artist is different with regards to when and how much intuition is utilized in their process. Some are very deliberate, with years of study, theory, and training guiding their process. They may start with a plan of execution and know exactly what their finished product is going to look like. This method is the exact opposite of mine. I literally don't have an idea what my finished product is going to be many times. It is almost as if I go into a meditative state, where I let go of my expectations and surrender the movement of my hands to something much greater than me and let this power have control. I can honestly say that I am often surprised and delighted by the forms and nuances that appear before me. They are gifted to me, and as I observe them being created, I am frequently humbled that I am the vessel that has been chosen to bring

this particular piece of art into the world. My painting process has been like this from the very beginning, and I am highly aware that this is a gift that has been bestowed upon me.

As to my self-portraits, the subjects of this book, these are a bit different from the abstracts because I am, in fact, painting a form. Painting the human form is tremendously difficult, and obviously I follow no rules or norms as I create my faces. I often look to Picasso, surrealism, and anime for inspiration if I get stuck on particular facial features. I have to admit, if I was tasked with actually painting a proper portrait, I would be so screwed. I admire those who possess this skill. Nevertheless, as I am painting my self-portraits, it is so fascinating because as I paint each feature, especially the eyes and mouths, the characters change. It's like we are having conversations and each addition of paint to the canvas can change their moods. They can go from friendly to totally pissed with one stroke of paint. It's pretty incredible. I certainly have the largest emotional connection to my self-portraits as I tend to think of them as snapshots of my past, present, and future, brought to life in the strangest of ways.

Self-Portrait II, the companion portrait to this particular vignette, is a perfect example of a Reflectionist painting. It was the third painting in this series and emits the purity of my process as it was brand-new subject matter at the time. Sure, the viewer is aware of a human form, but all the features are just a bit distorted and not quite right. Shadows and thick lines convey emotion and tone, and her soul is shining in her eyes. By the way, did you happen to see the tiny teardrop barely escaping from her right eye? This girl looks so happy. I wonder what she has to cry about?

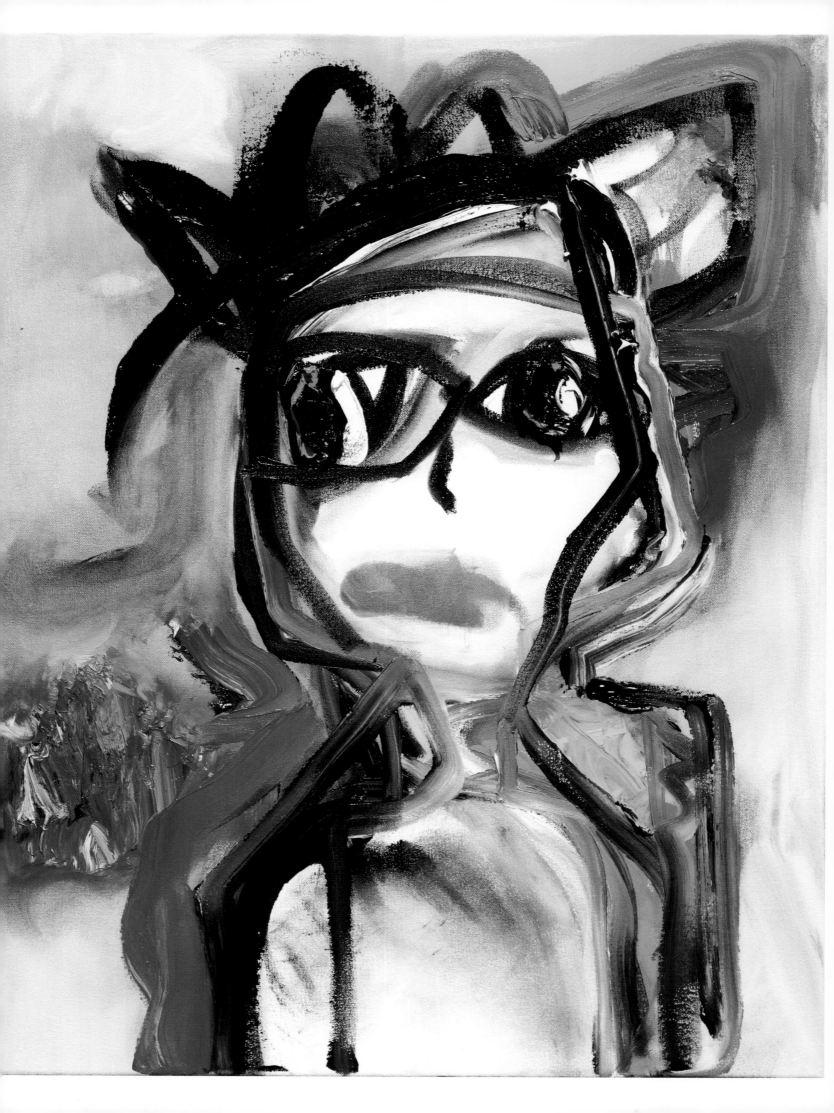

W ell, I don't think any viewer of this painting would have much doubt as to what this character is feeling. Her eyes tell us everything we need to know. As she gazes judgmentally at the world with her right eye, her left eye is steadily fixed on us, we who are most certainly to blame for her stormy mood. She is agitated, out of balance, angry, and, well, we may be safer not crossing her path anytime soon. We may long to hug her and give her sound advice about self-care and spirituality, but our time would most definitely be better spent beating our own heads against a wall, an activity that would likely be far less painful.

Despite my best efforts to thwart her, this beauty we are gazing upon lurks within the depths of my subconscious. When she wants to come out and rage, I try to keep her contained a bit, as I know she will eventually pass out from exhaustion. When she does finally run out of steam, I will welcome her to see what we both have to learn from one another. I usually try to pick up the pieces for her, but there is no question about it, sometimes she just leaves me feeling like hell.

Occasionally, I know why I turn into this tyrant, but other times I have no idea. It could be old trauma coming back to haunt me, or perhaps that I didn't sleep well the night before, or maybe that I drank with some friends over the weekend and it totally crashed the good vibe I had been previously cultivating during my week. Or possibly, I have had a distressing conversation with a friend or family member, or I had some unsavory social media interaction. I know I feel better when I meditate, when I drink water, when I am productive, when I exercise, and when I limit my TV, but damn, it's so hard to keep everything so tight all the time! It is so very annoying, because if just one of these things is off, it can totally knock me out of alignment! Which makes me wonder if I'm normal, or bipolar, or what?!

I can't help but try to shake the thought that I am, in fact, not normal but entirely and unequivocally screwed up and there is this whole group of unicorn people in the world that have their shit together. In my imagination, these people wake up early, get all their work done, work out, create Pinterest boards, donate time to their local charities, and after all of this, catch a buzz at happy hour without major consequences the next day. I feel like they are the same people who have gardens, are vegan (and never cheat), and are totally successful at practically diminishing their carbon footprint. In addition, their sock drawers are always totally organized.

As for me, this is not my normal, not even close. I often

Self-Portrait Zero | 3-Dimensional Oil on Canvas | 20 x 24 in. | 2017
In the private collection of Lisa Benson

wonder how anyone stays focused. I mean, I just had to take a break from writing this to check out the new daily Snapchat filters. Seriously, I'm not even exaggerating here for dramatic penmanship. Combine answering emails and my social media addiction, and it all adds up to a hot mess. In turn, this stresses me out, so I just want to do something, anything, that feels good and relieves stress.

Now, let's be totally honest here, most things that feel good to me are not actually great for me. As an example, I find eating a pizza to be way more fun than doing a yoga class. Don't get me wrong, by the time I have triumphed at yoga, and I am in Savasana, I am 100 percent happy I went to class, and I feel amazing, but, oh, the getting there … First, I have to find a cute yoga outfit, then get to the studio, then actually get past the point in the class where I have a panic attack right after my first downward dog, and inevitably think to myself, "I cannot even believe I thought this was a good idea! I still have sixty-two more minutes of this class! And there is wine in a glass somewhere, just waiting for me to drink it!"

Now, this isn't to say I am a glutton and I live like this every day, but it is a struggle to align all the stars ALL the time, and it seems to me when I don't, I just, at the very least, feel off. At worst, I feel totally useless. I ask myself: is there something wrong with me? Does this happen to everyone? There are just those people who, in my mind, that would never happen to—and also, they would never, ever be caught dead on Snapchat.

If it seems like I am ranting and complaining, good— mission accomplished. I just wanted to take a brief moment to honor the side of me that just kind of sucks, the part that lives in the Matrix and chooses the red pill. The good news is I have spent some time getting to know this side of me and have come to a bit of understanding as to why and when I get in this state. What I have learned from Artie Wu, of Preside Life,

is we all really do feel like the intense character in my painting sometimes, because we have all universally, 100 percent of us, been wounded in life. Our wounds come from a variety of sources such as our parents, interaction with our peers (both as children and as adults), our past romantic relationships, our perceived career or academic failures, the list goes on and on. It is important to recognize, however, that even though the injury may stem from other people at times, it is not their fault. Besides, finding someone else to blame never ultimately makes us feel any better. It may be instinctual to blame others, especially if the particular wound seems deliberate and cruel, but the fact remains that it is people who are wounded who tend to wound others, due to their own unhealed pain. Hurt people hurt people.

Finding someone else to blame never ultimately makes us feel any better.

So, given these inevitable wounds, what do we beat up, traumatized humans do? We do what many other animals do. First, we attempt to protect ourselves from further injury, and then we lick our wounds to make them feel better. Artie calls this shielding and soothing. There are various ways of shielding, which is a larger subject better served in another discussion, but what I would like to focus on here is how we/I soothe.

Much of what I have discussed in this piece describes how I soothe at times. The fact is that soothing with social media, food, wine, romantic intrigue, and TV works for me when I am feeling like "Zero." Self-medicating with these tools is, in fact, normal. In the past, however, when I would engage in these behaviors, I would beat myself up about it, inducing guilt and shame and perpetuating the cycle of wound activation, soothing, shame/guilt, and back to wound activation. However, current day, I have a new perspective on this behavior thanks to Artie Wu.

Artie explains that I engage in these not-so-healthy

and what would appear to be self-loathing behaviors because I am, in fact, loving myself enough to try to make myself feel better. If I hated myself, I would do nothing and just let myself suffer, right? Although my methods are misguided and lack intentional consciousness, I am still nurturing myself. I am treating myself like that sweet grandma who adores her precious grandchild and would never intentionally do something to harm them and instead always offers cake and ice cream when they are upset—even though she knows they have been trying to lose weight and be healthy.

So, armed with this knowledge and new perspective, I have begun doing things a bit differently. I look at this version of myself with compassion and consciously offer some soothing but with no shame attached. I may still use some of my old soothing methods, but I also offer other options, healthier options, as alternatives for comfort. This normalizes the self-soothing process, which is vital at times. In turn, my shame and guilt are reduced, and I start to heal, which is fantastic because I become happier and in much less need of soothing, as well as more capable of choosing healthy soothing options when necessary.

As for "Zero," I have a message for her: I am here for you and will always listen to what you have to say. I will do my best to make you feel better, and whatever method of soothing you chose, I will not shame you for your choices. In addition, while you are hiding, lying dormant, and our higher self is driving the wheel, I will nourish you with love and emotional resources to give you tools to heal. I love you no matter what you say or how destructive you become. My love for you is unconditional, and we are in this together.

Resource:
Artie Wu, Preside Life (meditation), presidelife.com

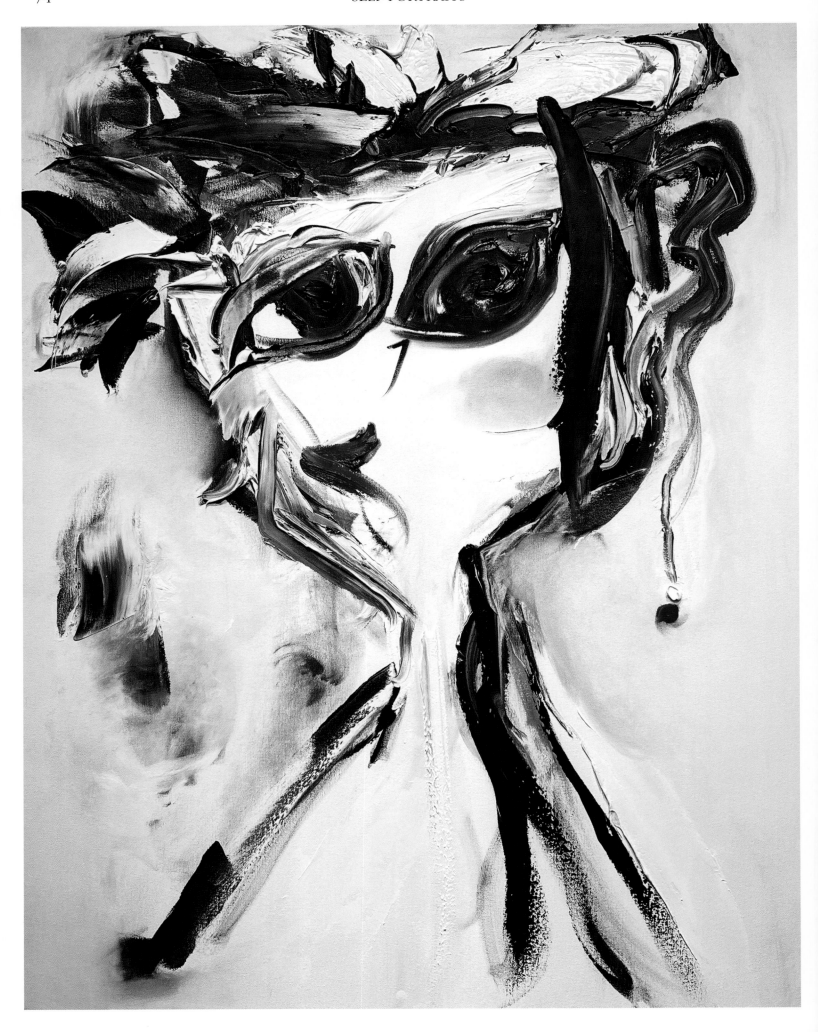

As a child, my perception of how the world perceived me was the way I formed my identity and determined my worth. If the kids at school and in my neighborhood liked me, I was good, if they didn't, I wasn't. As an awkward child of neglectful parents, this was tough because, often, these kids didn't like me. I was wild, I was loud, and I lacked discipline. I was too much for most people. Although I had a rough start and it was difficult at first, I adapted quickly. I observed what were deemed acceptable and desirable behaviors in others, and I emulated those characteristics, evolving into someone who was pleasing, attractive, and socially worthy. My obsessive goal was to pass as a "normal" person, so I morphed into that girl. I received much external validation. By the time I was an adult, I was acceptable—at least on the outside.

On the inside, there were parts of me that no one knew, including me—especially me. I had spent a lifetime covering my anger, pain, fear, and guilt because my shame told me this part of me was unattractive and rude and an inconvenience for everyone. I sure as hell didn't want to show anyone else these feelings because I was afraid that they would hate me just like I hated myself for having them. What I later learned, ironically, was that the people in my life were already

aware I possessed these qualities. As I got a little older and life did what life does, it got harder and harder to pretend I was OK. The facade faded as time passed, and I became a little less normal; bit by bit my cracks were beginning to show. So much for having my shit together.

To cope with my issues and to avoid complete self-destruction, I went into therapy, worked a few twelve-step programs, and worked on my own self-awareness while obtaining a master's degree in counseling. All of this effort certainly helped me cope with my life, and I wouldn't undo any of it, but somehow I was still having significant issues with my emotions and in my life. Fast-forward to forty-six years old. I became aware of "shadow work" from different sources, and as a former therapist, I was intrigued by this "new" terminology, and I started to investigate. As it turns out, "shadow work" is not a new therapeutic technique but a modality first formulated by Carl Jung that is spreading like wildfire among those who are currently interested in spirituality and self-development.

Essentially, Jung suggests our shadow is the darker side of our personality that primarily exists in our subconscious, the demons all of us possess, with which we are in constant conflict. In response to the never-

Self-Portrait Shadowland | 3-Dimensional Oil on Canvas | 48 x 36 in. | 2020
In the private collection of Carlo Ramirez

ending whirlwind of discomfort and dissatisfaction in our lives that we are always one step behind controlling, our shadow enters stage right. All the painful muck that shows up in our lives, over and over and over, no matter what we do, well, we can thank our shadow. The idea is that our shadow consists of the dark side of our personality, repressed memories, difficult emotions, chaos, and deviant desires (to name but a few). Our shadow resides in the unconscious part of our personality. For a good majority of the time, our shadow is running our life behind the scenes, so it is no wonder we do things that are directly opposed to health, wealth, and general peace—and then we shame and guilt ourselves into depression, panic attacks, and a general sense of doom.

We tell ourselves, and society agrees, that we should hide these aspects of our character and portray that we are just fine because it is much more fun and pleasing to polite, agreeable circles. If we could just rid ourselves of this negativity, everything would be alright. And, hey, if we deny having these nasty feelings, everyone wins right? There is just one teeny, tiny problem. After all our pretending, all these pesky demons are still there, still part of us, no matter what we do to suppress them. And oh, the things we do to suppress them! Lying, medicating, perfecting, producing, overeating, under-eating, achieving, competing, rationalizing—and this is only a small sample of the things we might try to avoid our nasty little shadow. But guess what? The shadow is still there. So, we try praying, meditating, thinking positively, reading, or perhaps twisting ourselves into every distorted, inverted yoga pose. Guess what? Still there. So, what is a rational person to do for fuck's sake?! Why are our relationships, finances, and lives in general just never quite good enough? Why is happiness so elusive, and why does success never satisfy us for long?

Consider this thought: In general, we are taught the concept that life is never satisfying. Discontent is just the human condition, and if we have a problem with it, then we are little, weak, and pathetic, and need to toughen up. I mean, no one likes a loser weirdo, right? And it's no wonder, given that this denial mindset is a fairly common societal norm, that suicide, major depressive disorders, and anxiety disorders are so common and that there is not one of us whose lives have been unaffected by them. If being better, looking better, and doing better does not work, are we ruined?

Drum roll, please ... This is where the shadow work comes into play.

Shadow work is basically getting to know and completely owning ALL of our shadow instead of denying, repressing, and/or medicating it into suppression. When doing shadow work, we learn about the unsavory aspects of our personality. We learn to accept and appreciate these pieces and to make friends with this forbidden part of ourselves. We may even develop a sense of gratitude around our shadow and learn how it has truly served us or protected us during vulnerable times in our lives. We also learn that we are not terminally unique, and every single thinking person on the planet that has ever existed has or has had a shadow just as dirty, shameful, disgusting, and embarrassing as ours. It is a transformative process of self-acceptance, and the by-product is self-love.

For me, as I have done my shadow work (which is a never-ending work in progress, by the way), I had to choose to be transparent and learn that what I previously judged to be my bad qualities were not damaged, rotten parts

When we work from this space, we automatically see problems and patterns we have dealt with our entire lives dissipate and work themselves out.

of me but rather normal parts of my personality and completely reasonable considering the context of my life experience. In addition, some of my shadow aspects were genetically inherited and influenced by societal conditioning. In short, I had to learn that my bad qualities did not make me a bad person.

Now, to my skeptics and sharp thinkers, this is not a clever way to avoid taking personal responsibility for actions, attitudes, and behaviors by minimizing, normalizing, and scapegoating, rather it is a paradigm in which we embrace these traits instead of snubbing them. As we lean into this framework, we navigate from a powerful, loving space where we can gain awareness and recondition our automatic responses, instead of reacting to them and beating ourselves up, which, as we very well know, creates infinitely more problems than it solves. When we work from this space, we automatically see problems and patterns we have dealt with our entire lives dissipate and work themselves out. We are then free to create our lives and get off the hamster wheel of problems we previously called an existence.

Learning to love and accept my shadow is my task, responsibility, and sacred honor. You know how they say you can't love anyone until you love yourself? I have always hated that and thought, "Great, and how the hell do I do that exactly?!" Now, I finally get it. It's accepting and loving even the ugly, shameful, dark

sides of me without blaming anyone else or trying to fix what's "wrong" with me. I am learning to be intimate with ALL of me, even the parts that I have hated, hidden, and felt were bad. As I practice presence, develop self-awareness, and have the courage to be honest with myself, I suit up and show up and the shift happens. I am trading self-hate for self-compassion these days, and I could not be more grateful.

Shadowland is an interesting depiction of portraying to the world one image rather than what is actually occurring internally. The right side of this character is polished and stable, projecting an air of confidence, complete with jewels and perfect makeup. The left side of the portrait is off-balance and sad. She looks us in the eye but it takes every ounce of energy she has to do so. It is interesting to notice the dark black wisps in the background of the left side of the canvas that could easily be symbolic of a shadow. The two sides of her live together as they fight for dominance on a daily basis, but one thing is for sure: her shadow follows her wherever she goes, and it is prudent to make her shadow her friend, as it is her constant companion.

References:
Knowing Your Shadow: Becoming Intimate with All That You Are, by Robert Augustus Masters, Ph.D.

Existential Kink: Unmask Your Shadow and Embrace Your Power by Carolyn Elliott, Ph.D.

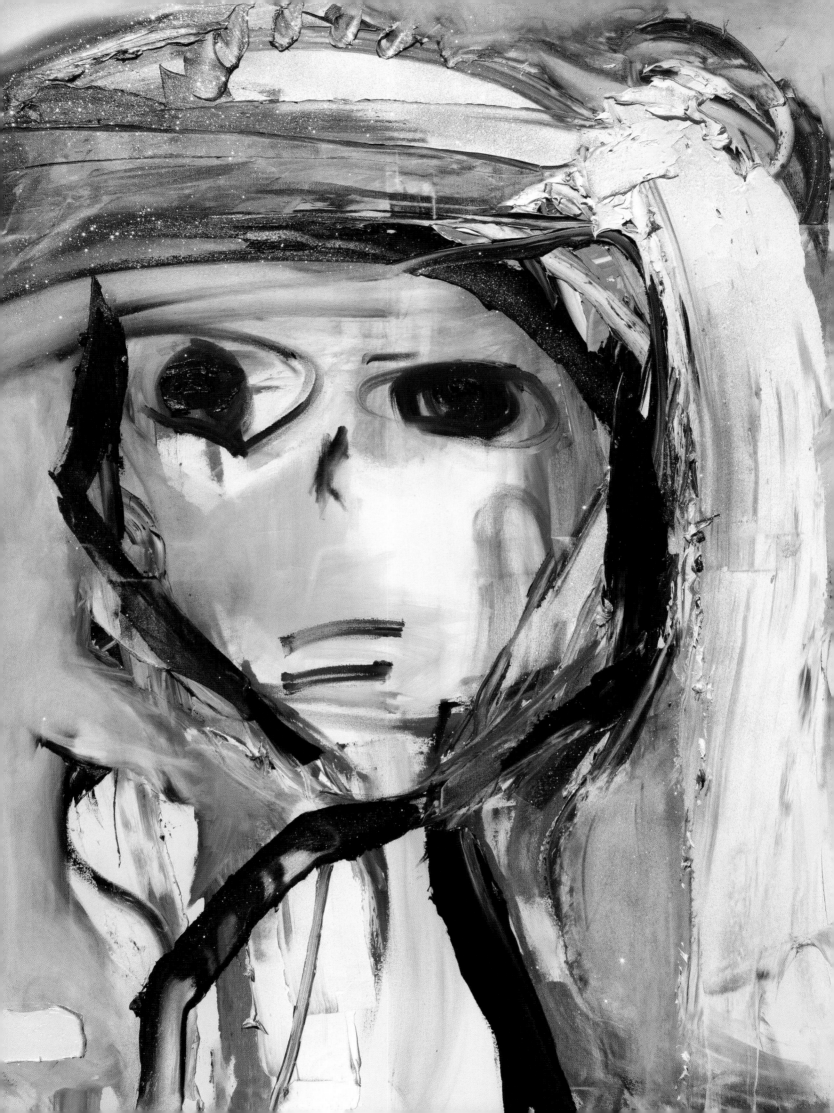

Abandonment is a core issue that keeps many therapists in business. As humans, we have all experienced abandonment to one degree or another. Whether our parents put us up for adoption, were emotionally crippled by mental illness, worked obsessively, were consumed by narcissism, or simply left us at daycare against our will, any of these scenarios can be experienced as abandonment. As tiny humans, we naturally feel that our caretakers, the people who are supposed to love us more than anything else in the world and protect us from all that is evil, have forsaken us, and that is painful. It matters not how big or small the perceived injury was. For most of us, original fracture abandonment wounds leave a nasty emotional scar and bestow upon us dysfunctional relationship attachment styles. This can interfere with our relationships with friends and especially romantic partners. We may need too much love and attention, causing potential partners to run away from us, or we may push away intimacy and do the sprinting ourselves. Well, thank you very much, abandonment issues!

As fate would have it, we go about life and an abandonment pattern seems to show up over and over, especially in our relationships. People leave, romance fades, people fail at meeting our expectations (after ALL that WE have done for them!), and loved ones die. The memory of this abandonment pain resides inside us, lingering and waiting, and our defense mechanisms kick in to protect us from feeling this uncomfortable terror once more. The interesting thing is this response can be so second nature. This self-preservation mechanism is deeply ingrained inside of us, and we don't even know we are protecting ourselves. We are unconsciously looking, analyzing, and EXPECTING that people will hurt us. Whether we remember the first time we felt the sting of being abandoned or if it is buried deep down inside, our subconscious does everything it can to protect us so we never have to feel the trauma of that pain again.

Now, some of you enlightened, spiritual connoisseurs out there might be thinking that all of this conscious and unconscious energy swirling about our minds and bodies, according to the law of attraction, might be creating this pattern of abandonment in our lives instead of it just happening or being the result of a flawed personality. Because if our thoughts and feelings can manifest things, then we may actually be manifesting this heartbreaking phenomenon over and over. So, if it is true that we have influence over our reality, and we are aware of this deeply ingrained ego protection, how do we stop it? Why don't we just

Self-Portrait Where Do You Think You Are Going? | Mixed Media on Canvas | 60 x 48 in. | 2020
In the private collection of Misty and Bill Ried

change our minds, practice feeling loved and safe, and image scenarios where people are loyal and never reject us? This should cure all that is unwell according to the law of attraction, right? This kind of pain is the last thing we want for ourselves. We hate this feeling, right?!

Maybe not ...

Let me propose this to you: Maybe we actually like it. In fact, we may even love this special flavor of suffering. I know what you are thinking: there is no way in hell I love the hollow, devastating feeling of being abandoned; I actually hate it. But humor me and ask yourself: what might I gain from my subconscious mind silently sabotaging my relationships and wrecking my lifelong dreams? I can't answer this question for you but let me tell you what I gained from this kamikaze of a defense mechanism.

I believe, in my past, that I was subconsciously not only sabotaging my relationships but also doing a damn good job engaging in a few other destructive behaviors. For instance, whether a person left me or not, I would always brace myself for the impact because I KNEW it was coming. Also, I never had to make myself truly vulnerable to anyone and let them see the worst of me, my shameful nooks and crannies, because I knew they were going to leave eventually (just like mom, dad, best friend, third-grade teacher, and family dog did),

so what would be the point? In addition, I was released from taking personal responsibility for my actions and how I showed up in a relationship and, conveniently, it could always be my partner's fault. This one is super special to me because there is little that I enjoy more than being right. Also, I got to be a victim, and they had to feel sorry for me, take care of me, and bend to my emotional will because they'd feel guilty if they didn't since I was so frail and pathetic. And last but certainly not least, as long as I was sabotaging my relationships, I was in control. If the hit was coming, at least I could see it before the fatal blow. Ah, yes, control, my ultimate drug of choice. Wow, no wonder my subconscious loves this shit!

The self-awareness I have shared with you is the result of doing shadow work. By doing this work, we can learn to look at the pieces of ourselves we have denied or viciously hated and make friends with them instead. Until we examine and become intimate with the shadow aspects of our personality, this part of us we hate will run the show. When we are constantly berating and abusing the unwanted aspects of our existence, it certainly doesn't help us live a joyful life with people we love who love us back.

We are human and all this pain and ugliness is part of the human experience, yours and mine. We can learn to love these aspects of ourselves and bring to light how even our most painful coping mechanisms

have served us in some capacity in our lives. We can thank these misdiagnosed monsters, honor them, have compassion for them, and integrate them into our conscious experience, transforming them into unicorns. In turn, our thoughts and feelings are no longer waging war on our outer experience, and finally, the law of attraction actually works in our favor. I think this is what we call healing, my friends. Once we rid ourselves of self-hate, we are left with self-love. Pretty cool and beautiful, in fact.

"To love others, you must love yourself. ... You can only give to others what you have yourself." —Leo Buscaglia

References:

Knowing Your Shadow: Becoming Intimate with All That You Are, by Robert Augustus Masters, Ph.D.

Existential Kink: Unmask Your Shadow and Embrace Your Power by Carolyn Elliott, Ph.D.

The Expanded Podcast, hosted by the founder of To Be Magnetic, Lacy Phillips

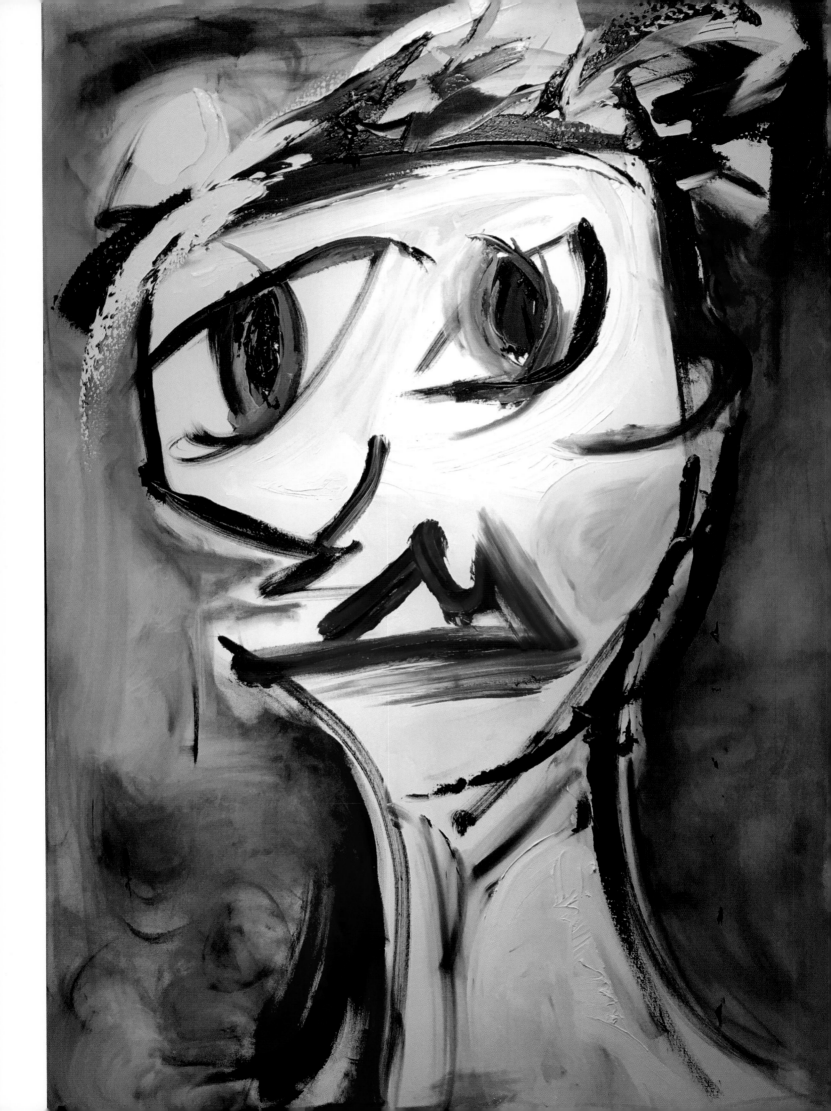

Emotions are funny things. They are not given much credit for what they encompass, beyond being what we recognize as our thoughts and feelings. Emotions are also the biological states and chemical reactions within our body that occur in response *to* those thoughts and feelings, and they are the lens from which we experience the world. Emotions can be wonderful and full of delight, but they can also bring the mightiest of men to their knees. It is every human's plight to master their emotions or become a slave to them and, unfortunately, from what I have observed, most of us live our lives in bondage.

One of the core emotions, and one of the lowest in energetic vibration, is guilt. I have felt guilty for so many things in my life. I have the residual Jewish guilt passed down from generations before me. I have felt guilty/responsible for my parents' addictions. I have felt guilty for not being productive or responsible enough. I have felt guilty for drinking too much and making a complete ass out of myself. I have felt guilty for spending too much money on a pair of shoes. I have felt guilty for not spending enough time with my family or even my dog for that matter. I have felt guilty for my carbon footprint, as well as my general ignorance of world distress. I have even felt guilty for being happy when so many around me that I love and care for have experienced a great deal of suffering. Yes, guilt, it's a big one for me.

Some of this guilt is borrowed guilt and doesn't even belong to me and has little to nothing to do with anything I have actually done, but that is a whole different matter. The type of guilt I would like to illuminate presently is the kind of guilt I have carried, the kind that belongs to me and me alone, because I earned it by doing something wrong that hurt someone. This is probably the type of guilt I have experienced the least in my life, but make no mistake, I still know this emotion very well. It is heavy and heavily laced with shame, another dandy of an emotion that will aggressively consume us from the inside out. Of course, I have known that this emotion can be purged by telling the truth, but normally when faced with this specific shade of guilt, I would prefer to lie in order to not suffer the consequences of my offenses. The worst part about this kind of guilt is that it festers and intensifies with time. It eats us from the inside out and tells us what a bad person we are while accompanying us every day and terrorizing our dreams at night. This is one of the most toxic of all emotions, and it can destroy all aspects of our life if left unchecked.

Self-Portrait 45 | 3-Dimensional Oil on Canvas | 72 x 48 in. | 2017

Coming to terms with my mistakes and how I have hurt others is a work in progress, and it has been extremely difficult for me to admit my shameful, selfish behavior. Baring my indignities and exposing my underbelly to puncture might be the most terrifying feeling in the world, but let's be real here, secrets have a way of floating to the surface. No matter how much we try to hide them, they usually find their way into the light, so owning up is the best plan of action, in my opinion, although I think most of us, certainly me, had to learn this the hard way. Telling the truth and taking responsibility for your actions doesn't automatically guarantee us a complete absolution from our crimes, and it's delusional to think an "I'm sorry" will always be a magic pill to avoid significant losses and consequences. In this case, we must simply take our medicine, do our best to not injure further, and move on with life. Sometimes this is all that can be done. Ironically, though, what I have experienced is that people in my life whom I have wronged have been much more forgiving than I gave them credit for, and I have learned two lessons as a result. One, having the courage to tell the truth is worth it, and two, when someone wrongs me, being generously forgiving is favorable because this grace has been bestowed upon me. That's it.

Listen, we all fuck up. We are all imperfect people, and there is not one of us who hasn't acted selfishly and hurt others at some point in our lives. The human condition can suck sometimes, what can I say?

Nonetheless, there is this part of us that can rise above our lowest nature, the part that is capable of mercy and compassion even when people have hurt us in the deepest way possible. I know it exists because I have received this gift firsthand. So, this is what I strive for, to forgive others and then, even harder, to forgive myself. This may take a lifetime, or two, or a thousand—but, what the hell? This is the stuff spiritual gangsters are made from and the key to freedom—so, sign me up.

Resource:

Letting Go: The Pathway of Surrender by David R. Hawkins, M.D., Ph.D.

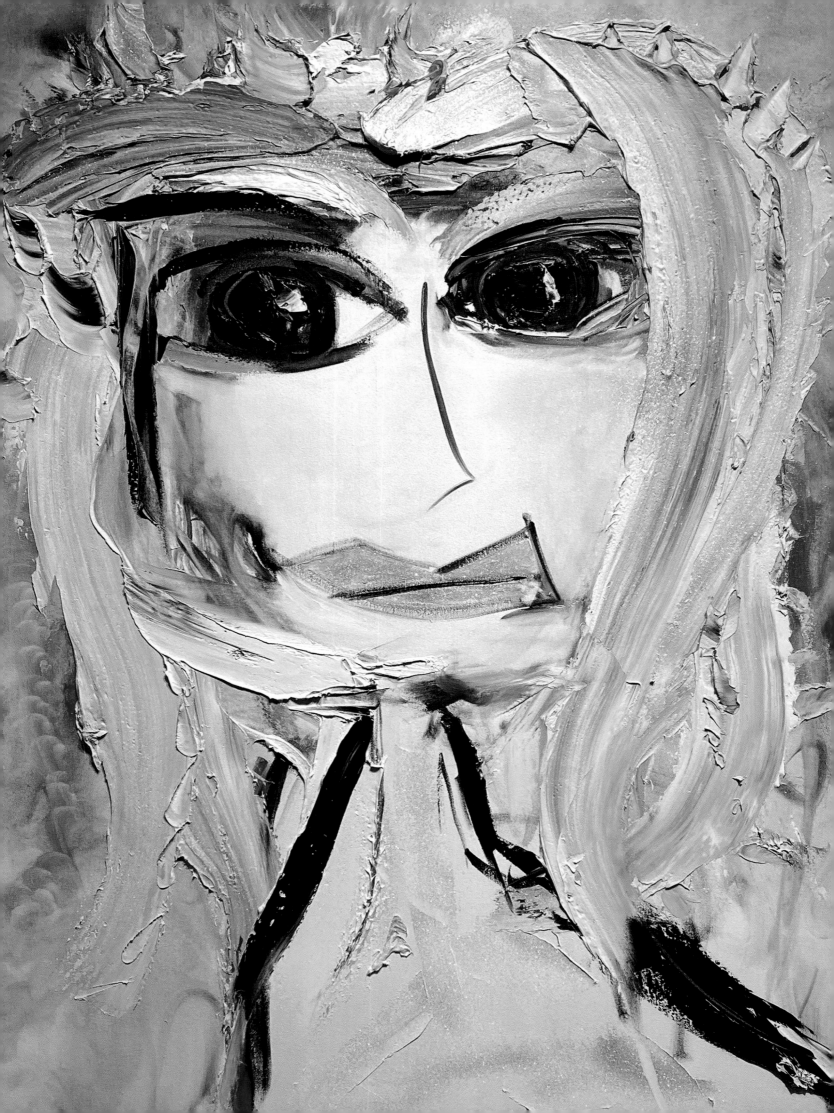

Once upon a time, there was a twelve-year-old girl who lived in a trailer park in Irving, Texas. Her mom had a heroin addiction and was much too consumed with her illness to provide this little girl with proper supervision. One day, the girl was at her friend and neighbor's house and some boys from across town came over. The girl in our story didn't know much about boys at the time, but one sixteen-year-old boy paid particular attention to her, and they ended up having sex. The girl was very confused and upset, but when she went to tell her mother about it, her mother was not emotionally equipped to handle the magnitude of the situation. The mother grew very agitated and upset. She was not able to provide the girl with the comfort that she needed. Whereas a parent who was healthy and capable might have taken this little girl to the hospital and called the police, that was not the case in this story. Instead, basic survival instincts kicked in for the girl and her mother, and the incident was never mentioned again.

As the little girl developed into a young woman, she grew to be strong and capable, rarely thinking of events from her past. When she started dating, it never went smoothly. When someone loved her deeply and wanted to know her intimately, she was repulsed.

On the other hand, if someone was unavailable or emotionally abusive, she always believed it to be true love. This was a pattern with her over and over, and as she got older, she started to suspect that something was innately wrong with her.

It wasn't until our girl was way into her forties that she realized what had happened to her when she was twelve was actually rape. Rape was a word she had been avoiding her whole life, and yet it was something that had affected all of her intimate relationships. She wanted to be strong and normal, and she didn't ever want to be thought of as a victim. However, when she had the courage to review her entire history with regard to the men in her life, she always came back to that summer day in that trailer park. She decided it was time for her to look at that day, examine that day, reclaim that day. As she did these things, she admitted to herself that she was, indeed, a victim. A victim of impoverished circumstances, a victim of neglectful parents, and, yes, a victim of rape.

So, what was our girl, who was now a woman, supposed to do with this personal realization? She decided to tell her story. Why? I'll tell you why: she wanted things out of life. She wanted to help people and believed her story would help others who had been in similar

Self-Portrait 46 | 3-Dimensional Oil and Mixed Media on Canvas | 58 x 48 in. | 2019

situations to feel less alone and encourage them to step out of the shame of their abuse. She also wanted to be seen for who she really was rather than as some shell of a story she had been projecting her whole life. And, most importantly, above all else, she wanted to be loved, and she wanted to be able to love someone back, and she knew that this could never fully happen unless she was truly herself.

So, this former little girl decided to write a book. A book about her art and her life, and she decided she would tell the whole truth. She desperately wanted to leave this sad detail about her history out of her story, but she knew that if anyone was to truly understand her journey and her art, this tale must be told—no matter how uncomfortable it made her or other people. She wanted to acknowledge how she was deeply hurt as an innocent girl and in doing so take away the sting of secrecy. She wanted to warn parents to watch their children closely, especially when they first venture out to experience the world. She also wanted to stress to parents that if they have an addiction, to please do what it takes to heal themselves because their children need their protection and presence, and every moment they are in their illness, these are things that they are unfortunately incapable of providing to vulnerable young souls. She wanted to express her deep sadness about a world where young boys are constantly conditioned by society to sexualize women and taught to believe conquering a woman (or a girl)

makes them more of a man. She wanted to be sure to say that this boy, although an abuser, was also a victim of society and circumstance, and that she has compassion for him.

Yes, the heroine of this story had a lot to say, and she knew that saying it was the first step in letting it go. Even as she was writing her book through her tears, she had a deep assurance, knowing that she was finally taking back the power that was stolen from her so many years ago. Now that her truth was out, she was ready to heal. She knew this would not be an easy journey but at least she had started on her new path. Others had traveled this path of healing before her, and she would follow in their footsteps, having faith that she was not alone and could, indeed, live happily ever after.

The End.
Or maybe we should say:
The Beginning ...

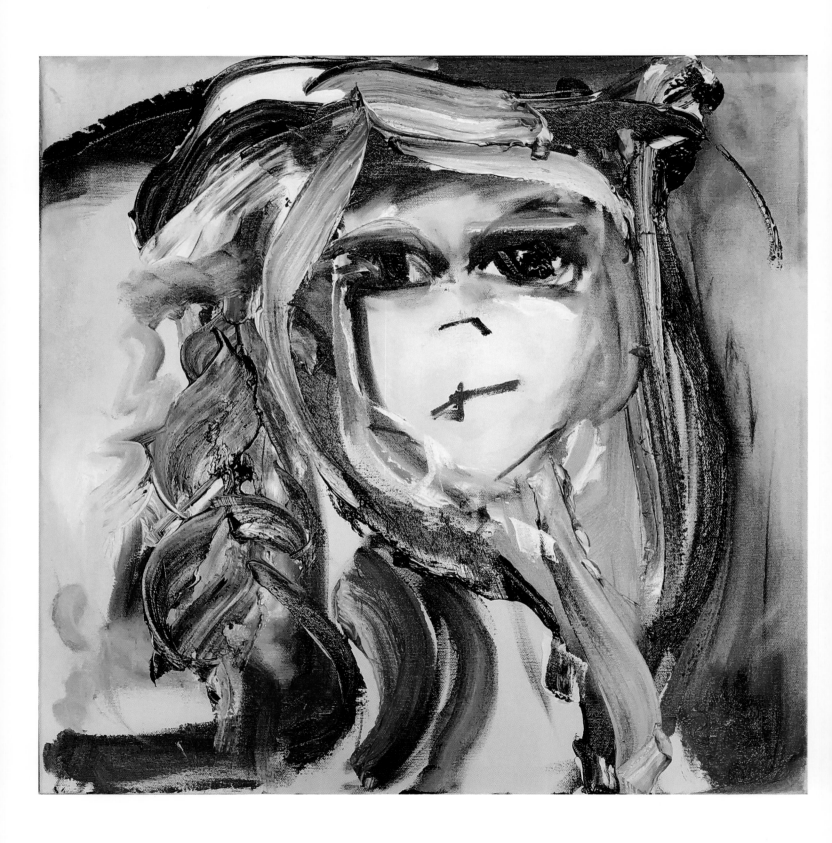

F or me, there is something simultane-ously sad and sweet about this painting. This young girl, probably around the age of seven, is beautiful in the way that only very young children can be. However, her eyes express disillusion-ment and wisdom that don't seem appropriate for her age. She expects disappointment but continues to have faith in a world that will keep letting her down, despite her inherent, naive optimism. She has tried to voice her concerns and fears, but no one was listen-ing, so at some point she just stopped talking. No one has spoken to her in years, but she has never stopped wanting for attention.

Along the road to my recovery, I became conscious that I had abandonment issues, but this awareness did little to help me heal them. I always assumed I had residual emotions from my parents' divorce and my estrangement from my father as he struggled with his mental illness. Being cognizant of these feelings, however, did not help me with the lingering emotions I experienced when triggered by adult relationships or other circumstances that elicited feelings of unworthiness, rejection, or loneliness. In fact, it took a while to for me to even begin to realize the reactions, or shall I say overreactions, I had when faced with these challenging relational issues, reactions that usually had

little to do with the present circumstances. Often, my response would come from a wounded child space rather than relating to the situation with intellectual adult understanding. Luckily, I came across a method, called "inner child work," to help heal these wounds and ultimately build a trusting relationship with myself and others.

Inner child work is done with the intention of healing psychological injury and dysfunctional patterns that originate from traumatic childhood experiences. I have found it extremely helpful because it is an easily accessible tool, which I can facilitate myself rather than relying on a therapist and traditional talk therapy, which is only available at certain times and certain places. Where traditional therapy is undoubtedly useful when reasoning out exactly what issues need attention, inner child work is a more specific modality, or instrument, used to address and heal those precise issues once teased out.

As a child, I was not emotionally equipped to process painful situations, nor did I have the capacity to fully understand what was happening to me. Traumas range in severity and differ from situation to situation, but I daresay that I am not alone in having these experiences as no person escapes childhood without wounds.

Self-Portrait Inside Story | 3-Dimensional Oil on Canvas | 20 x 20 in. | 2018
In the private collection of Lisa Benson

Because a child's mind is challenged to process psychological distress, the response to this distress can be an exercise of self-protection, repression, and internalization. Needless to say, this cycle will cause trouble for one's future emotional and relational landscape, as it did in mine. As a result of these coping mechanisms, I have unconsciously functioned and managed in present-day life, utilizing the unhealthy learned emotional lessons of childhood. If you too can relate to having an overexaggerated reaction to a seemingly benign situation, you can probably thank your inner child for that. As I will further discuss, however, we will not be too hard on the inner child, because this work is all about nurturing this tender, forgotten part of ourselves rather than ignoring or belittling it.

As I grew from childhood to adulthood, I tended to disregard and reject a little voice that was deep inside of me, dismissing it as unimportant and weak. As a result, I had emotions that seemed to come from nowhere, disrupting my daily life and, at their worst, flaring up and causing all kinds or drama. When continually and consistently ignored, these erratic emotional annoyances manifested in depression and anxiety. So, my goal in engaging with my inner child is to carefully listen to, have compassion for, and re-parent this ancient part of me that I have previously exiled. The result is that my inner child feels acknowledged, loved, and important—no longer needing to go to such drastic measures to get my attention.

This inner child work is by no means a new therapeutic technique. Any therapist worth their salt will certainly be, at the very least, familiar with the process. There are different formats that can be used, but I will explain my personal process. Since it is my individual adaptation,

> I have unconsciously functioned and managed in present-day life, utilizing the unhealthy learned emotional lessons of childhood.

take what you like and leave the rest.

I like to do this work mostly when I am having uncomfortable emotions, although it has been useful for me to check in with my inner child during joyful or humorous times as well. When I start to feel slightly off or I am having intense emotions, I sit quietly and talk to my inner child, whom I lovingly call "Little." I do this silently, mostly, but I have heard of others doing it out loud or writing dialogue. This process is meant to be a two-way conversation rather than talking at the inner child, as that could be construed as speaking in a condescending manner with the inner child, eliciting feelings of powerlessness and shame rather than cultivating feelings of acknowledgment and trust. The overall tone is one of total acceptance, providing a completely safe space to let the inner child say whatever they would like without judgment or retribution. Cultivating this environment allows my inner child to express herself on a regular basis, no longer demanding my attention at inappropriate times and using negative emotions as a signaling method. As I, adult Lea, provide the consistent, disciplined, unconditional parenting my inner child needs, she no longer runs the show, resulting in emotions that are much more stable and befitting for my specific current-day situations. There is much less drama!

Here is an example of how a conversation between my inner child, Little, and me, adult Lea (AL), might go:

AL: "Hey, Little, how are you? I'm feeling kind of strange and anxious, and I just wanted to check in with you to see what is going on. Are you OK?"

Little: "No, I'm not OK."

AL: "I'm so sorry you are feeling bad. Is there anything specific you would like to tell me?"

Little: "I'm scared."

AL: "I know it is very uncomfortable to be scared, but I am here for you and want to hear what you need to tell me."

Little: "I don't really feel like talking to you. You don't listen to me anyway, even when I really need you. You have abandoned me and my needs over and over."

AL: "Little, I know in the past I have ignored you, and I am sorry, but things are different now. Since I have been aware that you need me, I have been checking in with you on a consistent basis. I know it will take a while longer for you to trust me completely and that's OK, but I promise you I am here for you now and anytime you want to talk to me I will be available. I may not always do this perfectly, but from now on I will be present for you as much as possible, anytime you need me, without judgment. Haven't I been paying attention to you lately and taking you into consideration?"

Little: "Well, yes, I guess you have."

AL: "Little, I know you are angry and scared. I can understand that. Is there anything you would like to tell me about why you are feeling scared? It's perfectly OK that you are feeling this way. I'm just curious."

Little: "I'm scared because I don't know what's going to happen to me and if I am safe. I'm scared you aren't going to be able to take care of me. Do you remember a long time ago when we got left at home for a really long time and we weren't sure if anyone was going to take care of us? It was super dark and cold, and I was scared being left alone, and I felt panicked. I thought something really bad happened, and I didn't know what to do."

AL: "I do remember that, Little, and I can understand how having that memory may frighten you. I'm so sorry you were in that situation; there should have been someone there to look after you. I do want to tell you that I am here for you now, and I will keep you safe. You can count on me to meet your physical and emotional needs. I am the competent adult in charge now, and I have your best interest at heart. You can count on me."

Little: "Are you sure?"

AL: "Yes, I am positive. I do many things to take care of us on a regular basis. I work to earn money for the things we need. I nourish our body with good foods and exercise. I have good friends and family around us so we don't get too lonely, and I read and meditate to keep us grounded and connected."

Little: "I really like those things, and they do make me feel safe."

AL: "Me too, and I'm glad you are happy with those life choices. Is there anything else that you would like me to do to help you feel safe and less scared?"

Little: "I feel safe now, but I'm kind of bored."

AL: "OK, good, I'm so happy you are feeling better. I'm a little bored too. Is there anything we could do today that might be fun?"

Little: "I would like to eat pizza without you criticizing me and making me feel bad about it. I can't even enjoy yummy food most of the time because you are so strict."

AL: "I do want us to be healthy and feel good, but I can understand how you feel. Today we can have some junk food and I won't be a party pooper. It is my job to protect us so I will not let us do this every day, but I certainly don't need to be so strict all the time. Is there anything else you would like to do that may be fun?"

Little: "I want to go ice-skating. We haven't done that since we took lessons when I was seven."

AL: "That sounds fun! Would you like to invite a friend, or would you like it to be just us?"

Little: "Nope, just us. I'm afraid I'm going to look silly in front of somebody."

AL: "You got it. We can go to the mall, go ice-skating, and have some pizza. I'm glad you brought this up. Anything else?"

Little: "No, I'm good. Thank you for listening to me and spending time with me. It really makes me feel like I'm important and that I am seen and loved."

AL: "I do love you, Little, and I accept you exactly the way you are, and if you need to talk to me more, let me know."

Little: "Thank you, and I love you too."

To some, this process may seem a bit strange, but it has definitely cultivated a sense of self-trust and self-love within me. It absolutely isn't lost on me that I am indeed talking to myself and that might be construed as a little crazy—but, what the hell? It works for me, so I am fine with a little crazy these days. It's a small, prideful price to pay to reconnect with myself and give myself what the adults in my life when I was a child simply could not.

Resource:

The Journey from Abandonment to Healing by Susan Anderson

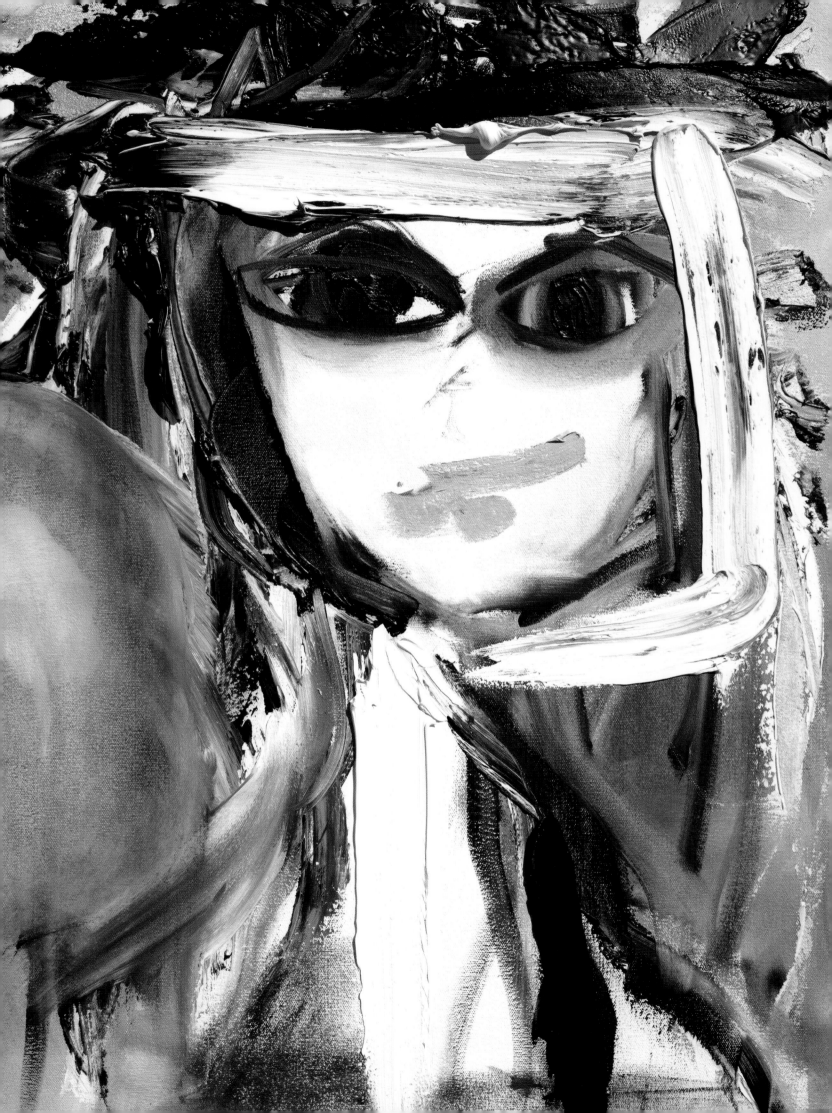

"Forces beyond your control can take away everything you possess except one thing, your freedom to choose how you will respond to the situation. You cannot control what happens to you in life, but you can always control what you will feel and do about what happens to you."

—Viktor E. Frankl, *Man's Search for Meaning*

Self-Portrait 911 | 3-Dimensional Oil on Canvas | 48 x 36 in. | 2017
In the private collection of Emily O'Halloran & Greg Douglass

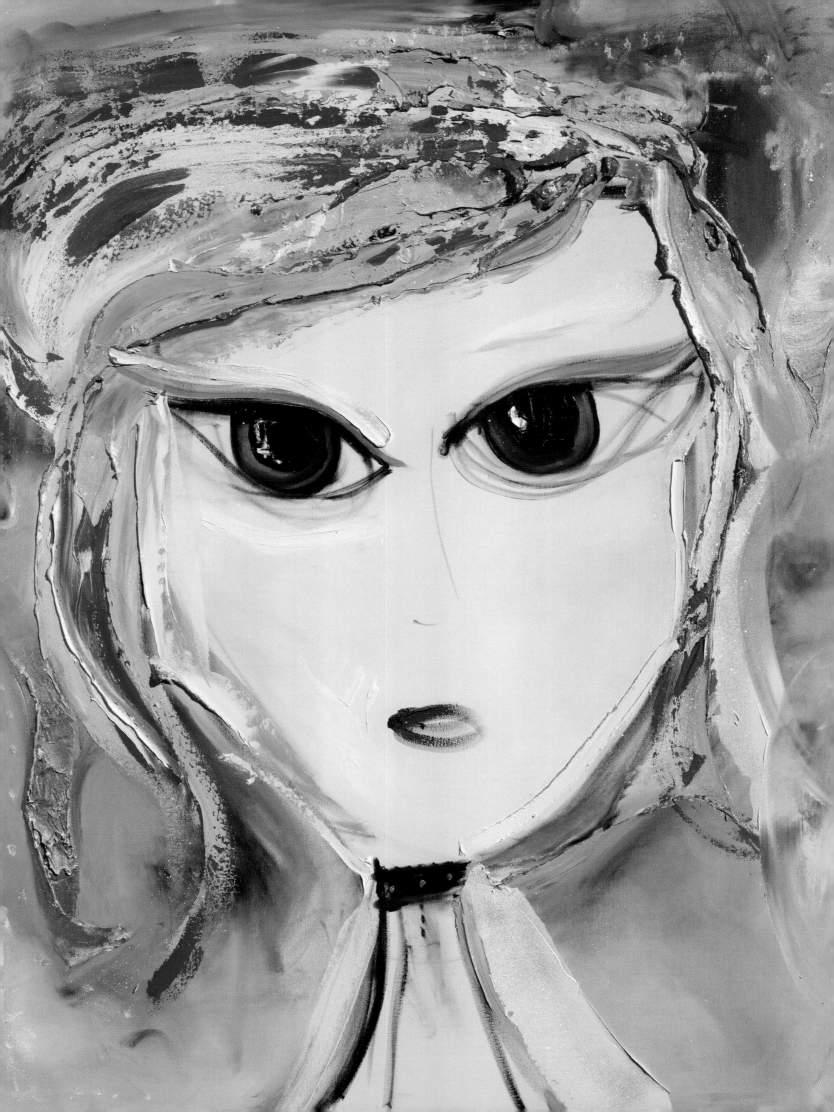

I always wanted to be like the girl in this painting, who undeniably resembles a Disney princess. Specifically, she resembles Cinderella, and we all know Cinderella is the top princess. She has no worries; life is kind and generous to her and her pastel color palette. The world is sparkly for this girl who floats through her days without a care nor the weight of trauma and responsibility. No heavy lifting for her. Because of her beauty and brilliance, the world is her oyster.

Many times, I have thought I was entitled to more in life. I thought I was entitled to parents who were not sick and were capable of giving me more of the time, discipline, and nurturing I needed as a child. I would often ask myself why my childhood happened to *me,* and why I wasn't given more or acknowledged more.

I questioned why I wasn't treated better in my romantic relationships, why I wasn't granted more understanding and compassion when I fell apart. I thought I was entitled to absolute acceptance no matter how difficult I was to live with—even when I was the abusive party. I had been through a lot, couldn't they see?! I mean, for God's sake, so what if I had fits of crying, moodiness, and anger issues. Was it really THAT bad?

I wondered why I wasn't prettier, smarter, or more dynamic. I pondered why others were bestowed with talents more extraordinary than mine, and why I lacked that certain charming spark that beguiles the attendees of cocktail parties. And while I'm busy reminiscing about all the things I wanted but was denied, I will just throw in that I also intensely desired to be a petite brunette with olive skin and for my name to be Linda instead of Lea.

Yes, I have to begrudgingly admit that for most of my life, I wore victimization like a winter coat in twenty-below freezing weather, and I accessorized this coat with my colossal sense of entitlement. I was in a perpetual state of waiting—waiting for my parents to correct their wrongs, waiting for a man to meet my emotional needs, and waiting for the world to bend to model a place where I had little discomfort, a place that did not require extra effort or sweat equity on my part. Alas, I had been an entitled princess in my tower waiting for rescue from my unfortunate, impoverished reality and all of its confines.

However, the truth is that what I was lacking was not any amount of love or gifts or preferred life circumstances; what I was lacking in was gratitude. It took a while for me to finally be able to recognize all the gifts that had been bestowed upon me.

Self-Portrait Princess Diary | Mixed Media on Canvas | 60 x 48 in. | 2018
In the private collection of Don Rakestraw

For example, maybe my parents were sick and lacked the dignity I believed other people possessed, but did they not give me other gifts? Would I be the artist I am now were it not for the depth and range of emotions I experienced in my family? If I had not seen great sickness and sadness, would I have still developed a curiosity for psychology or a compassionate drive to help people heal?

Also, my parents were always kind and loving, even when faced with the pain and horrors of their addictions. Pain and horrors the depths of which I now know that I can't even begin to understand. I was not subjected to verbal, sexual, or physical abuse. It was quite the opposite. My parents almost smothered me with adoration and put me on a pedestal. Not to mention all of the love and support I got from my grandparents and aunts and uncles. So, in the family area, although certainly unconventional, I have been quite blessed.

Then there is the matter of talent. Was I not given talent? I am a professional artist, now writing a book about my craft. There must be something here! In fact, I always possessed an intuitive gift for painting but never paid much attention to it until my thirties. I always had a creative streak and was forever dancing, singing, acting, and drawing as a child, so I was not lacking talent but rather the self-discipline to commit and practice. This was something that no one could do for me, so my family also gets let off the hook here.

And love. I have known love. Perfect love? Today I would say yes. The men I have loved looked different at varied times in my life. Some of them were kind, and some not so much. I will say what they all had in common was extreme patience. As I said, I wasn't easy to be with, especially before I started down a path of self-exploration, and even now I can be challenging. Even though some of these relationships were painful and the men couldn't live up to my impossible expectations, I learned so much from them, especially the agonizing ones.

I learned lessons about boundaries and self-respect. I learned that I wasn't as loving or generous as I believed myself to be at times. I learned that leaving someone in a relationship is painful but being left is exponentially more so. And, most importantly, I learned that no matter how much someone loved me, I simply couldn't feel it until I unequivocally and completely unconditionally loved myself. I had to experience loss over and over and over again until I finally got this concept, so it is with great gratitude that I thank these people for walking through these lessons with me and acting as mirrors so that I was able to discover my true self.

Challenging circumstances and self-limiting beliefs added texture and grit to my life story, so at least it hasn't been boring!

Speaking of my true self, I have come to believe that I am uniquely beautiful in my own way. Although it is easy to compare myself to others, I have been slowly noticing that I'm actually pretty great. Turns out, being a tall blond with big boobs isn't so bad after all. As an extremely fortunate bonus, I have always enjoyed good health, which, as I mature, I now realize is infinitely more valuable than my aesthetic qualities. My personality is a work in progress, but as I have grown more at ease with myself, I have learned to enjoy my own company, sometimes I even find myself laughing at my own jokes in private. I have a considerate heart. I am a good friend. I have a good sense of humor, and as far as being an interesting cocktail party guest, I excel at this. I love a good party and a good party loves me!

All of this being said, it turns out that my biggest hurdles, the circumstances in which I held the greatest resentments and felt the sorriest for myself, were actually my strongest professors and paved the way to my greatest successes and happiness. They forced me to look at myself and take responsibility so that I was able to be the architect of my own existence. In addition, if nothing else, challenging circumstances and self-limiting beliefs added texture and grit to my life story, so at least it hasn't been boring!

Engaging with this attitude of lacking when I felt I was entitled to more and deserved to be perceived "better" only led to a deep sense of oppression and an insatiable appetite for attention that left everyone involved feeling empty and hungry. On the flip side, with experience and perspective, I now see that what I needed and wanted was there all along, it just required me to see the beauty in my unique set of circumstances. I had everything necessary to create the life I currently have, and if anything had been different, I wouldn't be me—and I am really digging me these days, so I have abandoned wishing things were different.

I no longer expect to be served from a silver platter. I no longer expect others to do for me that which I can do for myself, because it is in taking responsibility for one's life that one cultivates self-respect. If I need acknowledgment or validation, I turn inward instead of engaging in the addiction of applause from an audience of one or many, because audiences can be fickle and even cruel.

These days, I have no interest in my princess archetype. I am not a helpless, fragile doll who only flirts with a pastel color palette, with little power to rule over my kingdom. I don't need to be rescued from my life or my opinion of myself. Today I live life on life's terms, and I appreciate the thorns and the blooms of it all, knowing they are both necessary components when cultivating a beautiful garden. Today I accept my past, present, and future, and I am grateful for it all: the elation, the shame, the good, the bad, the painful, and the disappointing—everything.

I believe it is through gratitude that pain can transform into joy, that loneliness can turn into acceptance, and princesses can turn into queens.

Reference:

I Am Enough: Mark Your Mirror and Change Your Life by Marisa Peer

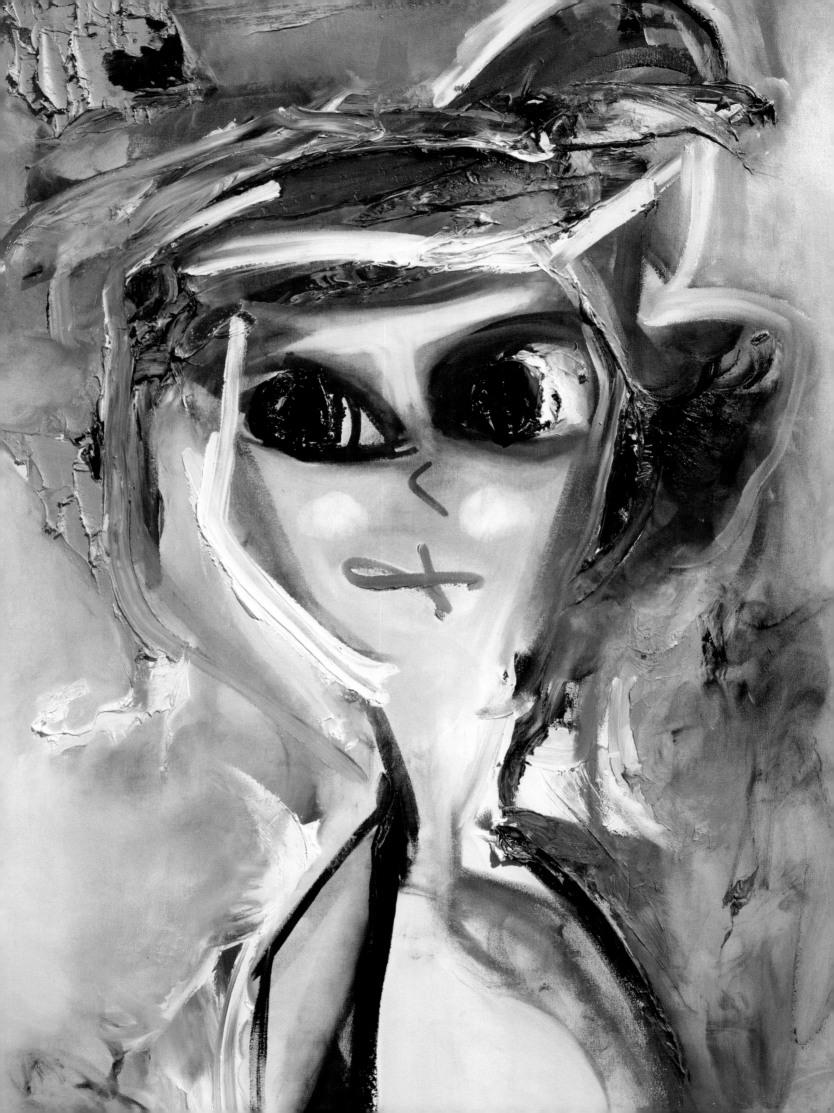

I have always had a deep desire to be successful. What this meant to me was that I needed to be educated, and with this schooling, I would then go on to a prosperous career. Oddly, I don't remember too many conversations about what, exactly, this monumental career was going to be, only that I was to go to college and the rest would work itself out. This set of beliefs was definitely taught to me by my dad's side of the family but also reinforced by my mother, as I think she always regretted not finishing her college degree. I was lucky that this type of messaging and programming actually benefited me. Getting this education, however, was only the start to achieving my goal of becoming "successful," or at least what I define as being successful at this particular point in my life.

Throughout my professional career, I have worn many hats, and my career path has taken several unexpected turns, including becoming a working artist. I have earned degrees, won awards in various fields, and been rewarded with great compensation. I think most would equate these things with being successful, but there is always a part of me that doesn't exactly experience it that way. There is always something more to accomplish, master, and achieve, and success never quite feels like I thought it would. This feeling has caused me to question myself and my motives and

has required me to change my definitions and beliefs about what being successful actually is and is not. I do not ever imagine an existence where money and luxuries will be unimportant to me, but with a little hindsight, I think I can see that they are only vehicles on my journey rather than my destination.

I now know that what I seek is a sense of safety and security and a deep knowing that I will be able to take care of myself. Because I did not always experience physical security growing up, I think this desire was amplified when I started designing my professional life as an adult. What I didn't realize was that monetary achievements were not the only ways to obtain this safety and security that I was seeking, although they are an integral part. It is absolutely true that being financially successful can provide physical security and reaching professional milestones can foster a sense of accomplishment and meaning, but without a practice of self-acknowledgment, these things will never be enough.

I think learning to give myself credit for my accomplishments has been the harder work as I have tended to credit my success to luck, being at the right place at the right time, or a happy accident. Learning that my talent, intelligence, and work ethic, essentially

Self-Portrait 1988 | 3-Dimensional Oil on Canvas | 48 x 36 in. | 2017
In the private collection of Lisa Benson

my own merits, were part of the equation in my professional success has shown me that I truly can provide for myself and create the security I lacked as a child. Could it be that knowing one is safe is the greatest measure of success? I'm beginning to think so.

However, what happens when life happens? Maybe safety is an illusion, considering we all have a one-way ticket to the great void anyway. Ah, yes, death. No one can ever be truly safe from that great equalizer.

Maybe we are successful just being here, doing the best we can with what we have—and safety and everything else is just an illusion.

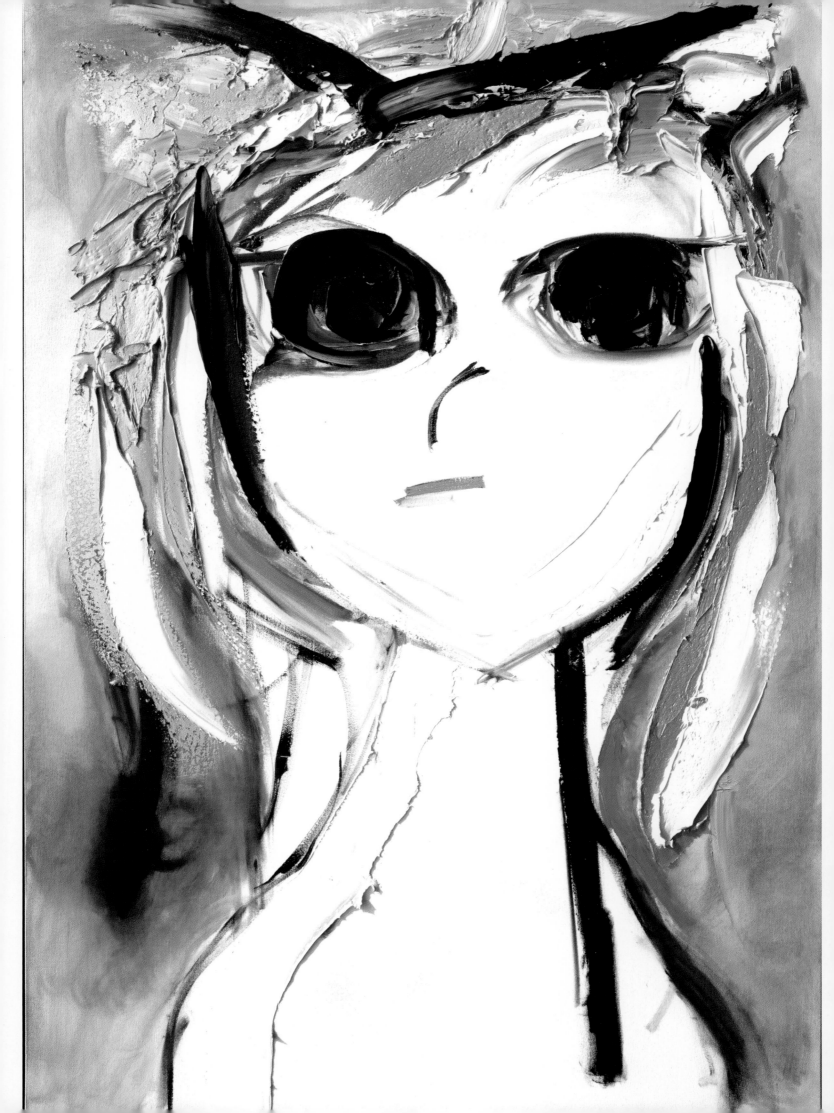

This portrait is one of the more beautiful in the series, but she is not without her demons. The lovely purple background suggests she lives in a picturesque world, but her eyes tell a story of determined resentment toward what she deems as social and personal expectations of perfection.

As long as I can remember, I have always thought I was just a few pounds overweight and less attractive than most other girls, even when I was a preteen, skinny as a twig, and had the undeniable blessing of youth on my side. Because of advertising, social media, movies, and TV, super thin and beautiful seemed the only acceptable thing to be, and by my conditioned standards, I always fell short. I have felt tons of pressure to be flawless, thin, beautiful, and lately, forever young. It would be rational to assume this pressure was coming from the men in my life but, although I value their opinions, for me this is not accurate. Another assumption might be that I have been competing with my girlfriends. I think there is a morsel of truth in that, but that idea too is only a small part of where these feelings stem from. Mostly my self-doubt is a war going on inside my mind and heart. The battle is a constant fight to be relevant, seen, heard, and, ultimately, loved. Maybe if I look great, then I will not feel the grief of the past? When I finally achieve personal perfection, maybe I will not die alone?

I consider myself a strong woman, a feminist with a great career and a promising future ahead of me, yet much of my income and free time is spent on decorating myself, attempting to turn myself into a pretty little Barbie so that people will like me. Do not even get me started on my grooming rituals. I mean hair, nails, tanning, shopping, lashes, facials, cryotherapy, blowouts, my nighttime regimen, morning regimen, water (gallons of it), and visits to the plastic surgeon. SIGH ... it's a full-time job. If I am not doing all of these things, I feel like I am failing.

Waking up to look in the mirror to see if the magic overnight cream worked and if changes in my diet translated to pounds on the scale is a daily ritual. I start my days judging and picking myself apart before they even begin, only to head off to the gym to make my fat cry!

Of course, with my psychology background and knowledge of the DSM (Diagnostic and Statistical Manual), it is not lost on me how many disorders I could be diagnosed with. Eating disorders, narcissism, body dysmorphia, obsessive-compulsive disorder, anxiety, and depression, all recognizable in my psychological

Self-Portrait Pretty Pout | Mixed Media on Canvas | 72 x 48 in. | 2018
In the private collection of Tom Cappello & Frank Battle

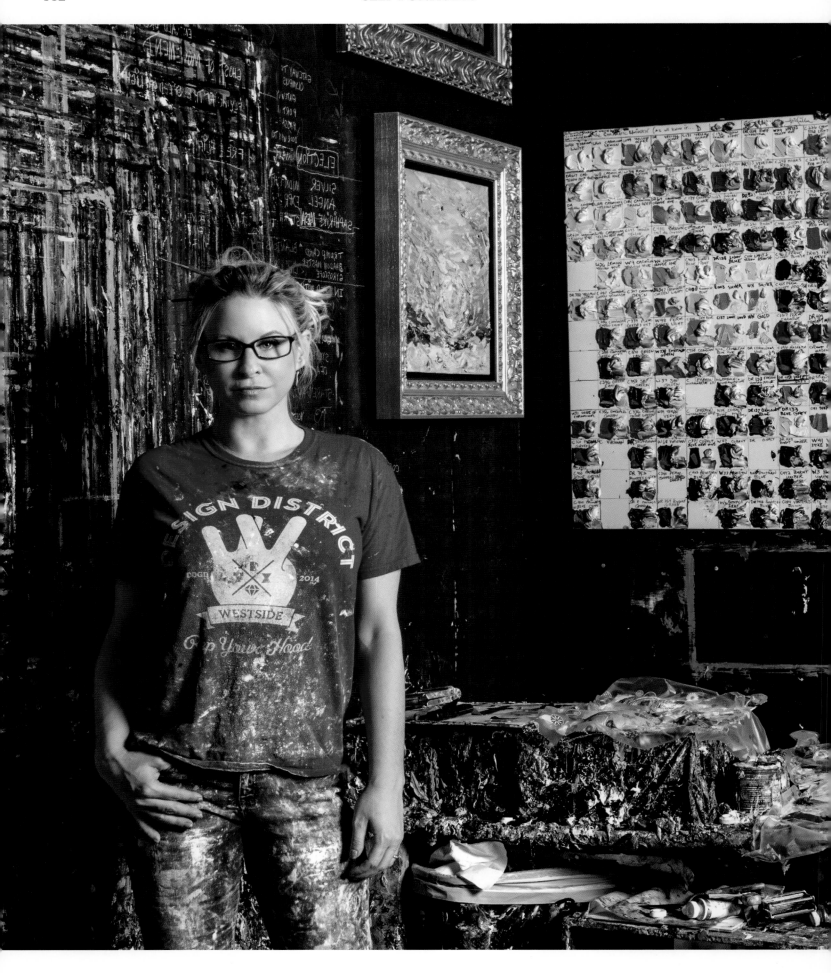

profile. The sad thing is I am not unique. In fact, the majority of women I know feel the exact same pressure.

I guess the question is, does all of this really make us any happier or are we just pretty on the outside and miserable on the inside?

Ultimately, my personal goal is to not disregard personal care and beauty rituals completely but change my intention behind them. I aspire to do these things from a place of self-love rather than self-improvement, which implies there is something wrong with me to fix. I think it would be wonderful to be able to age gracefully and value beauty on the inside as much as beauty on the outside. In all transparency, I'm just not there yet as of 2020, but it is on my spiritual wish list, and it's a goal toward which I aspire—so I have faith that I will get there eventually.

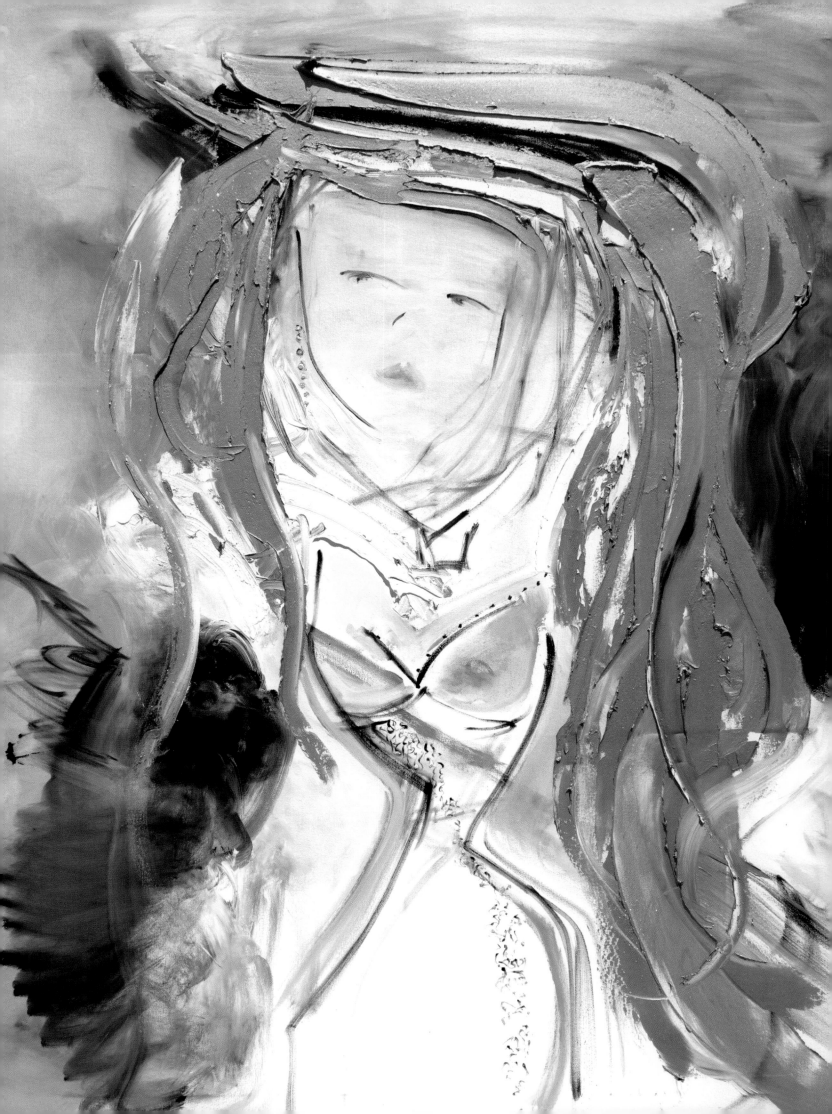

W ho is the woman in this painting? Do you think she is beautiful? Better question, at the end of the day, does she think she's beautiful? And look how she is exquisitely dressed and adorned. Who is she dressing for, and what did it cost her? A good bit of money? Or her soul?

I have decided to really get to know myself. It may seem like a strange thing to say, but it has been revealed to me, as I do my self-work, that I actually may not know myself as well as I once thought I did. I have started to ask myself questions about what I like and what I want out of this life. These answers seem to come easily enough, at least on the surface, but what has been infinitely more interesting is the reason why I like and want certain things rather than the "what" component of these questions.

For example, one thing I have always wanted was to be pretty. This has been a major focus of mine, and much time, money, and effort has gone into this obsession. Make no mistake, I am not exaggerating when I refer to it as an obsession. When I unpack this desire, a few things come to light. First, being beautiful for the women in my family, at least on my mother's side, was always the ultimate goal. Being attractive was regarded with the utmost importance and was how any modicum of self-esteem was achieved. As a result, I was programmed to believe that this is where the maximum value of a woman comes from. Sure, being educated was also appreciated, but as I watched my mother, grandmother, and aunt, it was easy to tell what the ultimate prize really was. I know they were probably not aware this was their belief system, but who could blame them? It was completely rational given societal standards and norms, which certainly reinforced the creed that a woman's worth is directly correlated to her external beauty, especially in youth. So, by default, I believed this and also have desperately aspired to conform to an aesthetic ideal.

Secondly, I have always had a deep yearning to be successful in life, particularly financially. What this meant to me was that I needed to be educated, and with this education, I was required to have a successful career. This set of beliefs was unquestionably taught to me by my dad's side of the family. They were infinitely more interested in intellectual currency rather than outward appearances. It was never even questioned that I would attend college. There were also lots of conversations in support of me succeeding in the business world and not being dependent on others to support me financially. Although in my thirties I

Self-Portrait Isn't She Lovely | Mixed Media on Canvas | 72 x 60 in. | 2021
In the private collection of Jessica Zweig & Brian Fisher

discovered my own passions I wanted to develop, I still held very tightly to the belief that being successful in my professional life was exceedingly important, even vital, to my self-worth.

But now, as I examine my reality and develop clarity regarding my authentic self and what I truly value, I find it necessary to ask myself: why do I really want to be beautiful and financially successful, and what does it all really mean? When I drill down to find this answer, I have discovered that it isn't so much about having good hair, the perfect body, or millions of dollars in the bank because, as I have had small successes in these areas, they alone have never provided me with what I really wanted and needed. It turns out, what I have really wanted and needed was to be seen, safe, and unconditionally loved. I have been trained to believe the path to feeling these things is through how I look and my material achievements. What I have learned, however, as I have incrementally accomplished these goals, is that these outside validations are conditional and, by their very nature, not supportive of my well-being and long-term growth.

Now, I want to be clear here. It isn't that I believe that wanting to be physically attractive or financially successful is inherently bad, but for me it is healthier to keep these wants in perspective and question my motives as I work toward my achievements. It is helpful for me to ask myself questions such as: Are my goals and wants in life really what I want or are they influenced by the programming of family or society? Are my desires coming from a place of self-hate and trying to "fix" myself or are they born from a place of self-love, ultimately moving me forward in my life goals of healing and community? Do my priorities really reflect my true passions inside and are they congruent with my values? Is my self-worth in danger if I fall short in one of these areas or if I don't achieve certain goals?

Today, I strive to find out what I really want and who my authentic self really is while practicing unwavering self-love, acceptance, and compassion. As part of this journey of self-discovery, I question the programming of my family and society and make decisions about my life based on what I REALLY want in my heart.

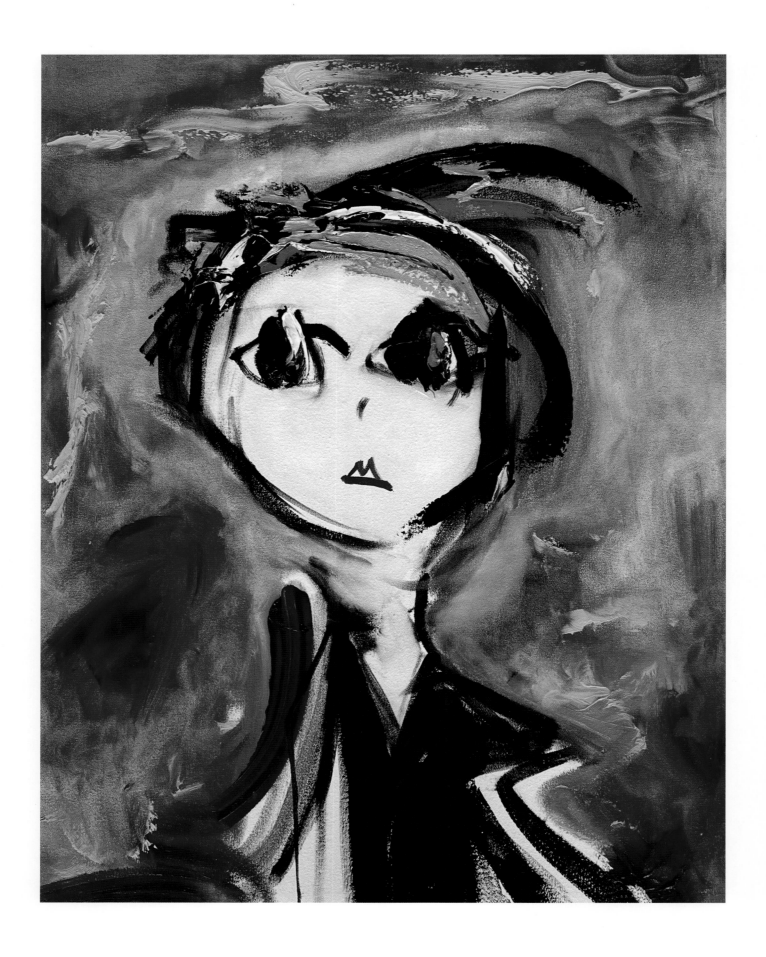

This portrait portrays anxiety, not general anxiety but my anxiety in particular as it relates to my fear of the opinions of others. I have consistently longed to be admired, accepted, and seen as worthy by those around me. As a child, specifically, I wanted these things, but I had an innate and intense understanding that I wasn't "normal" and, of course, because of this knowing, I was self-conscious and awkward.

My mother's parenting skills were handicapped to say the least. Already dealing with severe alcoholism and drug addiction, she was also a single mother contending with our day-to-day lives. This was at the same time that my father, who was in and out of mental hospitals, was struggling to come to grips with his reality. My grandparents helped when they could, financially and emotionally, but had yokes of their own coping with their adult children, so my mom did most of the heavy lifting with me.

My mother worked long hours, and I was left unsupervised quite a bit. While I never went hungry, a harsh reality millions of children deal with every day, I think it is accurate to say my needs for safety, discipline, and dignity were not met. Later, as an adult, I would learn this was a type of child abuse called neglect. I hate to use the word "abuse" because I know my mom did her best with the abilities she had to provide security and love for me, but nevertheless, abuse is what it was.

At eight years of age, I began to see the difference between my home life and that of my school friends. They lived in orderly houses, people were active and happy, and their parents were not sleeping off hangovers in the afternoons. This was when I began to realize my situation was not typical or normal. I began to hide or lie about where we lived, how my family lived, and essentially about every aspect of my life so it would match up to what I perceived to be desirable to others. As a product of my environment, I was a pretty odd kid, and I knew others saw me this way. I was not a polished little girl but disheveled and unruly. I hated my feelings of separateness and being less than and desperately wanted to be liked, so I adapted, and I started on my long road of people-pleasing and its tedious cousin codependency.

By the time I was eleven, I avoided my house, my mother, and my stepfather as much as I possibly could. I dreamt about college, where I would be able to leave my family and home life behind and become that coveted "normal." It is no surprise at all that my issues followed me to school. My location and distance from my family didn't solve my problems or heal my pain.

Self-Portrait 999.9 | 3-Dimensional Oil on Canvas | 30 x 24 in. | 2017
In the private collection of Kenny Tomlin

It wasn't until I was thirty years old that my extreme insecurity lessened, and I could begin to whisper my truth.

It's actually quite amazing to think about. The same obsession that drove me as an eight-year-old girl still programs all of us, at least to some extent, as adults. When are we ever going to be "OK"? Or possibly we are "OK" already, even with all of our insecurities, faults, and shame. Maybe self-acceptance is the answer, and we are, in fact, wholly complete and perfect, JUST as we are.

As for the painting, she is a young girl, pretty, cool, and pale on the outside, but the background is on fire. Her face is burning with embarrassment and shame. The title, *999.9*, refers to her aspiration of being and functioning at 100 percent all of the time but always failing by just 0.1 percent and focusing on that 0.1 percent, letting it drive her entire life force as if not one other thing in the universe even exists.

Reference:

Spirituality of Imperfection: Storytelling and the Search for Meaning by Katherine Ketcham, Ernest Kurtz, and David Drummond

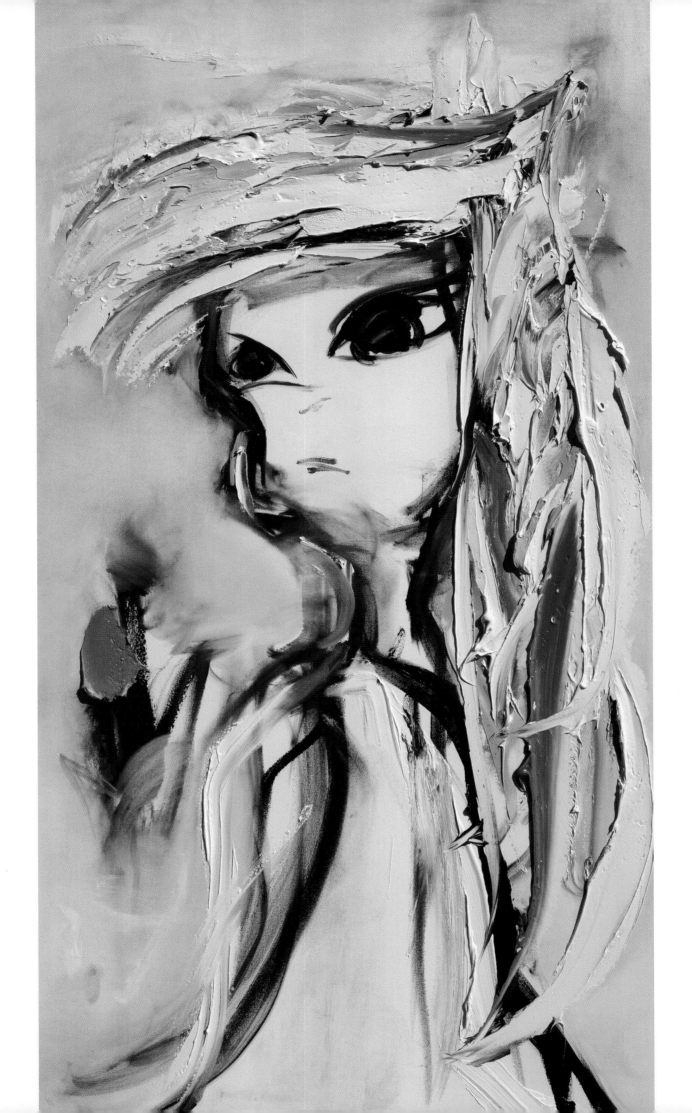

One of the most difficult things about writing this book was having the courage to tell my whole story. The gritty, unsavory part that under no circumstance would you ever reveal on a first date. Shame and perfectionism constantly whispered in my ear, "Maybe you just leave this detail out. We don't have to tell people EVERYTHING!" And I have been hesitant to share such personal secrets with others, many of whom I felt may not be able to identify with these emotions. I have, however, come to believe most people can at least sympathize, even if they were fortunate enough to be nurtured in enriching environments. I mean, can't we all identify with these emotions on some level or another? Aren't we all conditioned by advertising and social media to constantly question our position and appeal to others? A complete barrage of messages: buy this and you will be prettier, safer, richer, thinner, smarter, healthier … perfect. Do/buy/consume "this" and you will be happy and loved. It's astounding, really, that the same obsession that drove me as an eight-year-old girl still programs all of us, at least to some extent, as adults.

Artie Wu, entrepreneur and meditation teacher, put into perspective for me how I was wounded by this thinking and the coping mechanism of perfectionism.

He taught me that I was conditioned by my family, society, and myself to believe I had to wear certain "masks" in this world to be accepted and loved. In my particular instance, I had to wear the masks of good girl, pretty girl, smart girl, normal girl—and I have discussed how this affected me. I started to understand how conditional my love toward myself was and how even the slightest inadequacy was detrimental to my perceived worthiness. If all of me wasn't in line with the world's and, more specifically, my own unrealistic expectations, I was bad, not worthy of love, not even from myself.

I think this will be an ongoing process for me to recognize these masks I wear and slowly but diligently remove them one at a time, and perhaps I will put them back on from time to time. But I truly believe that we are all much more similar than not under all these layers, and underneath it all is our divine humanness waiting to be revealed.

So, I push through my shame and self-doubt with the goal of communicating vulnerably and with authenticity. I hope to see these aspects in others as they join in on the unveilings as well. I will have to work diligently at reserving my judgment about myself and others, and I have a sneaking suspicion that this is

Self-Portrait No Mask Required | 3-Dimensional Oil on Canvas | 56 x 29 in. | 2020
In the collection of the Thompson Hotel Dallas

where the really tough work actually begins. It's fine, though—I think I'm up for the task.

And, in the end, I really do believe what I have heard from many wise souls: what other people think of me is just really none of my business. Isn't how we see ourselves the only thing that really matters? Maybe it's true, but I'll never know until the masks are gone.

Reference:

Artie Wu, Preside Life (meditation), presidelife.com

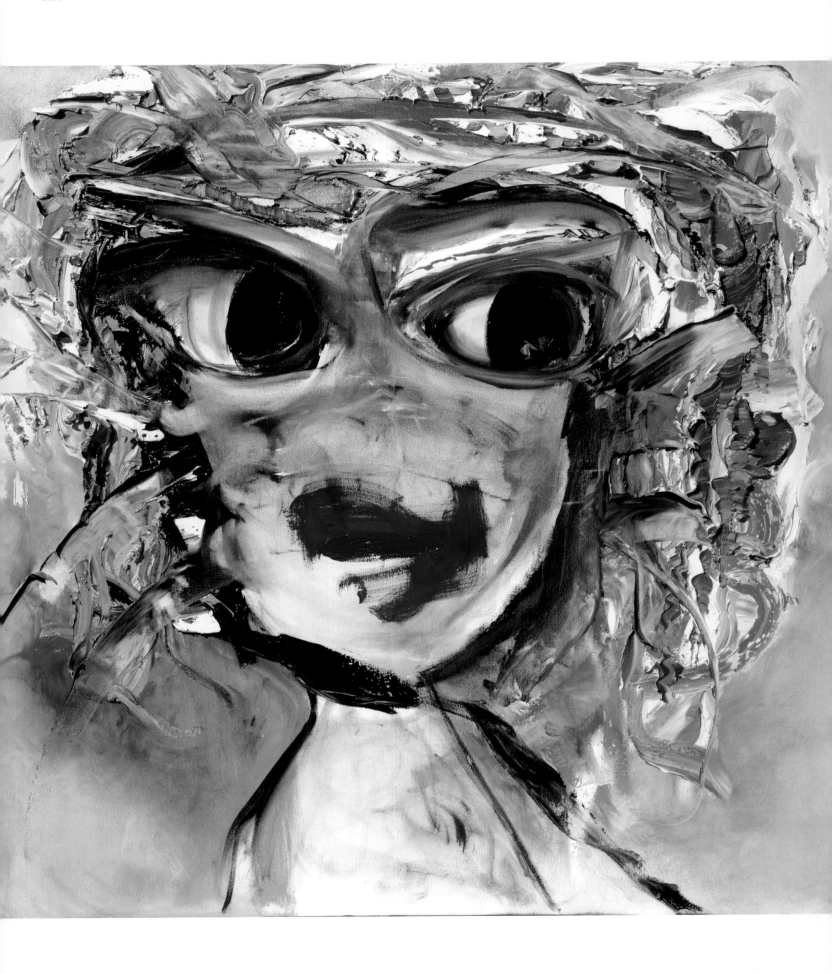

Everything about the young woman in this painting is BIG! Big hair, big eyes, big colorful energy. She is completely unapologetic about the physical and emotional space she takes up in the world. Who does this girl hang with? The popular girls? The "it" crowd? I think not. She is at the table with the free thinkers, paradigm destroyers, mad scientists, and tattoo artists. She loves to use the word fuck indiscriminately, and her celebrity crush is Joan Rivers.

Can I be who I am, can I be my true self, and still be loved? I think this is the question I have been unconsciously asking myself pretty much my whole life, and it is only now that I hold this question up to the light. It seems as if I have been on some path to fix or correct myself for as long as I can remember. I can't recall when it wasn't my mission to conform and be a good girl so that people would approve of me. I know this tape has been running in the back of my mind on repeat so I would fit in, be accepted, and ultimately be loved. I longed to please everyone all the time, that was my goal.

I have always been extroverted, and I doubt those who know me well would describe me as timid. I have big energy most of the time, especially in social situations.

In spite of my bigness, I have shrunk to ensure that everyone around me is comfortable, my fear being that if I did not, I would be ousted from our existential social construct. Whatever you do, I would tell myself, don't be too smart, too loud, too broken, too powerful, too assertive, too emotional, too opinionated, too sexual, too impulsive, too successful, too proud, too dominant, too selfish, too independent, too trusting, or too vulnerable. This was the red, flashing warning sign looping in the corners of my mind. In essence, don't be too much, little girl.

Don't be too happy because it will make those who are suffering resent you. Don't be too proud of your accomplishments for then others will judge you as arrogant and prideful as you remind them of their unrealized dreams and aspirations. Don't be too forceful because you don't want to be a bitch. Instead, be polite and pleasing and ladylike or men won't want you. Don't be unhappy. Put a smile on your face, and whatever you do, don't air your dirty laundry. It really makes people uncomfortable. All of these ideas I have lived by, aspired to, and forced upon myself.

But now, today, I am committed to becoming the best person I can be, and I am starting to realize that dimming myself is not the answer. Instead of being a

Self-Portrait In My Tribe I | 3-Dimensional Oil on Canvas | 48 x 48 in. | 2018

good little girl, how about I become an honest woman who acts on her own behalf, even when it appears "bad" to others. Instead of hiding my power, maybe I harness it and help those who have not quite stepped into theirs yet. Maybe I am responsibly selfish today, setting boundaries and taking care of myself first so that I am ultimately equipped to be accountable for my own reality (and, as a result, others are free from being blamed for when my seasons of suffering arrive). How about I release my fear of the judgment of others and hold a microscope to my own judgmental attitudes, every last one of them. Instead of being "OK," how about I show my shameful cracks in their full glory so that others will know they are not alone.

So, can I be myself and still be loved? To answer the question, yes. I think I can be both, but it won't come without a price. There will be those who don't care for this level of authenticity, those who are just not OK with being uncomfortable, and this I understand. However, they will no longer be my tribe. I send them love and light but, as of now, I cut the cord of my dependency on their approval. They can lose their taste for me and that's OK. I'm onto bigger and better things these days, such as love. Love for others and love for myself. The currency of the approval of others has gone way down in its value in my personal economy. I have a sneaking suspicion that my "too muchness" might come in handy right about now.

Oh, and to those who know me well, you may be thinking, "Holy shit, that was her holding back?!" Yeah, it was, so get ready and fasten those seat belts because we are about to go on a magic carpet ride where voices are heard, power is front and forward, and hearts are healed.

Reference:

Spirit Hacking: Shamanic Keys to Reclaim Your Personal Power, Transform Yourself, and Light Up the World by Shaman Durek

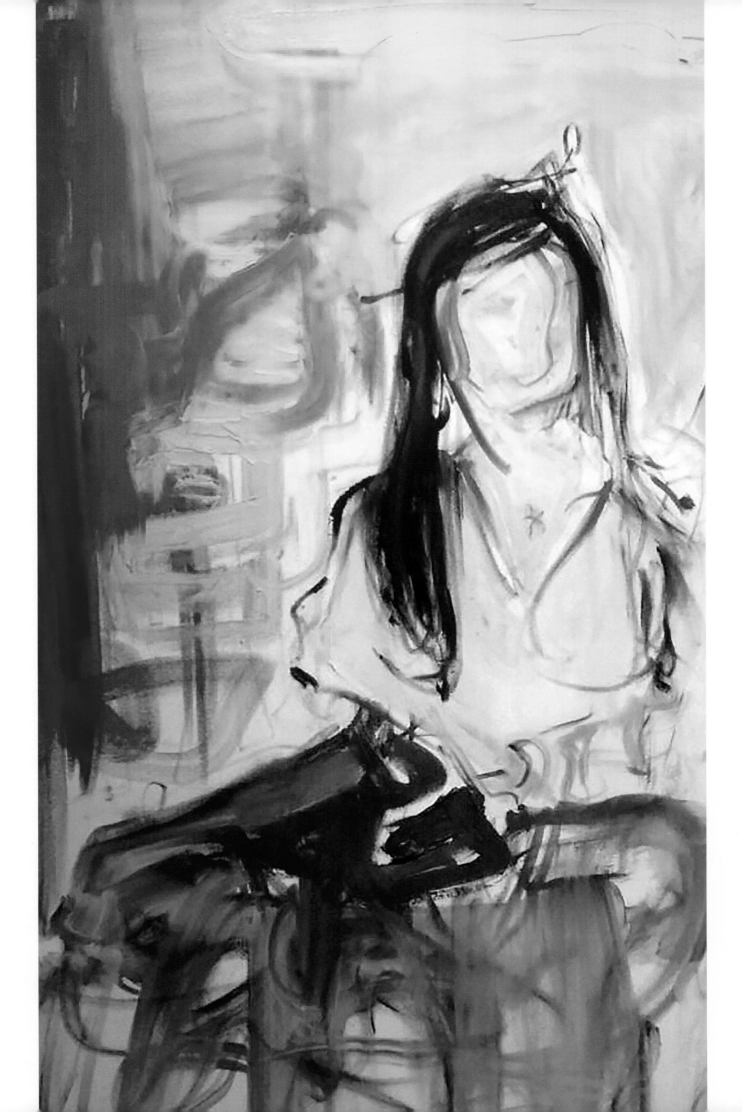

 he taught me to trust myself and value my intuition. I am grateful for the lesson.

I'll never forget the first time I drew a figure, rather a person. I had gone to the live performance of Dallas-based artist Rolando Diaz, and he drew a haunting figure, a face of a woman. In my limited experience as a painter, I had painted only abstracts. Inspired by the beautiful yet tortured woman I had seen created in front of me, I wanted to paint a person.

In the history of art and subject matter, the human form is not exactly cutting-edge or innovative, but for me it was revolutionary. Not only did I question my skill as an artist, but I also felt unqualified to even *try* my hand at something I perceived as so complex. The voice in my head said: "Just exactly who do you think you are? You aren't a 'real' artist. You can't paint 'real' things. Stick to abstracts. Stick to what you are good at."

By this point in my life, after long and ruthless self-exploration, I recognized that voice and knew she lied to me sometimes. She also filtered everything through the shadow of fear. The fear of not being perfect. The fear of people finding out who or what I really was. Would I be abandoned if the "real me" was exposed and my projected image was discovered to be nothing

more than an illusion? This critical voice also loved to distort the importance of the simplest of tasks and repeated in my head, "You are not capable. ..."

But in spite of this critical yet oh-so-familiar voice that had been my constant companion for as long as I could remember, I did it anyway. I drew the human form, my person. While doing so I heard the critic, the voice. Undaunted, I held up self-manifested and earned filters of courage and self-acceptance to experience a tonality change in the voice that allowed me to cut its binds to me and the noise in my head. I felt the fear but pressed forward.

I started with a brush, replacing my trusted painting knife, and conjured a figure out of my subconscious. Her one visible limb was distorted, almost as if her hand had been amputated at the wrist. Her body was on the sturdy side, which surprised me considering my constant preoccupation with being thin. My subconscious figure appeared on the canvas as an "Earth Mother," dressed in a bohemian long skirt that draped over her legs, and she had long, flowing brown hair. Intuitively, I painted the background in the strongest colors I could imagine, using my familiar knives, and rounded her out with three-dimensional oil to add life.

Self Portrait Ghost, destroyed by the artist

I decided to not give my Earth Mother a face as I felt I was not technically skilled enough to do so. Still, her face appeared, and I was fascinated that she commanded two glances—looking directly at me and glancing to the side. Upon reflection, I believe her face appeared from my brush as a symbol of my personal dichotomy. One that many women have had to contend with throughout history. The struggle between my authentic self and my image management obsession.

Mother Earth's manifestation on the canvas and the ease with which she appeared was invigorating. It was as if I knew her from another lifetime. She might have come from a vision I experienced at the end of a particularly intense yoga class while in Savasana. In this state of complete repose, I felt and saw all of my female ancestors dating eight generations back, lifting me up and holding me in the air. They were a unified force, protecting me. I'll never forget feeling so supported, empowered, and loved. I think my beautiful figure, my Earth Mother, was one of these women.

Unfortunately, this artwork, this vision painting, no longer exists. You see, although I had a temporary victory over the critical voice in my mind, in the end, after asking others' opinions and desperately seeking validation, which was not granted, the fear won. She wasn't perfect enough or good enough, so I washed her away with turpentine to reveal white canvas. Just as I had done to myself so many times when trying to run from "not good enough."

I kept a digital picture because, deep down, I loved it, and I have learned to love her more and more as time passes. She taught me a valuable lesson: to listen to the small, quiet voice underneath instead of the loud, desperate voice struggling to survive. Also, the opinions of others are not necessarily relevant, especially since others are mostly judging through their own filter and may not see the same beauty as I do because they are unaware of the context of the work. In a way, she taught me to trust myself and value my intuition. I am grateful for the lesson.

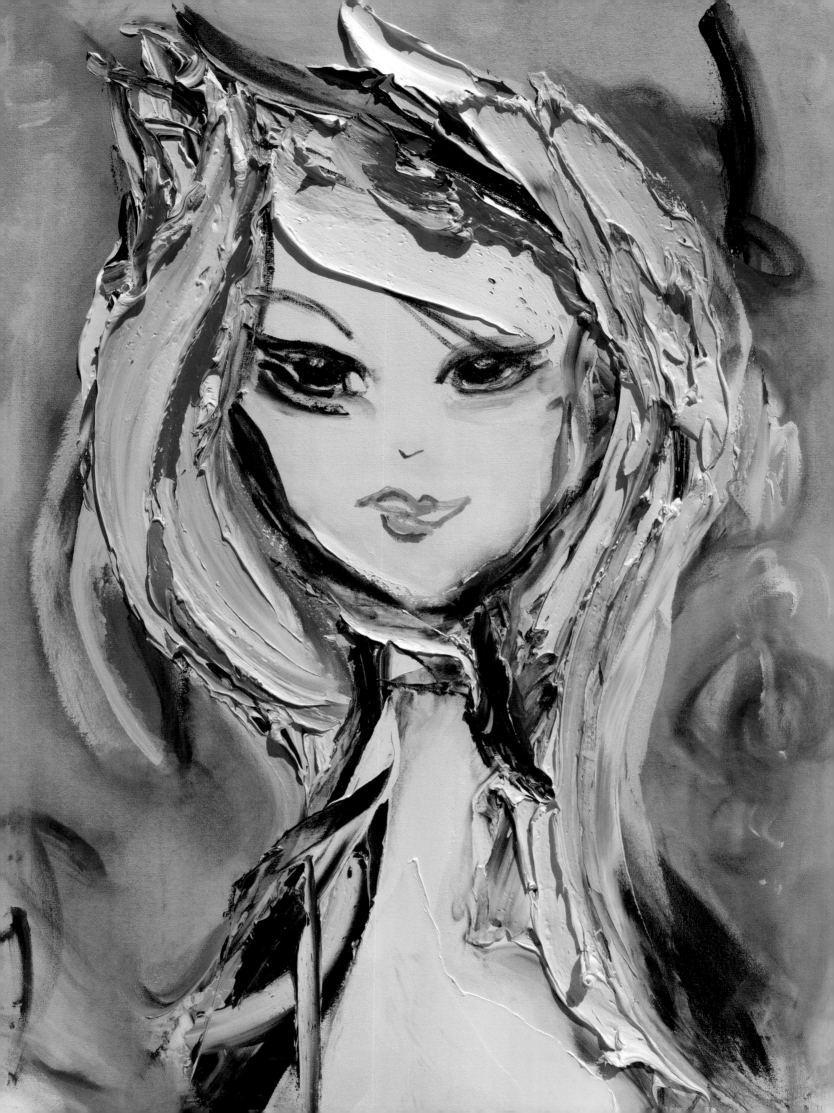

"She's sun and rain, she's fire and ice, a little crazy, but it's nice. And when she gets mad, you best leave her alone, cause she'll rage like a river then she'll beg you to forget her."

— Garth Brooks

Self-Portrait Ice on Fire | 3-Dimensional Oil on Canvas | 40 x 30 in. | 2022
In the private collection of Laura Baldwin

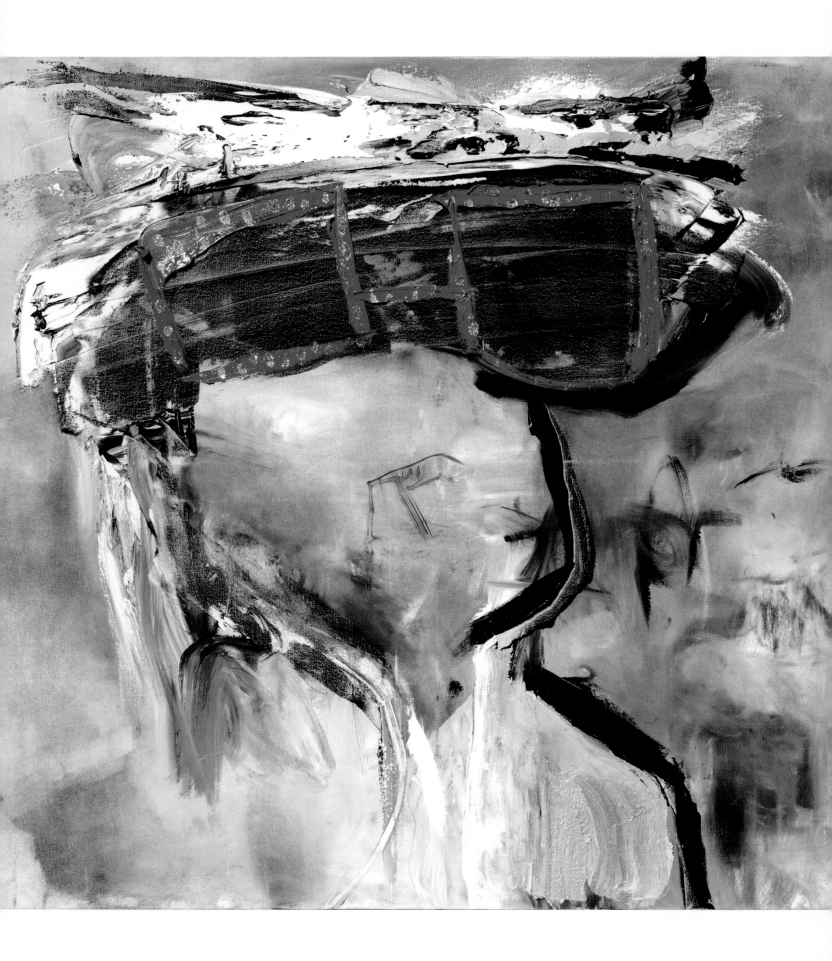

The process of creating this portrait was a real ride. I'd had a horrible week and simply could not motivate myself to get to the studio. I was struggling with a mild—who am I kidding?—a *severe* episode of depression and could not seem to lift myself out of it. I had been weepy for a few days, completely uninspired, and honestly not super productive in any area of my life. I was in a real funk and a real pleasure to be around. After a few days of this pity party had passed and I was tired of my wallowing, I'd finally had enough. I decided I was going to act my way into thinking right and go paint, whether I felt like it or not!

When I arrived at my studio, I had every intention of painting an abstract painting. I began to apply the thick oil to canvas and waited to be guided and granted what we Reflectionists like to call a gift from the universe. As I progressed, it was clear this was not going to be a gimme. The paint did not seem to be behaving and the canvas just was not cooperating. So, I changed my strategy and started using different colors, manipulating the paint, adding tons more paint, and then angrily wiping most of it away. I would get so close to something pleasing ... and then nothing. I would totally "lose touch with the painting," to borrow a phrase from Jackson Pollock.

I was extremely frustrated and almost gave up. I mean, I was throwing a fit, I was cursing, there were even tears. I know it sounds dramatic, but I am sure anyone who has participated as a creative can relate to these theatrics. Then I thought, maybe I was not supposed to do an abstract and decided to use my underpainting and try my hand at one of my portraits. I started to create this character, but I still could not nail it. She was too awkward, remedial, even boring. Finally, I got so livid that for the last several hours of the work I started to just go to town and thrash at the painting without regard or attachment. Ironically, after I did this, I landed on an interesting form. The character was disturbing and haunting, but I liked it ... kind of. Don't get me wrong, it was grotesque but not exactly repulsive, so she lived to see another day. I had created a true reflection of my current energy to be sure. By this time, I was exhausted and frustrated, and I was questioning if the gift of painting the universe had given me had actually been revoked. With reluctant, resentful surrender, I decided to go home and return tomorrow.

The next day, I was determined to brave the studio once more, but on this particular morning, I awoke in a slightly different mood. I felt gratified that I had painted the day before even though it was difficult. I went to

Self-Portrait What a Difference a Day Makes | Mixed Media on Canvas | 40 x 40 in. | 2018
In the private collection of Brad Gorrondona

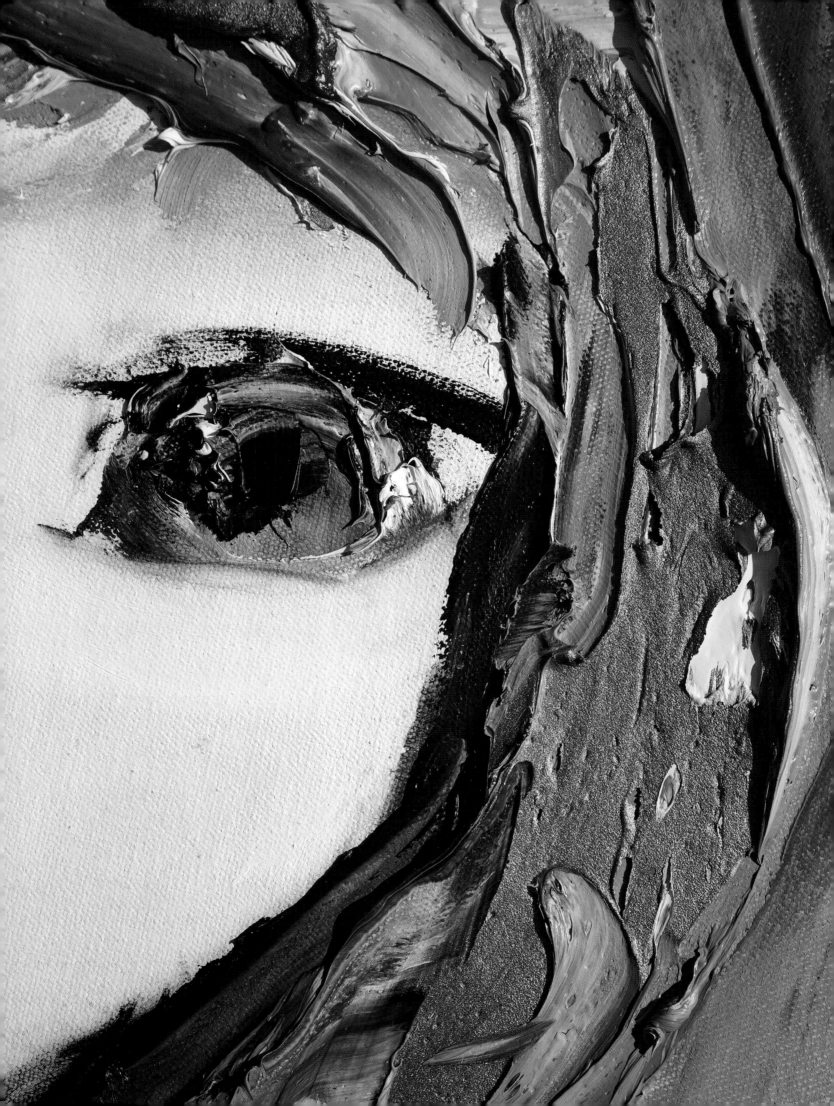

a yoga class, ate a healthy breakfast, and returned to the studio, which seemed brighter and as if the air was lighter. As soon as I laid my eyes on her, I knew exactly what she needed. I painted her red sunglasses, and she was complete. After all of the pouting, complaining, and drama of the past day, she was perfect. It was that easy. I mean ... what a difference a day makes.

But what was the difference? Was I a different artist? The painting certainly had not changed. The only differences were me, my filter, my perspective.

In hindsight, I now know why I had such a different outlook just a few hours later after my torturous studio experience. I believe it was my willingness to do something different, even though every ounce of my body just wanted to stay the same and nurse my misery. I made a mental left turn, got out of bed, and went to the studio. That was it.

This painting session is a specific example, but I have done this many times in my life. The world is actually a beautiful place when I am taking care of myself and doing things such as exercising, practicing gratitude, meditating, painting, and most importantly, serving others. Some days, however, doing all of these things can simply be, at best, overwhelming and at worst, downright impossible. So, on those days, I choose to take one tiny step in a new direction and pray for the willingness to be willing. With this minuscule bit of action, coupled with intention, one can move from despair to courage. But ultimately, if all else fails, sometimes maybe all that is needed is a great pair of sunglasses.

Resource:

I Am Enough: Mark Your Mirror and Change Your Life by Marisa Peer

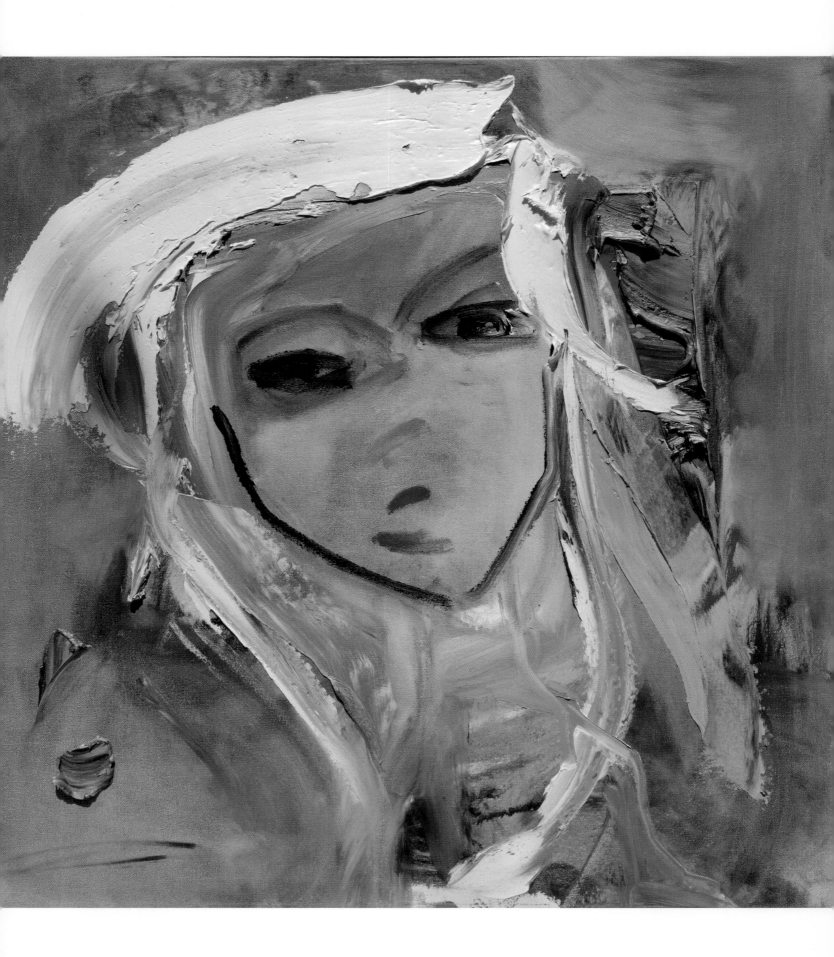

This is the first writing I've done during a very significant personal journey. At the time of this writing, I am in the beginning of a month-long stay in Sedona, Arizona. We, and when I say we, I mean me and the whole of humanity, have been dealing with COVID-19 for the past ten months, and it is also a little less than a week away from the presidential election between Donald Trump and Joe Biden.

For those of us living through this time, I don't think there's anyone who would say life has gone smoothly, on a micro or macro level. Global politics—hell, the world in general—has been disrupted, to say the least, and a society resistant to change under the very best of circumstances has been forced into a new normal with irritating limitations and no certainties. Businesses have been paralyzed, social lives have been stunted, and science has been castrated, as right now truth and facts are negotiable, for sale to the highest bidder. The word "apocalyptic" is casually thrown around and often met with a somber nod of the head, even if one isn't a studious Sunday school attendee at the local First Baptist Church.

It is a fact that rates of alcoholism, domestic violence, and suicides have skyrocketed because of the pandemic, but for me, I almost hate to say it, and I do say it with the utmost respect for those who have suffered during its reign, things have actually been good. When COVID started and the world grew still, I grew still as well—and I had been running on fumes for quite a while. There were no cocktail parties to attend so I read books that were on my "someday" list. As I had less obligations to others, more time could be allotted to investing in my self-development. I am grateful this was the path I chose, and was granted, because as the world as we knew it was ending so was my seven-year marriage. Although as far as amicable separations and divorces go, I could not have been more fortunate, I was still left alone to face myself, and let's be honest here, I had been avoiding *that* confrontation for a long time. That being said, as all perceived normalcies and safety nets on the world stage and in my personal life crumbled, I reintroduced myself to me. Well, hello there, You; it's been a while.

I experienced a good amount of personal growth during quarantine, but in spite of the reading, studying, and meditating I had been doing, I still had a residual energy that needed to be dealt with, and my life still didn't look the way I wanted it to. I still experienced low-grade anxiety and melancholy, which was not exactly debilitating but still frustrating. Despite the fact that

Self-Portrait Quantum Jump | 3-Dimensional Oil on Canvas | 24 x 24 in. | 2020

I had finally moved into a truly forgiving space with regard to my mother, I was still struggling with my sense of loneliness, worthiness, a lack of self-forgiveness, and an inability to love myself unconditionally. So, off I went on an emotional pilgrimage, to Sedona.

Of course, Sedona has a reputation for being an extremely spiritual spot, and people travel here from all over the world to experience healing. I had wanted to visit for a couple of years because, essentially, it was calling me. I really can't explain my draw to this mystical place, but I think I instinctually knew that it had something to show me that I needed to see about myself, and sure enough, the second night I was in Sedona, I received a gift from the universe.

While attempting to fall asleep my second night in Sedona, I did a guided meditation by John Moyer, "Meditation to Shift Your Reality Before You Go to Sleep." This wise teacher spoke about thinking positive thoughts and matching a higher vibration, more in line with a joyful life, therefore shifting into another reality and resulting in what he calls a "quantum jump." I had a revelation that if I replaced my weak, negative thoughts with strong, positive thoughts, I would be happier. I know what you're thinking: "Well, duh (eye roll); I mean haven't we all heard this before?" It's true, John didn't say anything that I hadn't heard before, but for some reason, I heard it differently this time. Maybe it was the delivery or maybe it was the vortexes of Sedona? I don't know, but what I heard was that we have the power to choose our thoughts. In essence, if we are depressed, anxious, or angry, we can decide to think other thoughts instead of our current thoughts and actually change our state, and when we change our state, we change our lives.

Even with massive exposure to self-help modalities and spiritual teachers, my emotions, have made me their bitch ...

As I said, I've heard "change your thoughts, change your life" a million times, but it never sunk in, and when I had been in one of these crazy states, changing my thoughts never exactly occurred to me. In fact, if someone were to suggest it, I would have definitely ignored the advice—or worse.

I have always had a problem regulating my emotions. I learned this from my mom and my aunt, who would melt down at any perceived threat, trusting that the louder, more upset party in a disagreement would win the argument by simply terrifying the opponent with a flood of emotion. There was a lot of yelling and histrionics in my home when I was a child, and with no heathy tools in their back pockets, survival was the basic objective in my family, by any means necessary. Feelings were hurt very easily, and everything was taken personally. It has been on my spiritual wish list to evolve from this unproductive and emotionally abusive defense mechanism, to limit my reflexive reactions and be the master of my emotions for a long while now. Even with massive exposure to self-help modalities and spiritual teachers, my emotions, for the most part, have made me their bitch, or just a bitch, depending on whom you ask.

Critical thinking and analyzing all possible hurtful outcomes in life has offered me shelter from destructive forces and, God knows, I have needed this protection throughout my life, especially as a child. However, now that I am an adult and more capable of taking care of myself, physically and emotionally, this defensive way of thinking is not generally necessary, and it doesn't serve me at present. In fact, I believe it is the number one stumbling block in my personal relationships and prevents me from following my path to bliss. So

here we are, once again. My brain is so conditioned to protect itself, and the majority of my thoughts are about getting what I don't have, being something different than I am, and replaying old mental movies.

But then, like a magical download from Sedona, I was enlightened with the simple solution of letting go of negative thoughts that do not serve me and replacing them with positive thoughts. I came up with a plan to shift my vibration so that it could match the vibration of the reality I aspire to, one full of sustained joy and happiness. I finally think I may be able to release attachments, judgments, and expectations and let the universe unfold as it may, with its infinite possible solutions.

Given this spark of hope, I went to the local crystal shop in Sedona, as all diligent tourists do, and bought the loveliest journal that I could find. Then, I proceeded to dedicate this journal to everything that feels good or that has felt good in the past. In addition, I have decided to write down alternate realities of past circumstances that have been disappointments, literally rewriting my history and giving myself permission to put into words my hopes for my future. In essence, I have decided to write down anything and everything that feels good!

Maybe this is similar to a gratitude journal, but it feels slightly different to me. I am writing down everything that makes me grin, gives me chills, or brings tears of joy. I'm writing about delightful things my dog has done, good times I have spent with people that I love, and laying in the laps of my grandparents as a little kid. I'm writing about vacations I have taken, concerts I have seen, and personal and professional accomplishments that made me proud, as well as sunsets that I told myself I would never forget because they were so beautiful. I am rewriting my history with my past loves and creating space for new love to enter my life. I am rewriting things I have done that, when recalled, make me feel ashamed, visualizing instead what I may have done in those circumstances if I had been armed with courage and faith instead of ego and fear. I am rewriting the story of my relationship with my parents, envisioning an alternate reality where they were well enough to actually provide the security and safety I know they would have given me if they could have.

My goal is that, in time, I can retrain my automatic, protective monkey mind by allowing her to relax and be a little quieter, because she knows we are safe now. Also, I will give her new toys to play with in the form of jewels from our past, acknowledgment of our incredibly fortunate present, and hope for our future as we make our "quantum jump." I will still respect the seriousness of our societal, current-day dilemmas and honor my battle wounds from the past, but I will no longer allow these thoughts to hold permanent residence in my head. The demographic is changing

in the neighborhood of my mind: the hippies are moving in, and the fear mongers are moving out. As I experiment with raising my vibrational frequency to match a blissful, enlightened reality, I will replace worry with wonder and observe what happens as I quickly fall in love with my new, pink satin-covered souvenir shop journal.

The portrait: It is always refreshing when I paint a self-portrait and the character appears to be happy and/or peaceful, as in the case of this piece. It is true that many of the paintings in this series tend to be moody and on edge, but not this one. She is happy and playful and open to possibility, represented by her soft-focused eyes and the relaxed tilt of her head. She has been doing her shadow work and is reaping the benefits of her soul investment. You can almost imagine her stumbling out of a meditation class saying, "Wow, that was incredible. I just took a trip to the center of the universe and back." She is not worried about politics or plagues because, right there in her present moment, all is perfect in the world exactly as it is.

Resource:

John Moyer, *Meditation to Shift Your Reality Before You Go to Sleep*

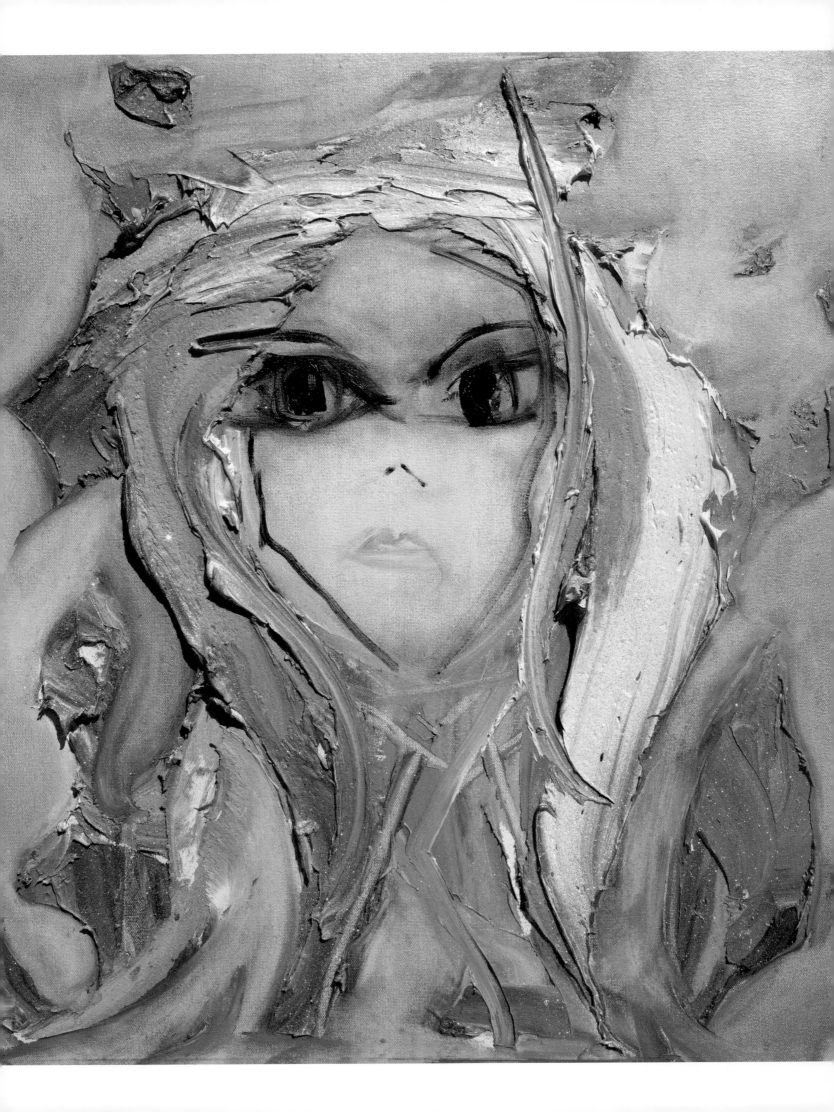

The version of me in this portrait is unapologetically standing in her power. She knows exactly who she is and feels no obligation to smile for the camera like a good girl. She appears to be surrounded by magic, but in truth, she *is* the magic.

I'm not a manifestation of my parents' shortcomings, nor am I responsible for their happiness or well-being. I am not what you think of me. I am not the sum of my accomplishments, profession, or education. I am not my citizenship or my religious affiliation. I am not my possessions or the balance of my bank account. I am not my failures, mistakes, or false starts in this world. I am not my wounds or anxieties. I am not defined by my relationship status or my social standing. I am not my age, the color of my eyes, or my weight on the scale. I am, however, the totality of all these things, but it is only a minuscule fraction of what I have been and will be as I continue on my journey through life.

Overall, I am my circumstances and the experiences of my ancestors, whether I judge them to be good or bad, plus the thoughts I choose to entertain in each and every moment. I am pure creative potential and an integral and necessary part of the entirety of the universal energy. I am consciousness. I am here and I am now. I am who I intend to be. I am intimately connected to everything and everyone. I am music, I am art, I am pain, I am light. I am infinitely everything that ever was and ever will be. I am the unique fingerprint of the only thing that exists or has ever existed.

I am love.

And so are you, by the way.

Self-Portrait Who Did You Think I Was? | 3-Dimensional Oil and Mixed Media | 24 x 20 in. | 2020
In the private collection of Misty & Bill Ried

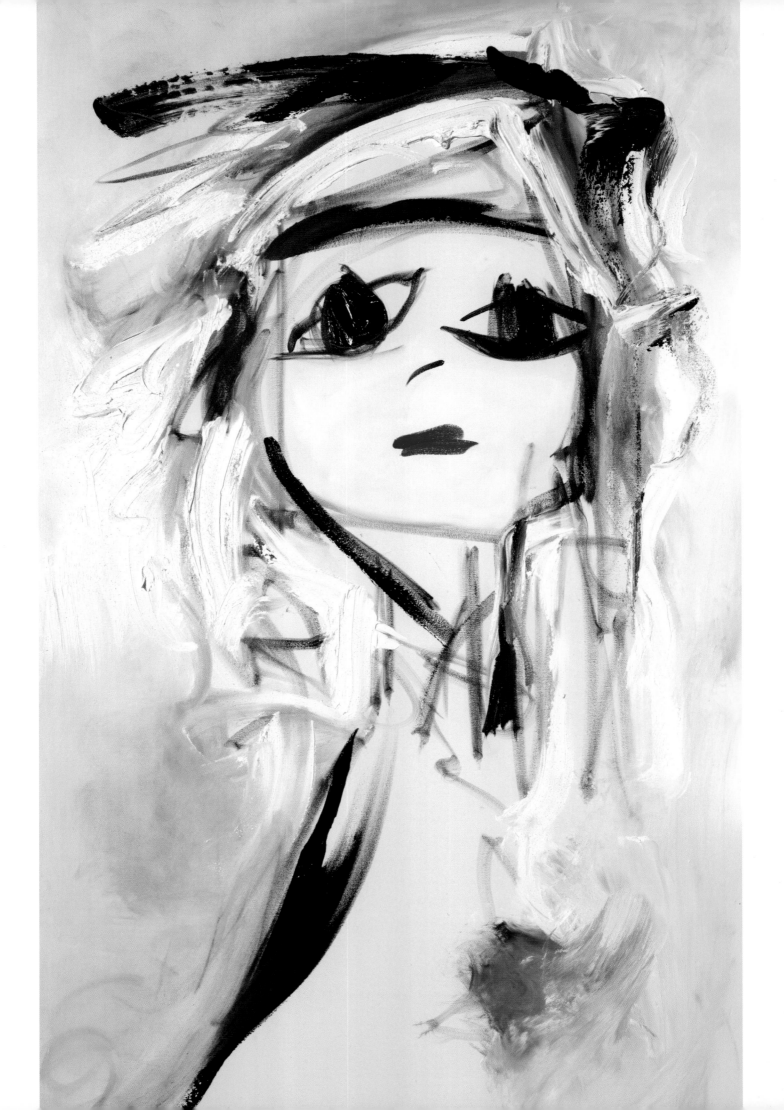

W hat is God to me? I have an innate belief that God exists, but I am still learning exactly what God is ... I do know that God is not religion. Religion is a vehicle we use to explain how we are to relate to and operate under God. God is not spirituality either, as spirituality is more a practice to utilize in order to experience the presence of God.

The idea of God in my family was not congruent across the board. I was taught by my mother and her mother about a Protestant God, or should I say Jesus, God, and the Holy Spirit—the Trinity. They believed, and still believe, in being saved and that Jesus died for our sins and that at some point he will come back to this earth in the second coming, and dead Christians will be resurrected, and living Christians will be scooped up and taken to heaven. As for the rest of humanity, they will be left here for a thousand years during a time of tribulation. If they then choose Jesus during this period, they can join the others in heaven, but if they don't, it's off to burn in Hell for eternity.

I attended a Baptist school where I learned this theory and was well indoctrinated in the book of Revelation. In my school, they had a massive oil painting detailing the destruction of the world at the moment when Jesus comes back. Car and airplane crashes, skeletons floating out of graves, and other spirits leaving the "nonbelievers" behind as they ascended skyward to meet Jesus. I can still see it vividly in my mind, and, oh man, did it scare the shit out of me!

I believed this narrative at the time, with my thirteen-year-old mind, and it was perfectly plausible within the sanctuary of First Baptist Academy. As I started to ask questions, however, there were certain facts and ideas I couldn't reconcile. For one, it became difficult for me to accept the Bible in its most literal sense. It was fine if I kept myself solely under the umbrella of the Baptist church, but as soon as I started to become aware of the other denominations and branches of Christianity, I realized the interpretations were vastly different. Wars have been fought over these differences for thousands of years, and I am well aware I am not going clarify the nuances of religion here in my humble little art book, but I will say: I don't identify with my Protestant roots and all they entail.

My father's side of the family was very different regarding their views of God. My grandfather was Jewish, and my grandmother was Episcopalian. It was a scandalous union at the time they got married, in the sense that it was certainly frowned upon that one

Self-Portrait Caught Me on a Good Day | 3-Dimensional Oil and Mixed Media | 60 x 36 in. | 2018
In the private collection of Katy and Lawrence Bock

would marry outside of their religion. Rebels they were! However, my grandfather, the highly intellectual man that he was, rejected the Jewish religion as he just could not make the leaps of faith, or perhaps logic, required to embrace religion. I wouldn't go so far as to say that he was an atheist, but I suspect he was an agnostic who really didn't care to think about it too much. My grandmother did identify as a Christian but was not entrenched in her beliefs. Whatever the case was, my father and his siblings were free to choose their own faith, and they did just that.

For me, I like the idea of Judaism. I like the traditions and lean into the tight-knit community. I celebrate the high holidays with my Jewish friends when I have the good fortune to be invited. I like how, at least in the Reformed communities, tolerance and acceptance are integral to the faith and individuals, and proselytism is discouraged. If I had to choose a religion to belong to, it would be Judaism. Alas, I still do not feel the call to join a synagogue and commit myself to this way of life because, although it is nice and reminds me of home, it doesn't quite fit me either.

So, what does fit? What works for me is to take the bits and pieces of what feels right in my deepest knowing and create my own version of God, one that I can live with and count on. I like to know that my idea of God can evolve as I change and that he/she/it will accept me unconditionally and provide me with exactly what I need in the moments that I need it. And you know what? This works for me.

I like to pull from a more enlightened version of

Christianity, focusing on the Christ consciousness learning from *The Course of Miracles* and the teachings of the Unity Church. The idea of a higher power that is often referred to in the twelve-step community (i.e., "a Power greater than ourselves") also resonates with me. To be honest, I was pretty traumatized by all the fire and brimstone stories I grew up with, and for a long time I really just wanted to deny the existence of anything that had to do with God. The "higher power" concept just gave me a tiny bit of space to be open to something greater than myself, no judgment, no shame, just an opening to a possibility.

I find Eastern religions and spiritual traditions, such as Buddhism, Hinduism, and Taoism, to be fascinating and powerful as well as rich in wisdom. I believe the pagan tradition has much to teach me about the majesty of the earth and my place on it as I honor my sacred femininity.

So, give me your religion, explain to me your spirituality, and teach me your traditions. I want to see it all. However, I need to let it be known—I will adopt what is useful to me and turn away from the rest. My spirit does not tolerate doctrine armed with shame for the purpose of control, nor do I accept that God hates anyone, so that ideology will not be a part of my personal construct of God. In addition, I do not believe God is sitting on a cloud watching me, waiting to judge my every action and thought. My soul staves this concept right out of my consciousness.

The one question I have when examining if something is going to fit my definition of God is, does it lead to love? Love is the one thing we all want, the one thing that we all need, and it has been like this for us humans

> Love is the one thing we all want, the one thing that we all need, and it has been like this for us humans for the entirety of history.

for the entirety of history. Everything we do, all that we work for, is all in the hopes to move closer to love. So, my definition of God, whatever it is for me at any given moment, will always reflect love at its core. My definition has been so very different throughout my life, and I want to say that just because my version of God has changed, it does not invalidate my past versions of God, as they have carried me through both hard times and good times. Whatever I call it, however I philosophize around it, however I ritualize it, even if I am in denial that it even exists, it is always the same—it is love.

I know that there are those who are reading this who are feeling very sad for me right now because they feel that because I do not believe in the same version of God that has been taught to them, it means I am going to hell. Or even worse, that I am evil and God's enemy and by association, their enemy. Believe me, I know this line of thinking all too well because it was coded into me for a very long time. But let me say this: if this is you, and you're willing to make a little room in your heart to accept me, I will do the same for you. The loving God I have a relationship with is big enough to accept all of you, even those parts that are different from me, and your sacred beliefs. Is yours?

So, what is God? I mean, who knows, really? I certainly cannot give you a solid definition. But, when you catch me on a good day, I can tell you what God feels like, and I can tell you how God has influenced me. I can tell you about our conversations and watch your face as you look at me with confusion or skepticism. I can attest that God is patiently, but persistently, nudging me to be of service to those less fortunate than I am. I can see versions of God in the trees and my little dog and the moon. I don't know, maybe on a good day the appropriate question is not what is God but rather is there anything beautiful that is *not* God?

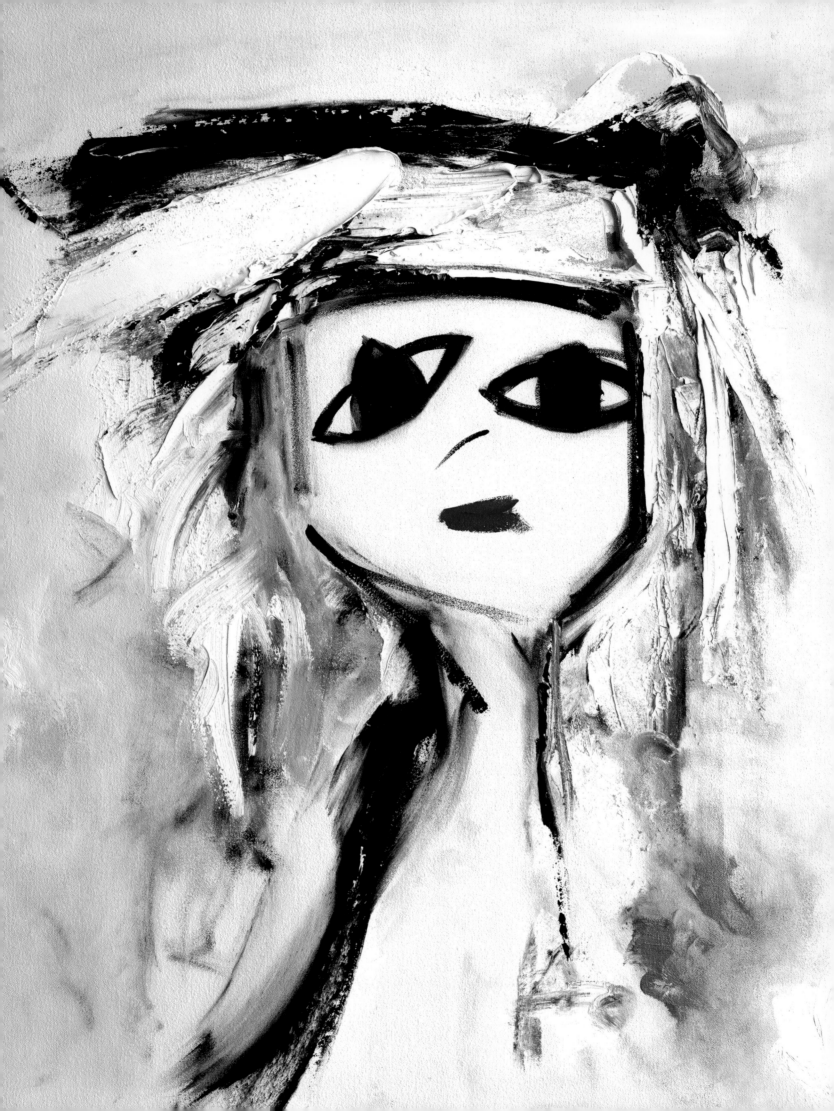

This was my father's favorite prayer, and I have to say it is mine too. Some spiritual thoughts simply transcend religion, doctrine, and human limitations. Some of these rare, divinely inspired messages gifted to us by the all-knowing and mysterious universe stay with us and quietly guide us in our most vulnerable and solitary moments. For this, I am grateful beyond measure.

> Lord, make me an instrument of your peace:
> where there is hatred, let me sow love;
> where there is injury, pardon;
> where there is doubt, faith;
> where there is despair, hope;
> where there is darkness, light;
> where there is sadness, joy.
>
> O divine Master, grant that I may not so much seek
> to be consoled as to console,
> to be understood as to understand,
> to be loved as to love.
> For it is in giving that we receive,
> it is in pardoning that we are pardoned,
> and it is in dying that we are born to eternal life.
> Amen.

—Prayer of Saint Francis

Self-Portrait Caught Me on a Good Day II | Mixed Media on Canvas | 30 x 24 in. | 2019
In the private collection of Teresa & George Meza

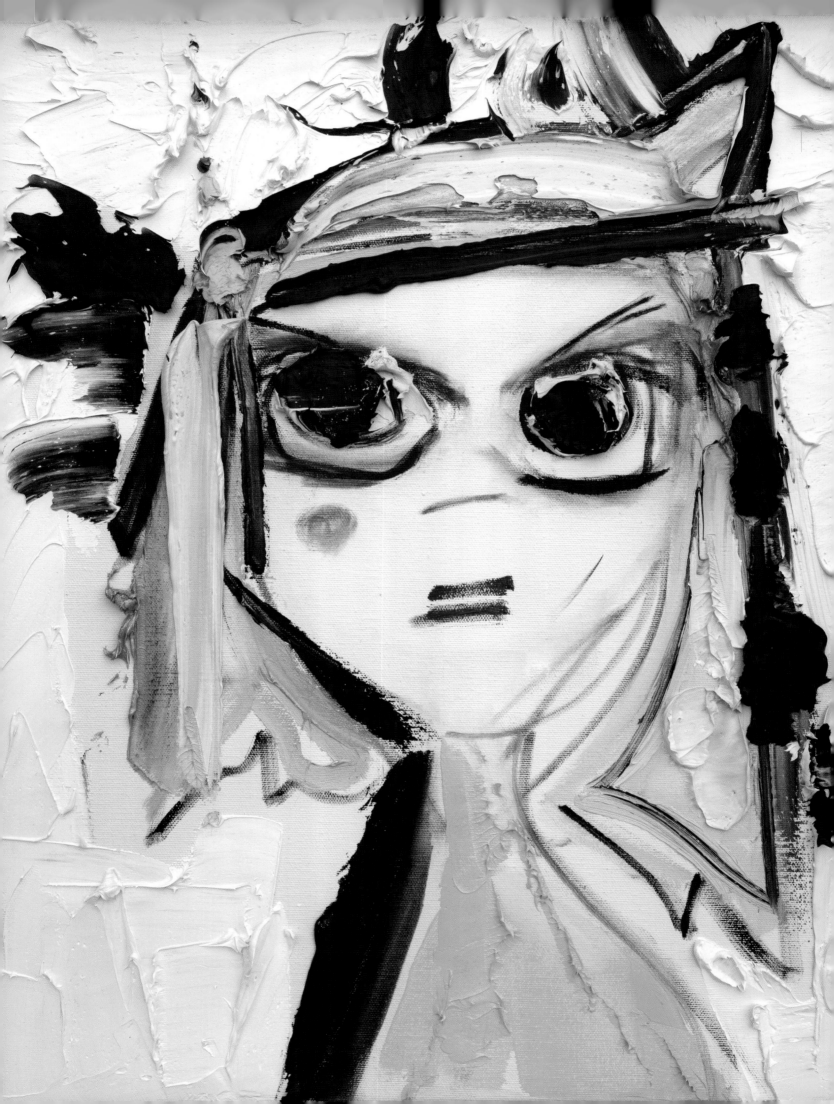

When I decided to get my DNA tested through 23andMe, there was a part of me that hoped the results would show that I had something shocking in my lineage—you know, something spicy. Just give me a little Egyptian, Samoan, or Moroccan for goodness' sake! Of course, the test came back with what deep down I already knew—the results showed that I am, in fact, so very European. Different flavors of European but, nevertheless, pretty much as white as you can get. The one little surprise I was granted is that I am 0.02 percent Asian! I thought this was pretty cool. I had certainly never suspected this, and it got me thinking. If I didn't know this about myself, what other things are there about me that I am clueless about? Who am I?

For the first half of my life, I did not care so much for this existential question. Life was much more about survival, avoiding pain, and experiencing as much pleasure as possible. Now that I have some hindsight, I have the privilege of observing my past self, observing how I have created my life and exploring if I want to continue on the same trajectory. So here we are. I find myself wanting to examine this line of questioning and was inspired by Mark Groves on his podcast.

What do I stand for? Not what I think I stand for but what do I REALLY stand for? What am I ignoring or not paying attention to? Am I honest with myself? Am I honest with others, and if not, why? Am I happy, and if not, why? Who am I not forgiving? Have I forgiven myself? Am I honoring my body? What is love? Do I love myself? Who am I? Who am I REALLY?

I wonder: do I really want to know who I am, and do I have the courage to stay the course to hear my own answers? I guess we will see. The ironic thing is that much like the fact that I am 0.02 percent Asian, the answers to these questions are a reality that exists whether I avoid the questions or ignore the answers. So, I believe I will try to answer these questions to the best of my ability because I think that is just what I need to do to navigate through this weird world. I know this will result in more questions and more answers, and then more questions and then more answerers, and so on and so on, but that's OK with me. I'm well aware this whole life thing is just a crazy joyride, but now I want to take the blinders off so I can enjoy the scenery.

Reference:

Mark Groves Podcast, hosted by Mark Groves

Self-Portrait .02 | 3-Dimensional Oil on Canvas | 20 x 16 in. | 2018
In the private collection of Terri Provencal

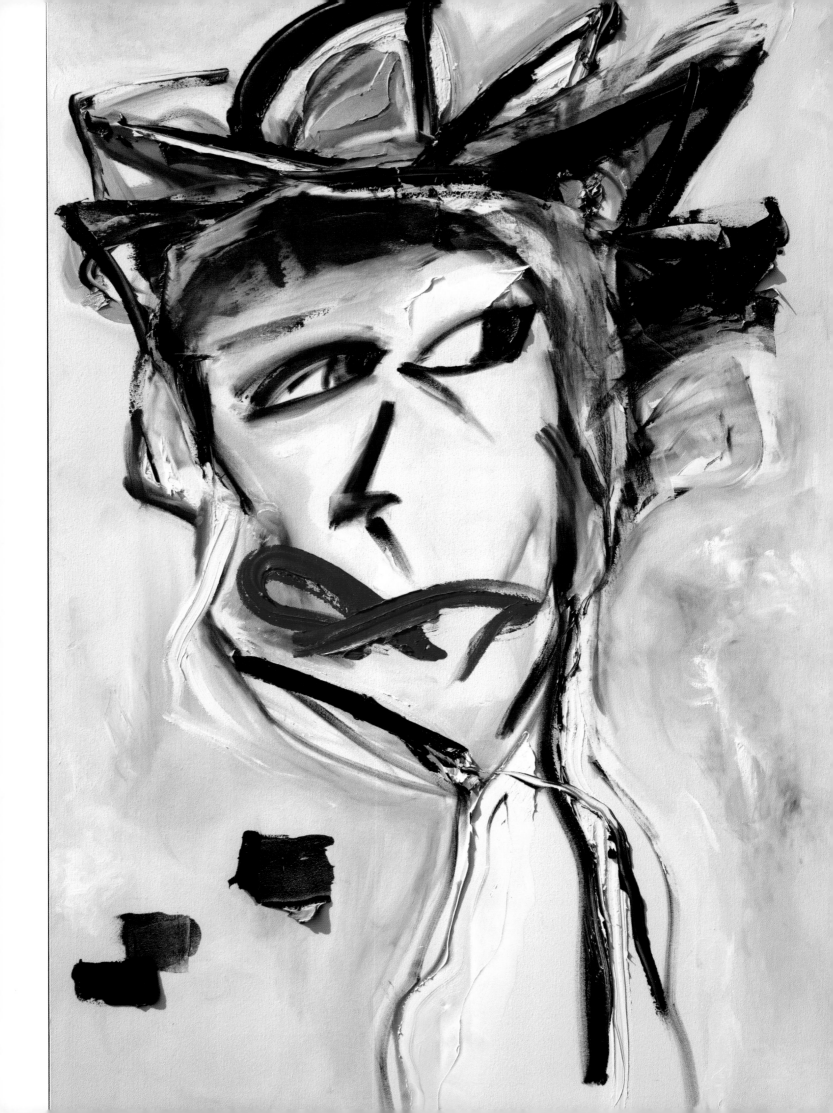

Scene: One early morning at hot yoga the instructor began to tell a story ...

One sunny afternoon a woman purchased a brand-new Maserati and decided to visit the local grocery before heading home for the evening. The parking lot was packed, as this was a popular time for shoppers, but nevertheless, she decided to park right in the middle of two parking spots so as to protect her new purchase. While she was in the store, a rouge sharping cart rolled through the parking lot and smashed right into her driver's side door, resulting in a not catastrophic but nonetheless obvious blemish to her new, pristine car.

As I was at the end of a yoga class, beaming with satisfaction that I had finally reached corpse pose, my immediate reaction to this story was wow, how inconsiderate that she would park in two spots with absolutely no regard for the other shoppers there. It served her right for being so selfish and an uptight control freak. It's kind of funny that the universe sent that cart to teach her a lesson. This narrative of mine was automatic, and believe me, the irony is not lost on me that I am having these thoughts at the end of a yoga class, and I am supposed to be all Zen, connected to the universe and God and everything, but just as quickly as I had this thought, my yoga instructor added to the story.

She said that what was interesting about this story was not what this woman had done but our responses to it, our judgment. I mean, how did she know that we were going to be judging this fictional lady? Was she a psychic or something?! I think not. No, this teacher simply knew that it is in our nature to judge others without awareness and higher levels of consciousness. She was giving us, her students, a chance to reflect on our automatic, judgmental monkey minds, and boy, did she nail me. I was prime for the pickin' and scooped up exactly what she was laying down. This was an excellent reminder for me to examine myself and my habits, so let's do that.

It is good to be able to assess a situation and make prudent judgments in life, and this skill has unquestionably allowed me to make decisions and protect myself from potential threats. However, this critical thinking ability has spilled over in certain circumstances, and I, unfortunately, have the tendency to look at others and form my opinions about their actions, choices, clothes, careers, and romantic situations, among many other things.

So why do I do this? For one thing, I do it because we all do, we are all judgmental of others at times. We need not flagellate ourselves over this fact, but I do think

Self-Portrait Side Eye | 3-Dimensional Oil on Canvas | 72 x 48 in. | 2018
In the collection of the Lorenzo Hotel, Dallas, Texas

we owe it to ourselves and others to at least examine this behavior. I think we would all agree that if we really thought about it, this behavior does not serve us well. I will focus on me here but maybe as you read this it will resonate. If it doesn't, no big deal; take what you like and leave the rest. God knows, I am not the authority on nonjudgmental behavior, not even close!

So, what exactly am I doing when I make snap judgments about others, negatively or positively for that matter? Essentially, I am looking at them and their behavior and comparing myself to them. Do they stack up to my moral high ground or social standards of how life is to be lived? Do they do life the way that I do, and if they don't, are they doing it worse or are they doing it better?

There is something so satisfying to my ego when I compare myself to others. An analogy to this mental exercise is I am on a ladder, and everyone is either on a rung above me or a rung below me. In either case, I get a mental payoff. If the poor soul is further down the ladder than I am, I assume I am doing better in life, looking more attractive, treating people better, or just better in general. In essence, I get to feel superior. On the flip side, if I observe someone and judge them as more attractive, more successful, more creative, etc., I get to beat myself up and indulge my masochistic, perfectionist tendencies while validating my thoughts of unworthiness. Therefore, I would like to make the case that judging others is actually one of the most selfish activities I can participate in, comparing others to my standards and deeming them worthy or not worthy.

So today in my life, I strive to be a better version of myself than I was yesterday. It is my intention to reach toward love, compassion, and acceptance. I have

chosen to examine my tendency to judge and possibly do a little better than I have in the past. Here are some points I am keeping in mind as I work toward progress not perfection in this area.

Focusing on others in this manner is wasting precious energy I could otherwise invest in my spiritual and personal development. With all that extra time and headspace, I can be meditating and educating myself in order to sharpen my skills at observing my thoughts while focusing on gratitude and forgiveness.

It may be helpful to notice exactly what is triggering me to judge. This is useful information to me because it pinpoints the areas in my life that need attention and healing. If I am negatively judging a person, it is normally because I am recognizing a part of myself that I am ashamed of and noticing it in them. The reminder elicits my negative response and judging them is easier than turning attention to my own behavior where I would have to take responsibility for my own thoughts and actions.

The goal for me, one day at a time, is to interrupt my habitual thinking pattern when I notice it.

I am in no position to judge because have I done things I am ashamed of, things I never thought I was capable of doing, violating my own ethical code only to excuse it because of my particular circumstance. Instead of judging, I can ask myself, "Self, do you have your life totally together? Are there things in your life that need improvement? Do you always treat people with kindness and respect? Do you take offense easily and take things personally? Are you taking responsibility for your physical and emotional health? Are your relationships with friends and family healed and peaceful, and have you made amends to those you may have injured or forgiven those who have injured you? Are you a good steward of the earth, and are you doing what you can to be a good citizen? Do you give back to those who are less

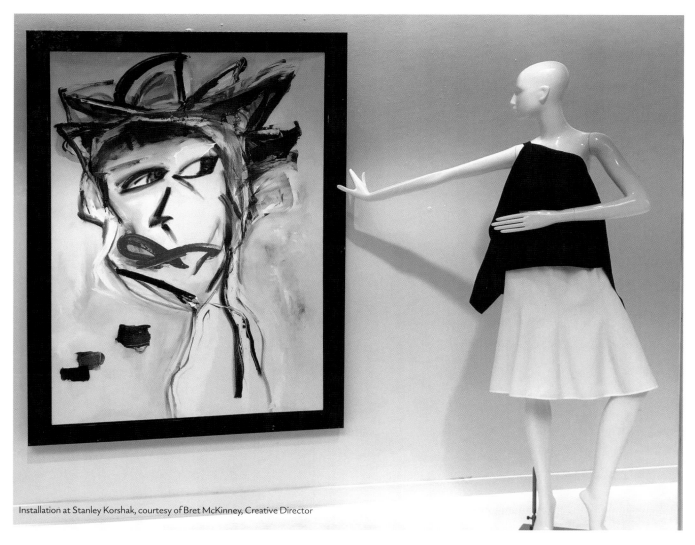

Installation at Stanley Korshak, courtesy of Bret McKinney, Creative Director

fortunate than you are? Are you kind to strangers, and do you treat them with respect? Do you educate yourself on controversial subjects, and do you truly listen to people you may not agree with in order to make informed decisions not based on your opinions and social conditioning? Have you faced your addictive tendencies?" Although this is not an exhaustive list of what I should pay attention to, it is a good place to start when I have the urge to focus on others' behaviors.

I don't know what is best for other people, nor do I know what others have been through or are currently experiencing that is causing what I perceive to be their faults. The truth is, I don't know people's stories, and everything I think I know about them is through my filter. Indeed, I do not know people's circumstances or what kind of day they've had or what kind of life they have endured. Given the same conditions, it is very arrogant of me to think I would not act in exactly the same way they have.

I will be gentle with myself if I am not able to permanently correct my judgmental attitude, and I will learn not to judge myself too harshly if slip into old behavior out of habit. I accept that it is not easy to change these patterns, and I am certainly no expert or guru. For me, it will have to be enough that I am giving a valiant effort by watching my thoughts and noticing when my judgmental attitude arises. The goal for me, one day at a time, is to interrupt my habitual thinking pattern when I notice it.

Who knows? If I can heal this toxic habit of judging those around me, I may actually get something my soul has craved for a while now as a result—grace.

Resource:

The Power of Intention by Dr. Wayne W. Dyer

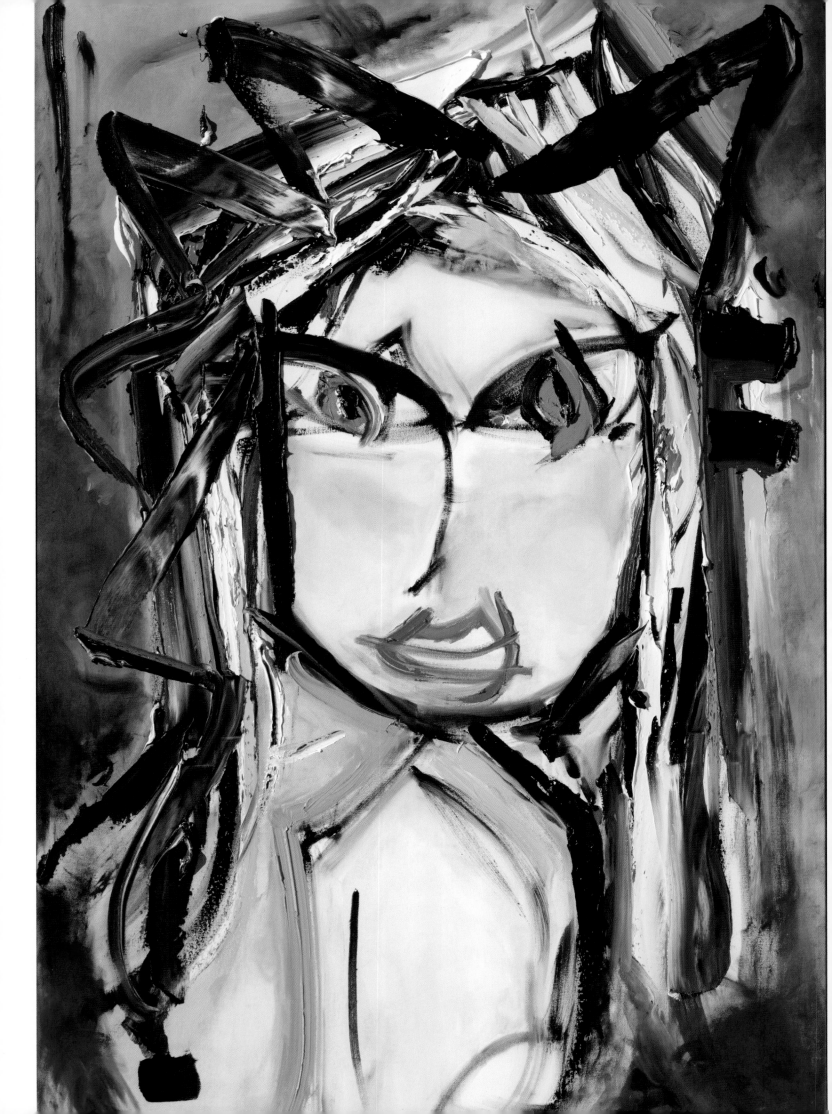

"**W**ell, I must endure the presence of a few caterpillars if I wish to become acquainted with the butterflies."

—Antoine de Saint-Exupéry, *The Little Prince*

Self-Portrait 2826 | 3-Dimensional Oil on Canvas | 84 x 60 in. | 2017
In the private collection of Kris & Mark Bradford

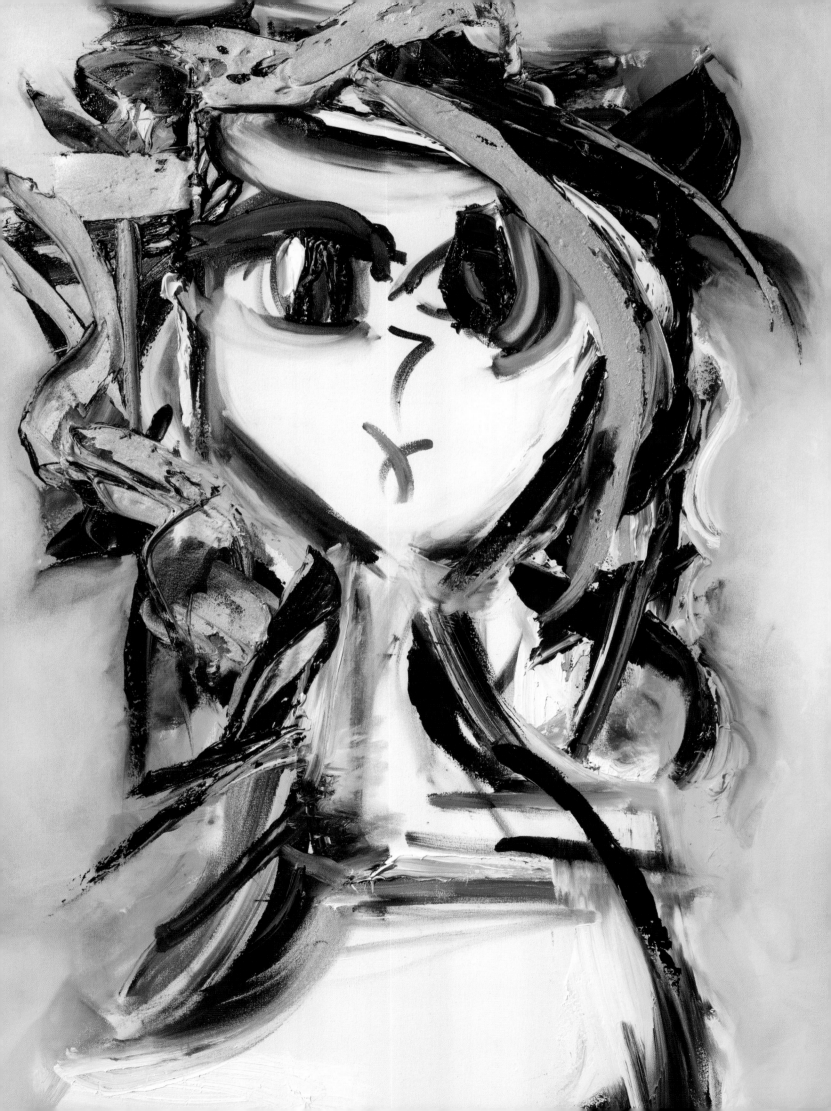

To my Past Self,

I want to start out by saying that I sincerely apologize for not communicating with you sooner. I have spent much time and effort attempting to not think about you. I can't lie: I have felt a lot of embarrassment about you, and I recall there were times I just wanted to pretend you didn't exist at all. I haven't spoken to others about you very much either, or if I did, I altered the truth much of the time, as I have been worried about what they might think of me because of your actions. As of late, however, I have come to understand you a little more, and there are some things I would like to tell you.

To begin, I'm not going to criticize you anymore. Because I have the benefit of hindsight, I now realize that much of what you did was because you were in pain, and you were mostly just trying to be seen and heard. You did the very best you could with the tools and experience you had. It wasn't your fault, so no more picking on you, OK?

Also, it is glaringly obvious to me now that what you wanted more than anything else in the world was to know you were safe and beautiful and to be accepted and loved unconditionally. I can see how hard you tried to get this assurance from other people and how difficult it was when, even when you received all the praise and adoration the world had to give, you still couldn't feel it deep inside. I wish I could travel back in time, sweet girl, to let you know that this was never the job of others. This acknowledgment was always supposed to come from me. But, since I can't time travel, I would like to make that up to you now, in this letter.

I want you to know how very grateful I am to you for never giving up on life and continuing to move forward, even during the really rough times. You were pretty brave on more than a couple of occasions, and I want to acknowledge that. Also, good job on committing to educate yourself and following your dreams, even when your goals were lofty. That took a lot of effort, but you did great. I'm really proud of you.

Additionally, you have been kind and compassionate when the people you care about have needed you, and I know that you have valued the people in your life. Hey, you must have been pretty great because you were surrounded by some spectacular humans. You know what they say: birds of a feather flock together.

Self-Portrait 1995 | 3-Dimensional Oil on Canvas | 48 x 36 in. | 2018
In the private collection of Ujwala and Nilesh Katkade

And, lastly, I just want to say that today I accept you unconditionally, and I no longer wish to forget or deny you. You are beautiful and interesting and oh-so ironic. I will never abandon you again, and I look forward to consulting with you as we move forward through our unknown future destinations. Thank you in advance. I have a feeling your wisdom is going to be a great help to our future self. I haven't met her yet, but I have a feeling she is going to be super cool.

Your friend,
Lea

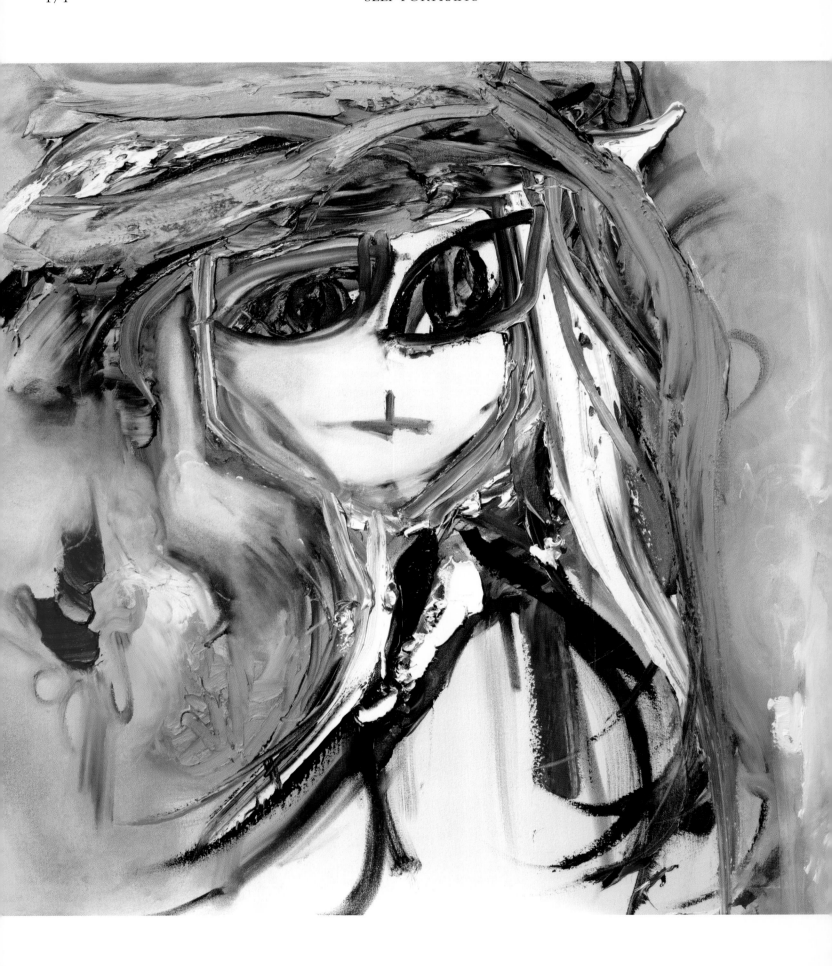

When I am old, I hope I still create. I want to sit in a field and paint flowers, mountains, and ocean waves. I hope I wear flowing caftans with big hats that shield my face from the sun, and I hope I sing, even if I sound like dying cats. I hope I still have something interesting to write about.

When I am old, I hope I finally, fully understand forgiveness. I hope to have let go of all the resentment I have carried and made amends to all the people I have wronged.

When I am old, I hope I finally understand my mother and her life's journey. I hope I will see the beauty in her pain and suffering and learn to think of her fondly and with overwhelming compassion.

When I am old, I hope I can finally let go of my self-obsessed vanity and truly accept myself as I am. I hope I am a few pounds overweight, wear comfortable shoes, dye my hair pink and blue, and do not give a damn.

When I am old, I hope I eat tons of chocolate cake with strawberry filling and use extremely shocking language at the most inappropriate times, causing people to giggle.

When I am old, I hope I look back on my life with the certainty that I have been helpful to others and believe the world is a bit better off because I have been here.

When I am old, I hope I still have some of the girlfriends I have now to laugh with, and I hope we are able to remember all of the crazy things we did when we were young.

When I am old, I hope I will have known every form of love the world has to offer, most importantly self-love. I hope I finally love myself unconditionally and am undeniably sure of my worthiness.

When I am old, I hope I will have had the courage to take chances and be free of regret.

And finally, when I am old and leave this bizarre, terrifying, exquisite existence, I hope I leave with the dignity and grace of my grandfather and the courage of my father.

And when I am done with being young and being old, I hope my final destination lets me see God, and I hope at some point in my life I have called her or him by the right name. I also would like to see all the people and pets I have loved in my life in the form of a glorious reunion.

Self-Portrait When I Am Old | 3-Dimensional Oil on Canvas | 24 x 20 in. | 2020
In the private collection of Jessica and Jim Courville

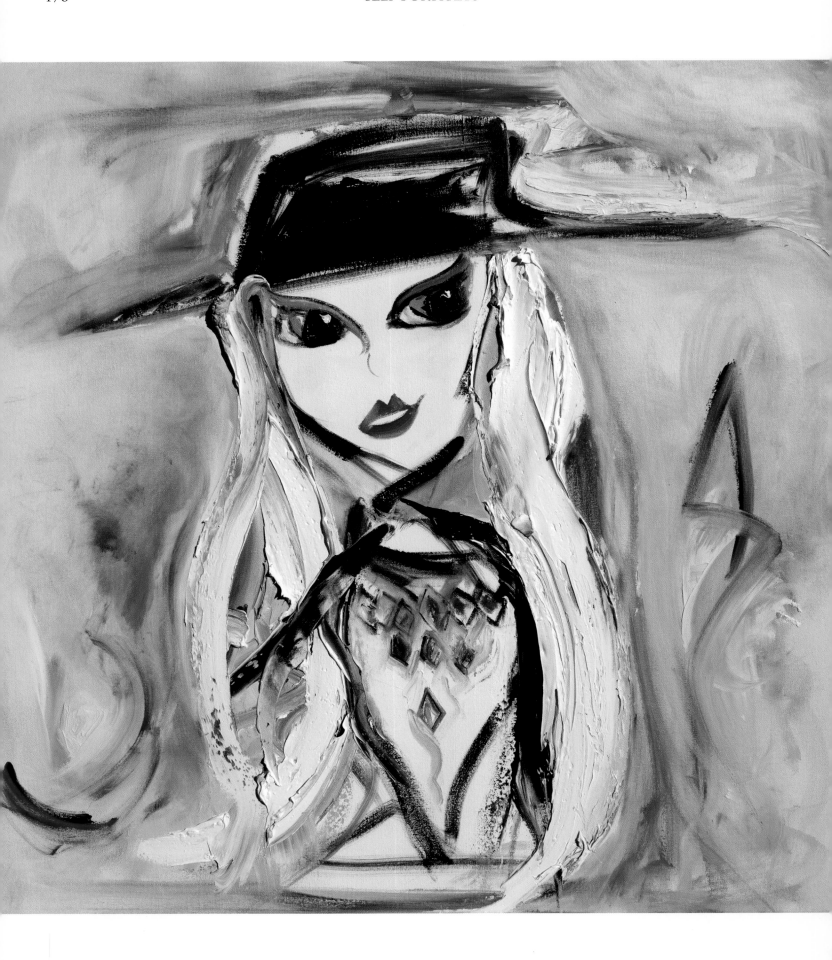

This was the first self-portrait I was commissioned to create, and I have to say, it was a fascinating experience. In the summer of 2021, Scott Miller and Sharon Virts, good friends, clients, and owners of Amlés Wines, hosted me in Napa Valley so I could visit their vineyard and discuss their vision for the commission. They planned to release a Bordeaux-style Semillon Sauvignon Blanc in early 2023 and wanted one of my paintings featured on the bottle's label. I was thrilled they chose me to do the artwork as an evolutionary follow-up to JD Miller's labels for their 2018 and 2019 Reflectionist Cabernet Sauvignon.

From the beginning, the three of us unanimously agreed that she had to be different than my previous self-portraits, a little less moody but not too whimsically dreamy. We wanted her to be California cool with the effortless spirit that is so familiar to the West Coast culture.

As I painted with this vision in my mind, she appeared graciously while I imagined her sitting and enjoying the ocean view. Relaxing with a beautiful glass of wine as her brim hat shields her from the midday sunshine, this lady is playfully carefree and grateful for this fortunate moment in time. Oh, yes, I know her well, as I have been her many times. California has always held a special place in my heart.

It was my honor to collaborate with Scott and Sharon on this painting and to be involved with such an extraordinary company that truly embodies the creative spirit, and in addition, to be included in this world-class group of artisans and craftsmen to add our imagination, innovation, and experience to these Amlés wines.

Scott and Sharon are both fiercely entrepreneurial but have closed their highly successful chapters in the competitive worlds of high-tech and government contracting. Philanthropy is the real driving force of their lives now. Central to Amlés is a firm commitment to supporting arts, healthcare, education, and historical preservation through philanthropy. Every bottle of Amlés will support communities in need in both Virginia and Northern California, two places that have become integral to Sharon and Scott's lives. To date, the Virts Miller Foundation has supported over 30 organizations.

Self-Portrait Amles Wine | 3-Dimensional Oil on Canvas | 40 x 40 in. | 2022
In the private collection of Sharon and Scott Miller

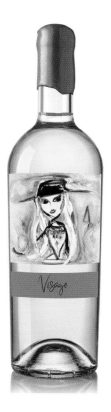

I wholeheartedly agree with these visionaries and their philosophy, which states that the meaning of life can be found in giving, and when skills and resources are utilized to contribute to the well-being of others, life is richer for it.

Along with her work for the foundation, Sharon is a fellow creative. In addition to being a painter and follower of the Reflectionism school of art, she is also an author of historical fiction. Her first novel, *Masque of Honor*, was released by Rosetta Books and distributed in print by Simon & Schuster in February 2021.

How privileged I feel to be living this life with people such as these. To be creating this art with like-minded souls is more than I could have ever dreamed of as a child. It just goes to show you, if you dare to follow the whisper of dreams, there is no telling what remarkable people may accompany you along your path.

Resource:

To learn more about Scott Miller and Sharon Virts and their expansive journey of creating Amlés wines, please visit amleswines.com.

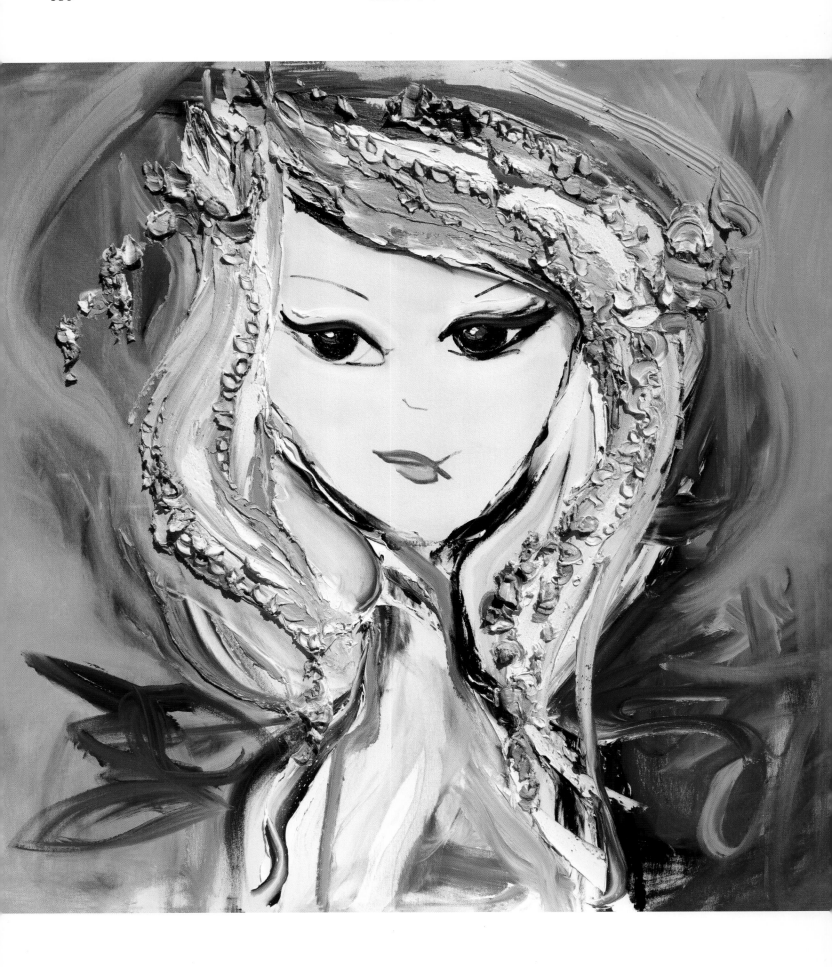

During the beginning of the Covid-19 pandemic in March 2020, I started leaning heavily into self-development because, whether I liked it or not, I suddenly found myself with lots of alone time on my hands. As fate would have it, I did like it, and it was one of the most expansive periods in my life.

At that specific time, I had separated from my then husband, and we were well on our way to getting a divorce. This opportunity for reflection and self-care came at the perfect time, because, God knows, I needed to reflect on my relationship and take a sober look at myself to see how I contributed to the breakup of my seven-year marriage.

I did quite a bit of self-study during those months. I talked with a therapist, over Zoom of course, while taking a deep dive into all things self-help, and upon reflection, not a minute of that time was wasted. But maybe one of the most helpful tools I utilized during this time was listening to podcasts.

The first time I ever actually listened to a podcast was during Covid, and I have to say, I was completely hooked from the beginning. Suddenly, a world filled with like-minded people was at my fingertips, and instantly I had a host of new friends there to educate and enlighten me. As I'm sure we can all relate, it was an isolating time, but the voices I was hearing provided the support and companionship I needed at that very moment.

I loved this podcast world so much—so raw, unedited, truthful, and real. I heard these brilliant people sincerely being brave and vulnerable, and I felt like they were doing it just for me. Their commitment to education and enlightenment was impressive as was their passion for bringing relevant information to light.

When I first began listening to these shows, it never dawned on me that I would start a podcast a year later. I looked up to these hosts so much that, truthfully, I would have never considered myself qualified to enter this space at that time. However, as I was finishing writing this very book you are reading now, it started to occur to me that I had been exposed to so many self-development resources, mainly due to the necessity of dealing with my past trauma, that possibly I did possess some knowledge that people might find valuable. So, in April 2021, I made the decision to start a podcast, and *The Art Of…* was born.

Self-Portrait Podcast Princess | 3-Dimensional Oil on Canvas | 48 x 48 in. | 2022
In the collection of Megan and Jeff Galgano

My call to this new creative path started as a small whisper in the back of my mind, a tiny spark of inspiration that was so meek, I hesitated to move forward with a response. It took a lot of courage for me to say the words "I think I want to start a podcast" out loud to an actual person, but almost as soon as I spoke those words into existence, I gained momentum, and I began working toward my goal.

I'm not going to lie, recording my first few episodes was nerve-racking, and I was painfully self-conscious and nitpicky about every word that came out of my mouth. I was filled with insecurity as I had serious doubts about my ability and thought, more than once, that I had overreached by starting my project. On top of that, I had already invested what I considered a great deal of money in the production of my show, so quitting was not an option, but believe me, I desperately wanted to forget the whole thing. I was petrified.

But then, after talking with trusted advisors, I calmed the hell down and returned to a more rational state of mind, and this is when I had some realizations that helped me move forward. Firstly, I had to keep in mind that I was not going to be an "expert" podcast host coming right out of the chute. I needed to commit to my process and engage in consistent, aligned action for a good amount of time if I wanted to improve. Discipline and practice hadn't been my favorite things leading up to this moment, yet there I was. Secondly,

I recognized that when I listened to the people I most admired on this platform, they weren't perfect. Their strength was being real and vulnerable and showing the parts of themselves that many would consider shameful. I knew I could do this. In fact, deep in my heart, I knew I was made to do this.

What I had to offer as a podcast host was something that no one in the whole pod universe had: my unique experience. Once I really owned this and realized that I justly had something unique and valuable to share, my fear subsided, and my self-critical, perfectionistic voice faded away. I slowly started feeling more comfortable, and now I can honestly say to you, I love recording my show. Absolutely love it!

I love talking with like-minded people and learning about their life experiences and healing journeys. I love exploring the topic of creativity and how creativity reveals the divine nature of humans as we slowly awaken to the fact God is pure creative energy, and we are part of that creative energy, not separate from it. I love sending my voice out into the massive universe and not knowing where it's going to land. I love being part of a community that values conversation and the sharing of ideas. And most of all, I love the connection I am able to experience as a result of recording *The Art Of*

I hope talking about my life experience and my healing

journey will reassure the listeners of my show that even the most painful of circumstances have the potential to improve if one is committed to a path of self-love and care. I have so much more to learn in the space, but I am so grateful that people are listening and learning and accompanying me on this wild ride we call the human experience.

As for the painting *Self-Portrait Podcast Princess*, well, she kind of speaks for herself. She is strong but not silent. She is joyful but not engaging in spiritual bypass shenanigans. She has wings and is ready to fly fueled by authenticity and creative courage. Above all, she wishes to be utilized as an instrument of peace because she knows this is her only path to herself.

References:
These were the podcasts I was listening to that inspired me to start recording my show. To this day they are still some of my favorites.

Almost 30 – Krista Williams & Lindsey Simcik

Ancient Wisdom Today – Shaman Durek

Aubrey Marcus Podcast

Expanded Podcast, To Be Magnetic – Lacy Phillips

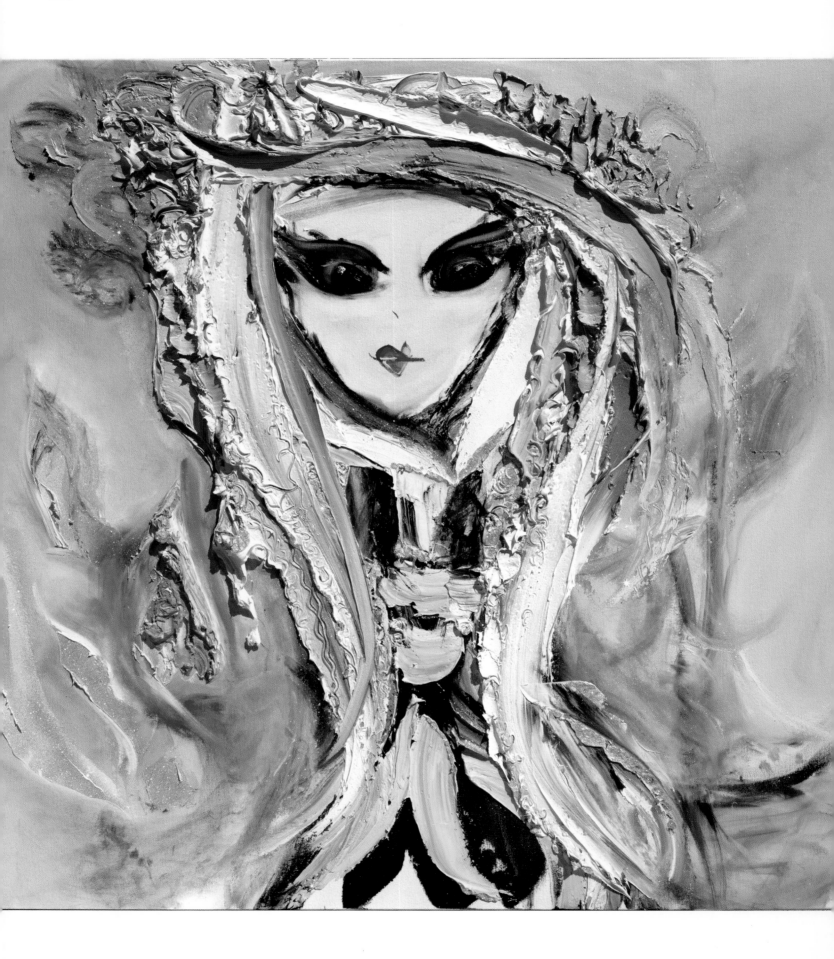

D ear God ~ Father, Mother, Yahweh, Buddha, Universal Energy, Krishna, Christ, and all the other titles you have been given throughout the beginning of time and creation, I have but one prayer.

Let me rise through thoughts of peace, knowing that I am not separate from you. Let me remember, with all my being, that just as the cells in my body are a part of me and sustain my life, I am a part of you. We are one. There is no separation.

Elevate my thoughts as they constantly remind me that other people are also a part of you and, by extension, are also a part of me. When I forgive and unconditionally love others, I contribute to the overall life force. When I forget this universal truth, please gently bring me back quickly so that I can sustain healing and peace for myself and the world.

Let me levitate, let me love, and let me experience myself as an expression of you.

With joy and gratitude.
Lea

Self-Portrait Let Me Levitate | 3-Dimensional Oil on Canvas | 48 x 48 | 2021
In the private collection of Misty and Bill Ried

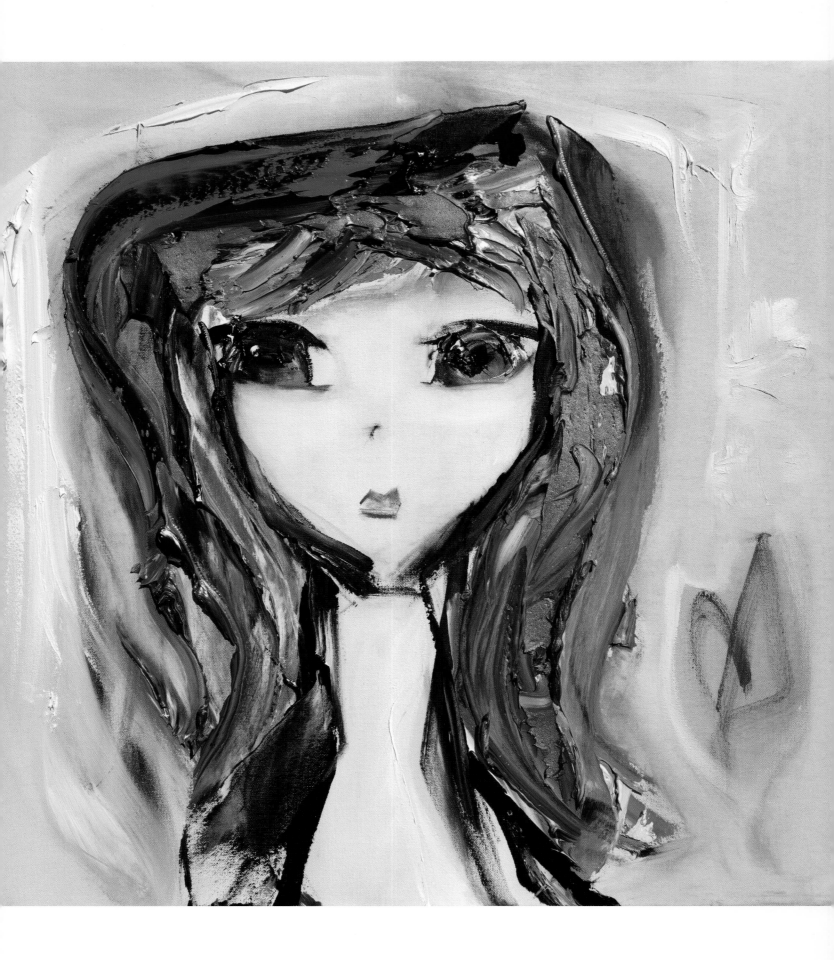

Self-Love has been the focus of my self-development over the past few years. For so long I was looking outward, wanting others to give me the love I so deeply desired. Little did I know that all I ever dreamed of came from inside me.

Now, developing a self-love practice didn't happen overnight, and feeling the effects of my efforts took even longer. In addition to that, when I first made it my goal to unconditionally love myself daily, to be honest, it felt bizarre, overindulgent, and a little stupid. However, the time and effort I invested in myself has been one of the best things I've ever done.

I finally can access the love that I have been grasping for my entire life. I'm no longer holding the people in my life emotionally hostage until they facilitate the dopamine hit I so desperately needed. I am now able to give the love I always wanted and, it's ironic, it boomerangs back to me tenfold.

So, hey, it's your lucky day. Here are 25 tips I utilize in my self-love practice. Take compassionate action toward yourself and start today. You are worth it. I promise.

Turn the page for a complete list.

Self-Portrait Self-Love | 3-Dimensional Oil on Canvas | 24 x 24 in. | 2021

1. Wrap your arms around yourself first thing when you wake up in the morning and tell yourself, "I believe in you, I'm grateful for you, and I love you."

2. Stretch for ten minutes a day.

3. Let go of any guilt for taking valuable "you time."

4. Invest in a character development tool such as a therapist, self-help book, personal trainer, online course, or healer.

5. Find something, ANYTHING, to feel good about for ten minutes a day.

6. Drink more water.

7. Find a podcast that speaks to your soul and listen to it!

8. Forgive ANYONE you hold resentment toward. (Yes, even THAT person!)

9. Practice breathwork.

10. Alternate hot and cold water while taking a shower.

11. Affirm ten wonderful things about yourself OUT LOUD while showering.

12. Forgive yourself for past mistakes.

13. Don't engage in gossiping.

14. Give yourself permission to say "no."

15. Study the idea of unconditional love.

16. Walk barefoot on the grass.

17. Check in daily with your emotional self. Speak to yourself as if you were an innocent child.

18. Pray and meditate every day.

19. Do inner child and shadow work.

20. Monitor the negative thoughts you tell yourself and write them down. Then write down what would be the opposite, and say them out loud once every day.

 For example: "I am beautiful; I am worthy of love."

21. When feeling anxious or depressed, have compassion for yourself.

22. Prioritize learning to regulate your emotions.

23. Give yourself credit for all that you have survived.

24. Tighten your social circle.

25. Wrap your arms around yourself the last thing before you go to sleep at night and tell yourself, "Thank you for doing your best today. I love you."

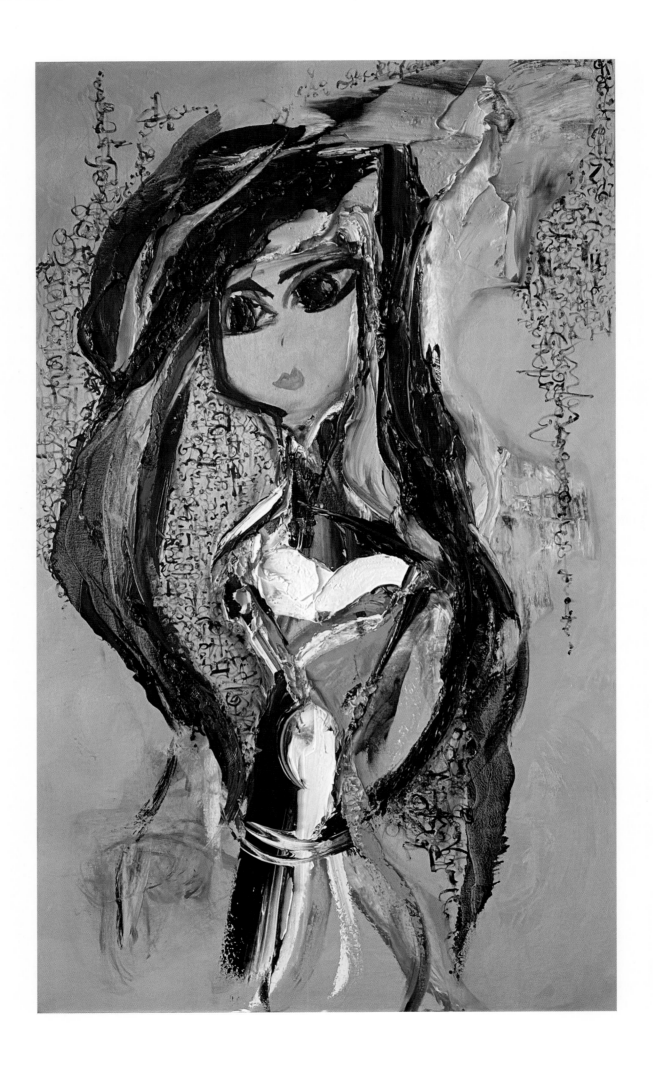

A FINAL THANK YOU

I am the only child and the only grandchild on both sides of my family, so this means that I have no cousins (first cousins at least) or siblings and that I am the last person in both of my family lines. I think it would be reasonable to assume that I was lonely as a child but, ironically, I was not. I never yearned for brothers and sisters for some reason. On an intuitive level, I felt that family, especially the family I lived with on a daily basis, equated to pain—so I think I recognized that having a sibling may not have been a fairytale addition to my life.

While I lacked in blood ties, I received overflowing gifts of incredible friendships. I have always been quite fortunate that making friends has come easily to me, so I never missed having brothers, sisters, and cousins. Many of the friends I have had in my life turned out to be my chosen family, and I am beyond grateful for this circumstance.

In addition to great friends, there have also been many angels in the form of family friends, coworkers, and teachers who have believed in me and given me support when needed. I cannot overemphasize how essential these people have been to my success personally and professionally, and I can only hope that I pass on the generosity that has been extended to me.

Also, although my family was small, I always knew that they had my back. Some of my family members made great sacrifices financially and emotionally to ensure I had the greatest opportunity to make the most of my life, and while some of them were too burdened to give me much, they gave what they were able.

So, to sum it up, I truly have been rich when it comes to having good people around me, so I just wanted to pause to show some gratitude to some of the key people who have had a significant impact on my life. Without you all, I would not be me—and because of that, an autobiographical book about me would be nothing without you. Thank you.

In My Tribe II | 3-Dimensional Oil on Canvas | 48 x 48 in. | 2018
In the private collection of Alexis Davila

ACKNOWLEDGMENTS

My mother, Stephanie Veal — Thank you for giving me life and reflecting to me what is necessary for my healing, which ultimately has led to my highest serenity, joy, and life's purpose.

My stepfather, Roger Veal — Thank you for coming through in the end when it really mattered.

My aunt, Leslie Williams — Thank you for never giving up.

My grandfather, Howard Fisher — Thank you for being my rock in this life, my one true north.

My grandmother, Beverly Fisher — Thank you for your unconditional, loving kindness and your undying belief in me.

My grandmother, Shirley Williams — Thank you for providing a sense of stability and a safety net that was often needed when I was a young child.

My aunt, Lisa Carroll — Thank you for making me laugh every time we talk and being there for me when I have needed to cry.

My uncle, Tim Fisher — Thank you for being the kindest, most nonjudgmental person I have ever met.

My uncle, Greg Fisher — Thank you for being the coolest cat ever and giving me tiny little gemstones that are still some of my most treasured possessions.

My aunt, Jackie Stein — Thank you for your devotion to our family and always looking on the bright side of things.

Glenna Fisher — Thank you for being a wonderful, loving wife to my grandfather in his second chapter of life and talking to me about politics over beautifully prepared feasts!

Lori Terkelsen — Thank you for introducing my family to a life of recovery and dignity.

Paul Sermas — Thank you for making me feel chosen.

Sonia King — Thank you for being my very first best friend.

Jody Tyler — Thank you for being my first love.

Melissa Gray — Thank you for providing a safe space when I had none.

Chris Mitchel — Thank you for being the brother I never had.

Robbie Cochrane — Thank you for watching over me when I was younger.

David Cochrane — Thank you for listening to me without judgment.

John Paul Turner — Thank you for always, without fail, making me laugh.

Jules Fredrick — Thank you for showing me that a woman can be simultaneously strong and graceful.

Niles Romano — Thank you for expanding my idea of what is actually possible in the world.

Amy Murrell — Thank you for believing in me, being totally present with me and showing me an example of true humility expressed through education.

Fancy Knebel — Thank you for your unpretentious and no-bullshit attitude.

Andrea Carr — Thank you for helping me grow up and providing an example of truly unconditional love.

Kipper Doughty — Thank you for teaching me how to have fun. Kipper did it...

Rhonda Green — Thank you for being a compassionate voice of reason that I can always rely on.

Shannon Tracy — Thank you for your quick wit, which is both enduring and entertaining.

Suzy Schul — Thank you for your eternal optimism and strong sense of commitment.

Misty Hasiotis — Thank you for your effortless style, not only in fashion but also in life.

Charla Montgomery — Thank you for your courage and commitment to telling your truth.

Jeanette Breen — Thank you for being as committed to your inner beauty as your outer beauty.

Jackie Barausky — Thank you for all our heartfelt conversations and supporting my artistic vision.

Anna Sandra — Thank you for accompanying me down the Scorpionic path. It takes one to know one!

Devin Savage — Thank you for just being YOU, the brightest ray of sunshine that graces us all.

Christy Houser — Thank you for your courageous and graceful vulnerability.

Abra Garrett — Thank you for your keen intelligence and eternal beauty.

Leti Lackey — Thank you for your beautiful spirit and stunning elegance.

Nickki St George — Thank you for adding exotic glamour to my life. Drink!!!

Yana Greenstein — Thank you for being a shining example of courage and your unwavering commitment to your self-worth.

Cassie Taylor — Thank you for never letting me spend a holiday alone.

Jessica Jade — Thank you for ALWAYS showing up, your fiercely loyal friendship, and your ability to tackle difficulties.

Jeff Henkel - Thank you for your intellect and brilliant conversations. I still believe love runs the world!!

Alison Volk — Thank your commitment to integrity, your infectious laughter, and your childlike wonder for life.

Kristin Rivas — Thank you for balancing your passion, commitment, and discipline perfectly.

Philip Romano – Thank you for laying the foundation for my artistic career.

JD Miller — Thank you for believing in me when I could not quite believe in myself.

References:

Elliott, Carolyn. *Existential Kink: Unmask You Shadow and Embrace Your Power*. Weiser Books, 2020.

Expanded: To Be Magnetic Podcast – Lacy Phillips

Mellody, Pia, et al. *Facing Love Addiction* - Reissue. Harper Collins, 2011.

Groups, Al-Anon Family. *How Al Anon Works for Families & Friends of Alcoholics*. Al-Anon Family Groups Inc., 2018.

Marisa, Peer. *I am Enough: Mark your Mirror and Change Your Life*. 2018.

Wolynn, Mark. *It Didn't Start with You, How Inherited Family Trauma Shapes Who We Are and How to End the Cycle*. Penguin, 2016.

Audiobook: *Knowing Your Shadow – Becoming Intimate with All that You Are,* Robert Augustus Masters, Ph.D.

R. Hawkins, MD, PHD., David. *Letting Go*. Hay House, Inc, 2014.

Frankl, Viktor E. *Man's Search For Meaning*. Random House, 2013.

Mark Groves Podcast

Meditation to Shift Your Reality Before You go to Sleep - John Moyer

National Suicide Prevention Hotline – 1-800-273-8255

Assisi), Saint Francis (of. *The Writings of Saint Francis of Assisi*. 1905. *Peace Prayer of Saint Francis*

Preside Meditation - Artie Wu

Whitaker, Holly. *Quit Like a Woman— The Radical Choice to Not Drink in a Culture Obsessed with Alcohol*. Dial Press Trade Paperback, 2021.

Myss, Caroline. *Sacred Contracts: Awakening Your Devine Potential*. Harmony, 2013.

Sex and Love Addicts Anonymous

Warrington, Ruby. *Sober Curious*. HarperOne, 2020.

Durek, Shaman. *Spirit Hacking*. Yellow Kite, 2020.

Kurtz, Ernest, and Katherine Ketcham. T*he Spirituality of Imperfection*. Bantam, 2009.

Jay, Meg. *Supernormal – The Secret World of the Family Hero*. Twelve, 2017.

Nelson, Bradley. *The Emotion Code*. St. Martin's Essentials, 2019.

Anderson, Susan. *The Journey from Abandonment to Healing*. Berkley Publishing Group, 2000.

Saint-Exupéry, Antoine and SBP Editors. *The Little Prince*. Samaira Book Publishers, 2017.

Dyer, Wayne W. *The Power Of Intention*.

McKowen, Laura. *We are the Luckiest – The Surprising Magic of Sober Life* . New World Library, 2022.

Podcast: *Almost 30* – Krista Williams & Lindsey Simcik

Ancient Wisdom Today – Shaman Durek

Aubrey Marcus Podcast

*Expanded Podcast, To Be Magneti*c - Lacy Phillips

200 SELF-PORTRAITS

Index

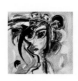
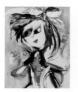
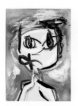
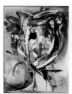
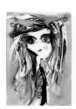
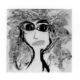
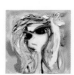
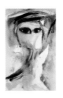
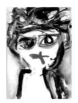
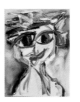
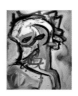
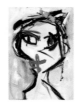
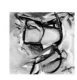
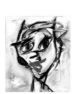
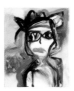
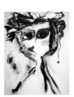

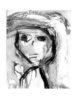

Self-Portrait Where Do You Think You Are Going?
Mixed Media on Canvas
60 x 48 in.
2020
page 78

Self-Portrait Isn't She Lovely
Mixed Media on Canvas
72 x 60 in.
2021
page 114

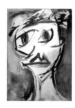

Self-Portrait 45
3-Dimensional Oil on Canvas
72 x 48 in.
2017
page 82

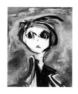

Self-Portrait 999.9
3-Dimensional Oil on Canvas
30 x 24 in.
2017
page 118

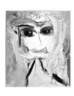

Self-Portrait 46
3-Dimensional Oil and Mixed Media
on Canvas
58 x 48 in.
2019
page 86

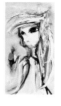

Self-Portrait No Mask Required
3-Dimensional Oil on Canvas
56 x 29 in.
2020
page 122

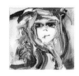

Self-Portrait Inside Story
3-Dimensional Oil on Canvas
20 x 20 in.
2018
page 90

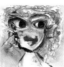

Self-Portrait In My Tribe I
3-Dimensional Oil on Canvas
48 x 48 in.
2018
page 126

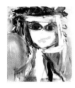

Self-Portrait Blue Monday
3-Dimensional Oil on Canvas
24 x 20 in.
2018
page 96

Self Portrait Ghost
page 130

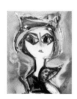

Self-Portrait 911
3-Dimensional Oil on Canvas
48 x 36 in.
2017
page 100

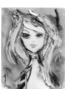

Self-Portrait Ice on Fire
3-Dimensional Oil on Canvas
40 x 30 in.
2022
page 134

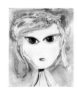

Self-Portrait Princess Diary
Mixed Media on Canvas
60 x 48 in.
2018
page 102

Self-Portrait What a Difference a Day Makes
Mixed Media on Canvas
40 x 40 in.
2018
page 136

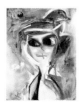

Self-Portrait 1988
3-Dimensional Oil on Canvas
48 x 36 in.
2017
page 106

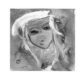

Self-Portrait Quantum Jump
3-Dimensional Oil on Canvas
24 x 24 in.
2020
page 140

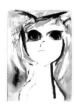

Self-Portrait Pretty Pout
Mixed Media on Canvas
72 x 48 in.
2018
page 110

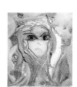

Self-Portrait Who Did You Think I Was?
3-Dimensional Oil and Mixed Media
24 x 20 in.
2020
page 146

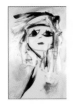
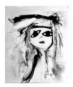
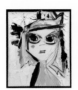
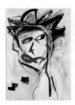
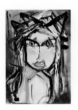
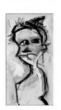
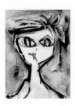
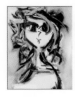
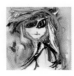
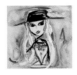
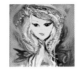
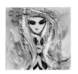
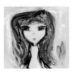
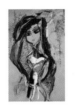
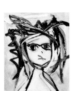
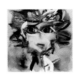